The Art of
~ J. M. W. ~
TURNER
David Blayney Brown

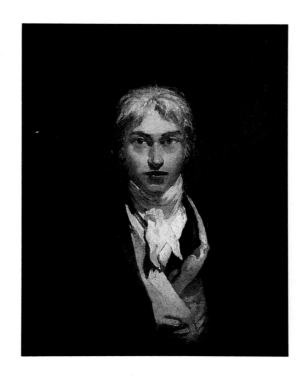

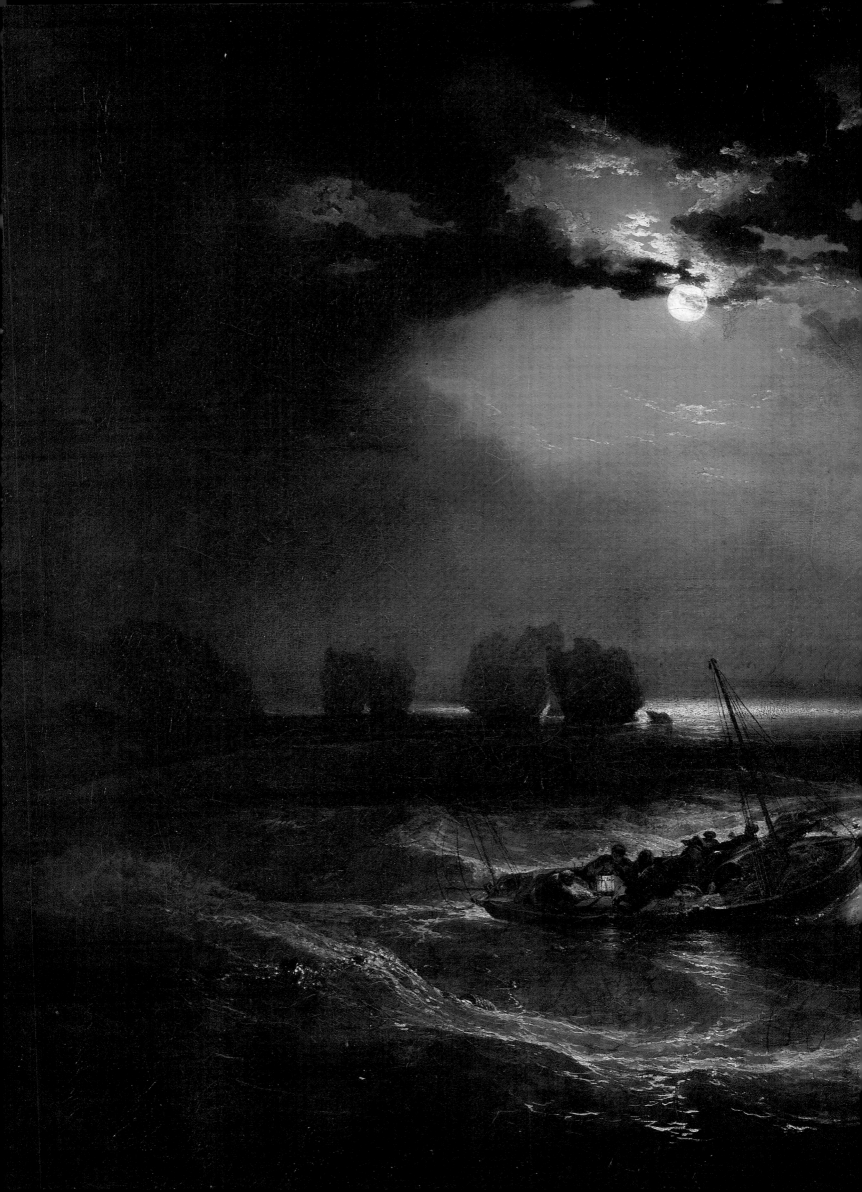

The Art of
J.M.W.
TURNER

David Blayney Brown

KNICKERBOCKER
PRESS

Published by Knickerbocker Press
276 Fifth Avenue, Suite 206
New York, NY 10001
USA

ISBN 1-57715-030-9

This book is produced by
Quantum Books Ltd
6 Blundell Street
London N7 9BH

Creative Director: Peter Bridgewater
Art Director: Moira Clinch
Art Editor: Anne Fisher
Designer: Stuart Walden
Project Editor: Barbara Fuller
Editor: Hazel Harrison
Artwork: Danny McBride
Picture Manager: Joanna Wiese
Picture Researcher: Arlene Bridgewater

Typeset by
Central Southern Typesetters, Eastbourne
Manufactured in Hong Kong by
Regent Publishing Services Limited
Printed in China by
Lee-fung Asco Printers Ltd.

HALF TITLE:
SELF-PORTRAIT

J. M. W. Turner, oil, c. 1800, Clore
Gallery for The Turner Collection.

CONTENTS

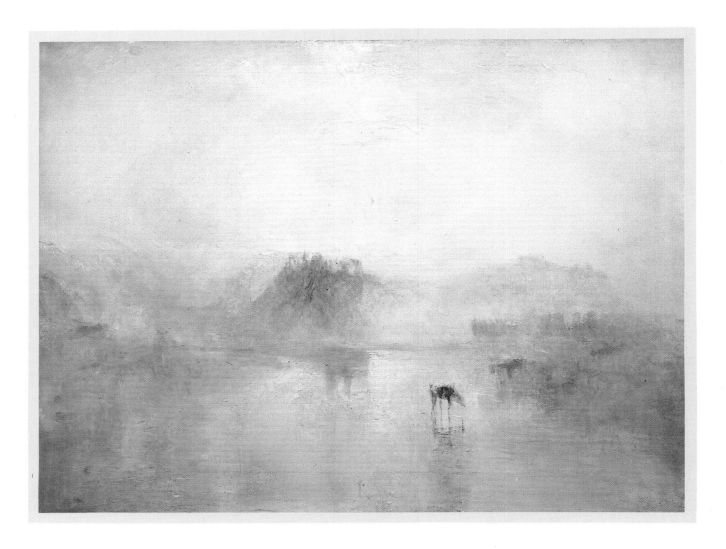

NORHAM CASTLE, SUNRISE

*J. M. W. Turner, oil, c. 1848–50, Clore
Gallery for the Turner Collection. Turner
first visited this castle, on the River Tweed,
in 1797. Thereafter, it recurred in water
colours, book illustration and as a plate to
his conspectus of landscape types, the 'Liber
Studiorum'. In this painting, one of a
number of late reconsiderations of subjects
from the 'Liber', the castle appears through
a sunny morning mist.*

INTRODUCTION

*Introduced today to the man who beyond all doubt is the
greatest of the age; greatest in every faculty of the imagination,
in every branch of scenic knowledge; at once* the *painter and
poet of the day.*

JOHN RUSKIN IN HIS DIARY, ON FIRST
MEETING TURNER IN 1840

Joseph Mallord William Turner is a giant in the history of art, but he was also very much a man of his time – a central figure of the Romantic movement. It was entirely appropriate that his artistic studies at the Royal Academy began in 1789, the year of the French Revolution, for the ideals of freedom, independence and liberation from tradition that inspired the Revolution were also the motivation of his progress as a painter.

Romanticism is not easy to define briefly, for it took many forms. But central to it was the expression of personal ideas, visions and emotions, unconstrained by old disciplines. Imagination, rather than convention, governed the creative act, and artists could create their own taste to an extent that had not been possible before. For some this meant searching their subconscious, and revelling in the extreme or fantastic; for Turner it meant above all a new appreciation of nature. This was unrivalled in its scope, ranging from extraordinary renderings of natural forces – torrents, waterfalls, storms on land or sea before which humanity could only cower powerless – to infinitely subtle explorations of atmosphere and light, achieved by techniques of astonishing sophistication and expressive power.

Turner's unique and independent vision changed for ever our concept of landscape painting – as indeed it was designed to do. But although he would have considered himself, from the beginning to the end of his career as a landscape painter above all else, his art also embraced historical subjects, themes from literature and mythology and the Bible, marine subjects and architectural renderings. Human affairs also fascinated him, yet landscape was almost always the central concern of his work.

In the last twenty five or more years of his life, Turner's vision of landscape was entirely new in vision and method. His knowledge of the forms and phenomena of nature was by now immense, based on years of study, and an astonishing visual memory, and it was expressed with a brilliance and freedom that dazzled, disturbed or even shocked his contemporaries. Even in an age of change and restless curiosity, such innovations as his did not pass without comment, and sometimes aggressive criticism. Yet he had begun his career in an entirely conventional fashion. His training and early work belong to the rational eighteenth century as completely as his later development does to the Romantic age.

Turner was born in London on 23 April 1775, the son of a barber of Maiden Lane, Covent Garden. He was brought up mainly in the city, but paid brief visits to relatives elsewhere in the south of England – visits that were sometimes occasioned by stresses at home arising from his mother's unstable mental condition. In 1800 she was confined to Bethlem Hospital, and four years later she died in an asylum in Islington. Turner's 'Daddy', however, remained close, a friend as well as a parent, and later a faithful assistant in his son's studio. To encourage Turner's early manifestations of talent, he hung up his son's drawings in his shop, and through family contacts, saw to it that the boy took

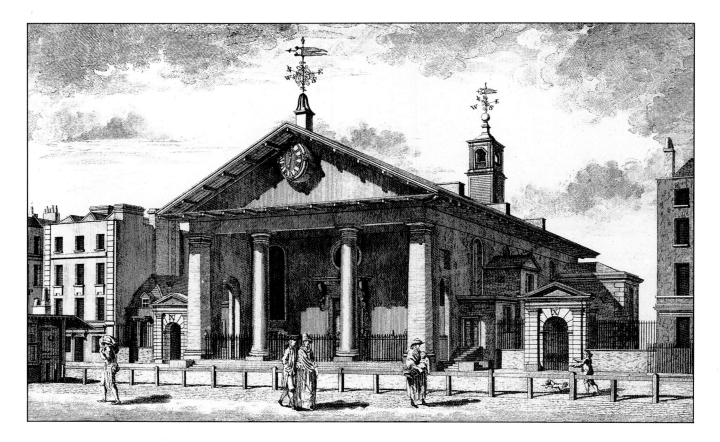

ST PAUL'S CHURCH COVENT GARDEN

A. Smith, after Thomas Malton, 1774,
engraving, British Museum, London.

some training in architectural drawing. This stood Turner in good stead when as a youth he studied the lucrative discipline of watercolour topography, the accurate recording of buildings and beauty spots.

Turner's first fully developed works, and his earliest exhibits at the Royal Academy – from 1790, when he was only fifteen – were in this field. But he was also becoming interested in the pictorial and atmospheric potential of 'view-making', and besides the work of established topographers, he studied watercolours by John Robert Cozens who had raised pure landscape to new heights of expression.

Studies at the Royal Academy began for Turner when he was fourteen. The Academy, with its fundamentally classical teaching and high aspirations for a national art, helped to foster his ambitions as a history painter in the tradition of the old masters which were to come to the fore after 1802, when Turner visited the great collections of the Louvre in Paris. Meanwhile it was not until 1796 that he felt sufficiently confident to exhibit an oil painting, a marine subject with a dramatic effect of light, which clearly announced his intention to broaden his art.

Success came early to Turner, and thereafter he was never without work or income. Caution with money – indeed what almost amounts to avarice – seems to have run in his family. By the time he died he had amassed a large fortune, and although his will included proposals for charity to artists less successful than himself, tales of his greed and miserliness had become legend. Even in his youth, on a sketching trip in Kent with some impecunious friends, he had attracted comment by refusing wine which, of all the party, he was already best able to afford. He was undoubtedly a good manager both of money and of his professional time, ensuring that he did not have to

depend solely on the sale of his paintings, by keeping up a flow of private commissions and instigating projects for engravings from his drawings and watercolours. To the end of his working life he was a true professional.

Turner cut a plain and unglamorous figure. He never lost his cockney voice and rather uncouth manners. It could never be said of him, as it was of his friend and colleague David Wilkie when he first arrived in London from his native Scotland, that after his first dinner with his aristocratic patrons he was as complete a gentleman as any of the party. The French painter Delacroix, whom Turner called on in Paris, probably in 1832, thought he looked like an English farmer, while others, seeing his heavy and ruddy features in middle and later years, were reminded of a sailor or a stage-coachman.

In old age he was reclusive, and appeared shabby and neglected when he appeared at all, while his London house fell famously into decay. He was no master of English prose – his letters rarely make thrilling reading, nor are they very grammatical – and although Constable was impressed by his 'wonderful range of mind', he had no reputation as a clever talker. His Academy lectures were clumsily delivered, and socially he could be uncommunicative or gruff. Yet with those who shared his interests, or who took him on his own terms, like Walter Fawkes at Farnley Hall or Lord Egremont at Petworth, he formed deep and lasting attachments that cut across social barriers. Theirs was a meeting of minds, and Turner's mental capacity – however untrained – was never in doubt.

His reading was voracious. The English poets and dramatists; Classical authors and historians; theorists of colour and aesthetics; antiquaries and historians; the growing breed of travel writers who were in the forefront of a new age of tourism – Turner devoured them all, building layers of information and memory which he poured back into his pictures, sometimes, in his later years, in confusing combinations. Besides books, he devoured the old masters. His reputation in the Academy and with the mainly patrician patrons and collectors who dominated the art world was made with a series of large and splendid historical subjects, landscapes and marines that owed much to the great painters of the past. But Turner's pictures were never mere exercises in established tradition. They deployed increasingly innovative techniques and tonal combinations, and penetrating analyses of natural effects – clouds, sky, moving water or foam, a sunbeam or a rainbow through mist – and the titles he chose for these works were composed to emphasize the importance of these natural phenomena.

Travel was always a moving force in Turner's life and art. From boyhood almost, the pattern was established – visits or tours in summer and autumn, work in London in the winter. Although he enjoyed several relationships, and produced two daughters, he never married, and freedom to travel for months at a time was built into his life. Of all the British Romantics – a generation of wanderers – Turner must have been the widest travelled. Byron, with his long peregrinations around Europe, was his only rival in this, but with his exile's temperament and his scorn for post-Napoleonic Britain, he could not match Turner's equally comprehensive knowledge of his own country. Turner travelled, not as a random or restless pilgrim, but in methodical pursuit of subjects and information, about nature as well as places, returning again and again to favourite spots like Venice, Lake Lucerne or humble Margate – for each day, each hour, they were transfigured by the elements.

The lonely mountains of North Wales and Scotland gave him his first hints of the dramatic potential of nature, but the revelation that changed his art for ever came in Switzerland in 1802. Drawings done in the Alps that summer, and paintings and watercolours based on the tour, display both a heightened emotional key and an intense naturalism – characteristics that informed all aspects of his work during the next decade and more.

By the time Turner crossed the Channel again some fifteen years later, to visit Waterloo and the Rhine in 1817, he was established as his country's most eminent landscape painter. Since 1807 he had served as Professor of Perspective at the Academy, and in 1804 he had opened his first private gallery for the display of his pictures. From 1807 until 1819 he

publicized his work and categorized a range of landscape styles in the series of prints entitled *Liber Studiorum*. Meanwhile he was devoting considerable time to making a series of views on commission from engravers and publishers. These continued to preoccupy him throughout the 1820s and 1830s, and kept his reputation and income high at a time when his paintings were becoming increasingly controversial.

Turner's first visit to Italy in 1819 was a turning point at least as significant as his first sight of the Alps. As he studied the cities and landscapes which had contributed so much to European Classical culture and inspired so many great painters – above all his beloved Claude – he was inspired anew by Italy's vivid colours and clarity of light. The translucent and crystalline effects of his first watercolours of Venice, Rome and Naples, and the brilliant tones of the first Italian oils painted from recollection a few years later, initiated the process of liberation felt throughout his work in the last thirty years of his life. As a young man he had at times attempted to raise watercolour to the scale and tonal density of oil; now his practice in oil was significantly modified by his transformed handling of watercolour.

Turner's next visit to Italy in 1828 revealed a different side of his character. On the first trip he had devoted most of his time to learning and drawing, and had gained a reputation for secrecy, not even disclosing his address, but on the second he was very sociable and held an exhibition of pictures he had painted in Rome. The duality in his nature became evident in his later years. He continued to work hard, and to play his part in the official life of the art world and the Academy – both in its business affairs and as a self-conscious master of technique on the Varnishing Days when pictures were finished for exhibition. Yet he also withdrew into his shell, his solitude increased by the deaths of friends and patrons like Fawkes and Lord Egremont in whose houses he had relaxed into a certain warmth and affability. He was assembling a collection of his own paintings and studies in his gallery, sometimes even buying works back at auction. This collection was supposedly destined for posterity – in the Turner gallery he planned in his will – but he did nothing to care for the paintings and showed them to few. And to the young John Ruskin, who had championed his work since the late 1830s, he could on occasion be discouraging to the point of rudeness.

Such contrasts are reflected in his art. The serenity of some of his late landscapes has its counterbalance in the dramatic renderings of storms or of subjects with disturbing or even tragic implications. While he embraced such emblems of the new age as steamships and railways, it was rarely without nostalgia for the past. Although he well knew that he had carried his beloved art of landscape forward by leaps as great as those that had produced such inventions, it was by his homages to the old masters, to Claude and the Dutch, that he wished to be remembered 'in perpetuity' in the National Gallery.

Turner died on 19 December 1851, aged seventy-six. He had lived through a period of extraordinary change both at home and abroad, in politics and society, in taste, education and the administration of the arts, in travel and mechanization. Born into a classical, antiquarian and still mainly agricultural society dominated by a landed aristocracy, he had seen the birth of the machine age and the rapid growth of an urban society ruled by new masters with new values. Those who still looked to the past for inspiration now turned to the middle ages rather than to antiquity. The summer before Turner died, the Great Exhibition had taken place in London, celebrating the achievements of a Britain that felt itself supreme in this new world.

Britain's greatest painter had reflected the momentous changes of his lifetime as no other artist of his period. Britain and the Continent at war and peace, travel and transport, country estates and burgeoning industrial cities, the army and navy, heroes of the age like Wellington and Napoleon and its great issues like slavery and Reform, and the different values implied by antiquities in Italy and new hotels in Switzerland – all had been acknowledged, whether literally or by absorption into the wider imaginative panorama of his art. He had illustrated the major voices of his time, Byron, Walter Scott, Samuel Rogers, Thomas

Campbell; and he had found a voice of his own: haltingly as teacher and poet, and powerfully in the explicit morality proclaimed by his art. Patriotism in war; liberty and a prophetic vision of the integrity of peacetime Europe; and above all man's place in the natural world as a sometimes vulnerable partner rather than a destructive and domineering master – these are but some of the messages of Turner's art and they are as relevant today as they were then.

This book is not primarily about Turner the artist, nor even about Turner the man; there are other and better books to explain him. I have allowed his art to speak mainly for itself through the plates, and have tried to sketch in at least some of its background, to provide as it were a voyage around Turner rather than a biographical or critical account.

I have tried to do this in a readable and accessible way, with each chapter self-sufficient. Thus Turner's Academy training and career serves as the foundation for an account of some aspects of the art world of his day, its institutions, preoccupations and personalities. Turner's lifelong admiration for the old masters and his relationship with certain contemporary artists is the basis for a summary of changes in taste and connoisseurship during the period. Finally, his travels at home and abroad are discussed in the context of the history and society of Britain and Europe.

More could be said about all of these issues, and much more about Turner himself. But I hope this book will not only confirm its readers' love of Turner, but spur their curiosity to delve deeper into the inexhaustible riches and complexities of his period.

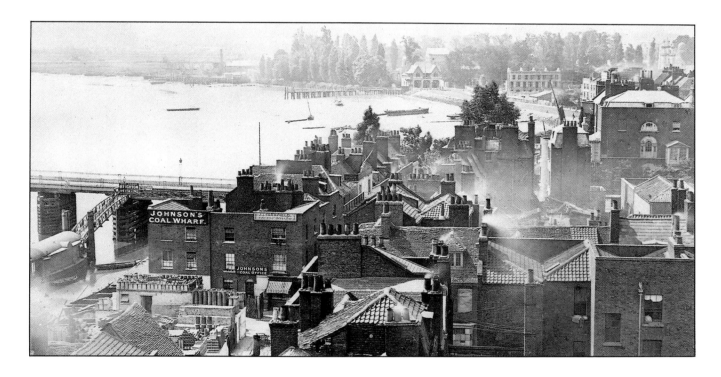

PHOTOGRAPH OF CHELSEA OLD CHURCH
AND CHELSEA EMBANKMENT

J. Hedderley, c. 1863-7. Royal Borough of
Kensington and Chelsea, Libraries and
Arts Service. Turner's Cheyne Walk home,
in the middle distance here but not actually
visible, still stands today. It bears a
memorial plaque by the Victorian artist
and designer Walter Crane.

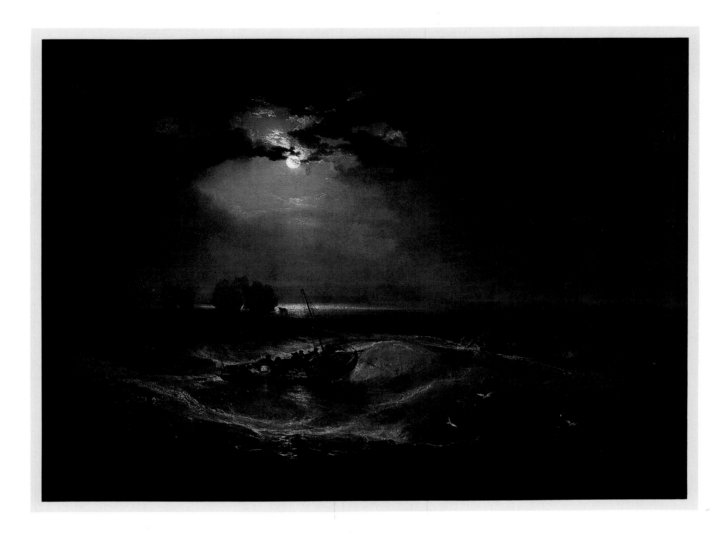

FISHERMEN AT SEA

*J. M. W. Turner, oil, Royal Academy
1796. Clore Gallery for the Turner
Collection. Turner's first exhibited oil, this
nocturnal marine depended mainly on the
continental tradition exemplified by his
mentor, De Loutherbourg.*

THE ROYAL ACADEMY AND THE LONDON ART WORLD

'Now', resumed the speaker, 'you are wondering what I'm driving at' (indeed we were). 'I will tell you. Some of you young fellows will one day take our places, and become members of this Academy. What I want you to understand is just this – never mind what anybody else calls you. When you become members of this institution you must fight in a phalanx – no splits – no quarrelling – one mind – one object – the good of the Arts and the Royal Academy.'

W. P. FRITH, PARODYING A SPEECH OF TURNER'S
TO STUDENTS OF THE ROYAL ACADEMY

In Turner's time, an artist's life was less assured than it is today. The rewards could be rich for some, and Turner, as astute a business man as he was a superbly talented painter, died a wealthy man. But both John Constable and Benjamin Robert Haydon, whose name was known widely in Europe, learned the hard lesson that genius alone was no guarantee of success, nor was it necessarily accompanied by patronage or prosperity. There were more artists in Britain than ever before. Between 1793 and 1815 they competed for reputation in a wartime economy. Meanwhile, and in the years after the Napoleonic War, they created great changes both in taste, and in the organization of the art world.

By Turner's middle years, a commercial art was beginning to grow up, but in his youth dealers dealt exclusively in the art of the old masters. Artists were even more fiercely independent – though often less radical – than they are today, and sought respectability and status through their own efforts and organization. They had to support themselves through their education, find patrons and purchasers, and ensure regular income to sustain themselves through long projects, either from advances, pensions or, most reliably, from the proceeds of engravings done from their work. A successful artist was likely to conduct his career on a number of different levels, and Turner's strong belief in himself, allied to his financial astuteness, ensured that he explored all of these.

ART EDUCATION

It is typical of his complete professionalism and commitment to his art that he took his training seriously from the start. In 1789, aged fourteen, he entered the Royal Academy Schools where he received the conventional painter's education of the day, but he also studied with individual architects and draughtsmen, and in the informal private 'academy' of Dr Thomas Monro, mastering the arts of architectural drawing and topographical watercolour. As a boy, Turner had begun drawing views, such as those in and around Margate, where he stayed with relatives of his mother, and he also copied the plates in the popular topographical books of the day. His father, keen to turn this budding talent to financial advantage, hung up some of his son's work in his shop, and found him a job making drawings for the architect Thomas Hardwick. The association was shortlived: Turner probably did not feel sufficiently stretched, and indeed it is said to have been Hardwick who suggested he should enter the Academy.

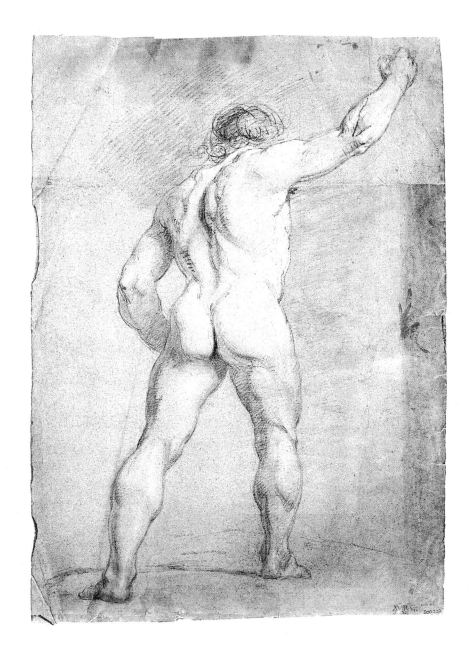

ABOVE:

ACADEMY STUDY OF A MALE NUDE

———

*J. M. W. Turner, black and white
chalks and red bodycolour on blue paper, c.
1797. Clore Gallery for the Turner
Collection.*

OPPOSITE:

*THE ANTIQUE SCHOOL AT
SOMERSET HOUSE*

———

*Edward Francis Burney, 1780, pen and
grey wash. Royal Academy of Arts,
London.*

———

There he was also a model student. In spite of its failings – it was then going through an unhappy period of internal strife – there was much to be learned there, and it was the obvious road to success for a young man without either social status or much conventional education.

Like all prospective students, Turner had gained admission on the strength of a drawing after an antique sculpture. This was submitted to the Keeper, and if it met with approval, a further drawing had to be made from a cast in the Academy's collection. The candidate then entered the first phase of study, a spell in the Antique or Plaster Academy to continue cast copying, after which he progressed to the Academy of Living Models (life class), which occupied two terms a year. Students drew men and women 'of different characters', posed nude, and usually in the positions of the sculptures already studied as casts. A combined total of six years had to be spent in these two academies, and the discipline of figure drawing was the real basis of training.

THE ROYAL ACADEMY

The Academy had been founded in 1768, seven years before Turner's birth. Like its counterpart in France, it was important both for teaching and upholding traditions in art. Moreover, its annual exhibitions formed the only marketplace for painting and sculpture, so no aspiring artist could afford to ignore it. Distinguished by the patronage of George III, it was a symbol of artists' sense of professionalism.

Then housed in Somerset House, it was a fully constitutional body, with an elected President, Academicians and Associates, and Professors lecturing on the fine arts as well as on academic subjects such as ancient history and literature. Its authority and privileges were jealously guarded, and although bitterly criticized in some quarters, it usually inspired loyalty and pride. Turner, who became a teacher at the Academy soon after his own education there had ended, served it all his life, but did once admit that it was 'not all that it might be in regard to art'.

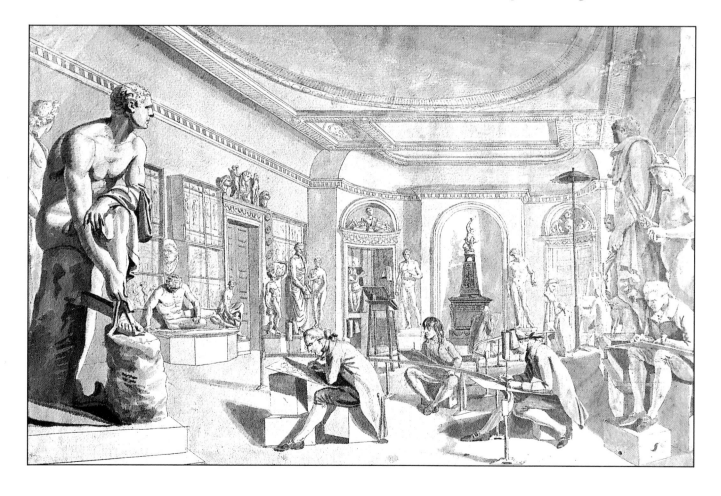

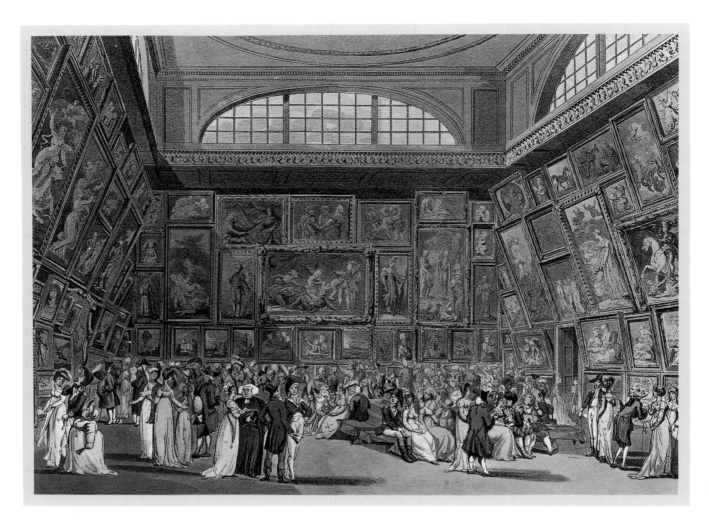

Although claiming to represent the range of artistic activity, it was in practice much more narrowly confined, and what was shown in the annual exhibitions did not really reflect its philosophy. Market forces dictated a preponderance of portraits, but in its teaching the Academy was committed to the 'highest' branches of art. Ennobling and morally inspiring subjects from the Bible, literature, mythology, and history realized in the heroic manner of the old masters were held up as the ideal. Sir Joshua Reynolds, the Academy's first president, provided the textbook formulation of these principles in his biennial dis-

courses to students and graduates, and so compelling were they that Reynolds's own concentration on portraiture did nothing to modify them. Moreover Reynolds was succeeded as President in 1792 by the American, Benjamin West, who alone among his contemporaries managed to sustain himself as a history painter on a truly grand scale.

Turner's own chosen field of landscape was, like portraiture, given low priority and little or nothing in the way of specific training. Turner was to devote much of his career to raising the status of landscape art, and later proposed that the Academy appoint a Professor of Landscape Painting. This did not come about, and Turner's own contributions to Academy teaching were confined to the more established areas of life study and perspective, subjects he certainly valued, but wished to set in a wider context.

By the close of the eighteenth century, the Academy needed not only to change, but to gain all the support

it could. Morale and teaching standards had declined, and while the prestige and intellect of Reynolds had set high standards, even he had become embroiled in some undignified disputes with his colleagues in his last years. West proved a far less popular president, whose term of office was marked by a series of squabbles. No less crucial was the effectiveness of the Keeper, in practice the chief administrator. Following the death of Agostino Carlini, who was in office when Turner's studies began in 1790, this post had fallen to Joseph Wilton, a distinguished Neoclassical sculptor but now past his prime and inclined to be lazy. Wilton retained the keepership until 1803, thus presiding over the greater part of Turner's student period and his election as full Academician.

To complete the relative unhappiness of these years, the Professor of Painting had since 1782 been the Irish history painter James Barry. Brilliant, but megalomanic and paranoid, Barry had openly quarrelled with Reynolds but had sided with him over an election dispute in 1790, and delivered the official eulogy after Reynolds's death. This would probably have brought him well-deserved respect, were it not for the fact that the antagonism of Reynolds's opponents contributed to Barry's mounting delusion that senior members of the Academy were out to frustrate his career – he even believed that they had arranged a robbery at his house in 1794.

Barry was very critical of the Academy in a book published in 1798 and in his lectures the following year, and was expelled – a unique distinction. He was succeeded by Henry Fuseli, the Swiss painter of history and fantasy, who also took over as Keeper in 1803. Clever and 'lovable', his teaching was described by one of his students, the American artist C.R. Leslie, as 'wise neglect'. He would bring a book into the drawing school and sit absorbed, only rousing himself when he spotted a particularly glaring mistake.

STANDARDS OF TEACHING

The minutely detailed diaries of Joseph Farington, a moderately talented painter of landscape and topography who by dint of experience, common sense

and manipulative temperament had risen to eminence in the Academy, chart the progress of an institution that often found itself in stormy waters, and was, a few years later, to find its supremacy in the arts seriously threatened. The traditions the Academy had acquired in its short history were in danger of atrophy, and against the background of internal arguments, it was understandable that the quality as well as the content of teaching might have been less than it should be.

Matters came to a head in 1799, not only with Barry's expulsion, but with the decision made by a Committee of Enquiry to expel some students and demote others. By 1800 the effects were clear: so drastic had the purge been that some students left altogether, and the engraver Abraham Raimbach was to recall being sometimes the only student left drawing in the life class – although he also noted that the teaching had improved. Turner's eagerness to serve in a teaching capacity as soon as possible must show his recognition that the problem could lie as much with poor teachers as with lazy students.

In 1796 Barry, still Professor of Painting, declared that 'the Academy, at present, is but a drawing-school, no more.' The Academy offered an annual premium for painting – one of several such incentives – but had not awarded it that year owing to the feeble standard of work. Even allowing for Barry's prejudices, there was substance in his remarks that the Academy 'unreasonably, cruelly requires from you, what it does not furnish you with means of performing', and 'holds out the temptation of a gold medal, inviting you to paint, yet does not provide you with any authorized, legitimate exemplars, for the study of painting.'

In the later nineteenth and twentieth centuries, a student would be able to study the work of earlier artists through books, exhibitions and permanent collections, but at this time there was no national collection, and most of the major works were privately owned.

In his *Letter to the Dilettanti Society* published in 1798, Barry urged the need for an accessible collection of masterpieces of art, for in the absence of a public gallery or study abroad, extended study of the

achievements of the old masters remained largely in the realm of theory. In 1800 the Academy acquired a set of copies by Sir James Thornhill of the Raphael cartoons, which were hung in the Great Room when the summer exhibitions were not on, and were often mentioned by the teachers. But this was only a small step, and the following year West, in his presidential address, threw out a 'hint' that private collectors might come to the rescue by opening their collections to students. In 1802 he tried to negotiate study facilities for them in the Louvre, but the same year the Academy council actually refused the offer of a group of pictures from the estate of Robert Udny. The first really positive move was the decision of another distinguished collector, John Julius Angerstein, to open his collection free to students in 1803.

The Academy was also lacking in its practical instruction in the techniques of painting. Both Reynolds and Barry had benefited from long periods of study in Italy, where it was not only possible to see a huge range of original works of art but also to consort with an international community of artists. In London such opportunities were limited, and the lectures on painting that the students heard were more historical than practical, or dealt in the abstract with such matters as connoisseurship and patronage.

London artists did not preside over *ateliers* of students as normally happened in Paris, with the result that most artists were self-taught to a degree that seems remarkable today. Some painters did open their studios and provided training of a relatively informal kind, and Reynolds himself, although he did not allow students in his studio while painting, employed young men to assist him in his busy portrait practice. These were able to pick up some of the craft of painting, but in fact Reynolds set a bad example by his own misguided technical experiments.

C.R. Leslie reported that Reynolds 'allowed young artists to call on him early in the morning before he had himself commenced painting', and commented on their work and lent them pictures to copy. Leslie recalled that Turner copied Reynolds's pictures when a student, and Turner also absorbed some of Reynolds's methods through his one-time student John

Hoppner, whom he knew well by 1798. Hoppner himself employed some pupils and assistants, among them Turner's future friend Augustus Wall Callcott, and West operated a flourishing school, though understandably enough he favoured young Americans, who like him, had made their way to the cultural metropolis of the English-speaking world.

Besides drawing and attending lectures, students could use the Academy library, which provided yet more academic theory and material for copying, but the mechanics of the studio could only really be learned from a practising painter or from London's growing number of retailers of artists' materials – 'artists' colourmen'. Turner himself does seem to have found something approaching a teacher of oil painting in the Alsatian landscape painter and scene designer Philippe-Jacques de Loutherbourg. This was a judicious choice, for de Loutherbourg, was regarded as one of the most skilled technicians of his day, 'both a practical Artist and a chemist'. He had been trained on the Continent, and his sleek and polished style brought European standards to London.

Student days merged quite easily into professionalism. Young artists began exhibiting while still studying, thus building up a network of potential buyers and patrons and attracting critical attention. Meanwhile, if they were wise, they cultivated senior members of the Academy whose influence might assist them in their election as Associates of the Royal Academy or Royal Academicians when their time came. While Turner continued to study in the life academy until 1799, he had been exhibiting since 1791. But given the practical difficulties of obtaining instruction, it was understandable that his precocious talent did not immediately express itself in oil. His first contributions to the Academy exhibitions were in the field of watercolour topography.

TOPOGRAPHY

Although watercolourists like Paul Sandby, or landscape and topographical painters and draughtsmen like Farington, were numbered among the Academicians, they took no part in Academy teaching, and

TURNER AND
STAGE DESIGN

*B*y the end of the eighteenth century a number of painters,
particularly landscapists, were involved in scene painting.
*Turner's mentor, De Loutherbourg, broke the previous tradi-
tion of anonymity as well as raising designers' fees, after bringing
his experience of Parisian theatre design to Drury Lane, and
his revolutionary stage designs were widely known. The topo-
graphical watercolourist Michael Angelo Rooker, who as the
son of a popular harlequin at Drury Lane had grown up in the
theatre, is also well documented as a scene painter. Lavish
opera productions also gave lucrative work: the Pantheon in
Oxford Street was converted in 1790 to present Italian opera
and ballet. Turner worked there between April and June 1791.
In 1792 he recorded its destruction by fire.*

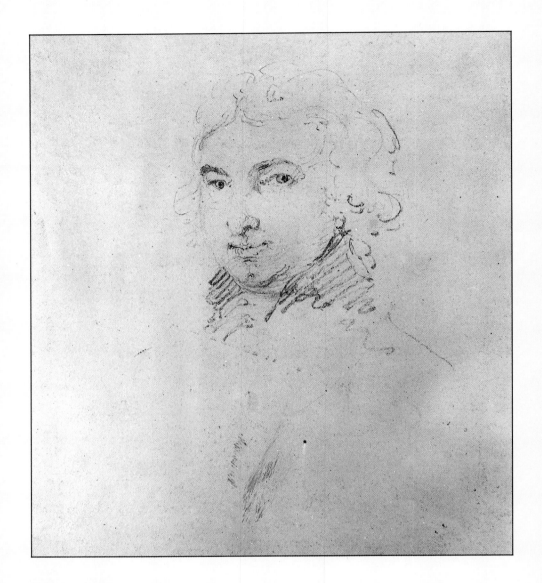

MASTER AND MENTOR

*B*esides training at the Royal Academy, artists of Turner's
*generation were very dependent on other contacts for prac-
tical instruction in painting technique, and for access to collections
in which they could study the work of other artists as the
Academy recommended. Turner took some instruction from
Philippe Jacques de Loutherbourg (1740–1812), a landscape
and historical painter and stage designer who had been born in
Strasbourg and trained in Paris. His sophisticated technique,
and paintings of dramatic and 'Sublime' landscape were to
influence Turner. Dr Thomas Monro (1759–1833), Physician
to George III and Bethlem Hospital, and a collector and amateur
artist, showed Turner his drawings by old masters and British
watercolourists like John Robert Cozens. He encouraged Turner
and his friend and contemporary, Thomas Girtin, to copy and
study in his informal 'Academy' in Adelphi Terrace.*

PORTRAIT OF DR. THOMAS MONRO

*ABOVE: J. M. W. Turner c. 1795, pencil.
Monro family collection.*

SELF PORTRAIT

*RIGHT: Philippe Jacques de Loutherbourg,
oil. National Portrait Gallery, London.*

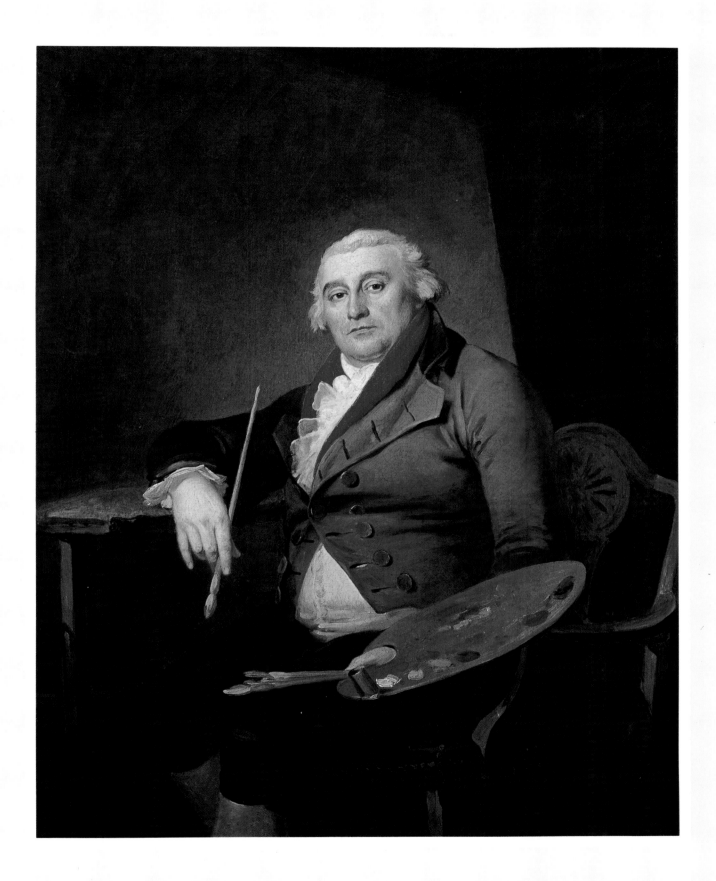

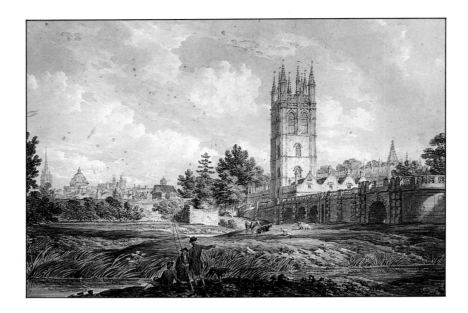

'view drawing' lay at the bottom of the artistic hierarchy. However, outside the charmed circle of the Academy, topography was a flourishing industry, comprising artists, engravers and publishers, and serving an ever-growing public. Despite its lowly status, it could provide a lucrative and regular income.

Travel to picturesque places at home or abroad on the Grand Tour had once been an aristocratic privilege, but it was now popular with the middle classes also, creating an insatiable appetite for guide books and works of scenic and antiquarian interest. A whole industry existed to illustrate these. Draughtsmen would draw and colour views, sometimes made by themselves or, quite commonly, developed from sketches by amateurs, travellers and antiquarians. No less numerous were the engravers who translated their work into prints, for a workshop would usually contain an etcher, who rendered the outline, and specialist engravers for the additional details of landscape and figures. Engravers and print publishers also employed young artists or beginners to colour prints by hand for sale.

It was thus possible for an artist to pick up work at a wide variety of levels, both to produce a subsistence income and gain experience. When an artist had mastered a range of techniques, he might act as his own engraver-publisher, calling on colleagues only to contribute particular skills at the appropriate stages. Thomas Hearne, one of the most successful topo-

MAGDALEN COLLEGE AND BRIDGE,
OXFORD, FROM THE RIVER

Edward Dayes, watercolour, 1794. Made for engraving in the 'Oxford Almanack' or University calendar of 1797, Dayes's drawing exemplifies the art of the late eighteenth-century topographer. Turner's show own designs for the 'Oxford Almanack' his own early mastery of topographical drawing.

graphers of the late eighteenth century, issued his great series of plates *The Antiquities of Great Britain* (completed in 1807) in this way. Turner, typically, was more precocious. Aged sixteen and with just three topographical exhibits at the Academy to his credit, he was already planning to draw, engrave and publish himself a series of *Twelve Views on the River Avon,* based on one of his first sketching trips outside London in September 1791.

For most of his life he continued to work extensively for engravers and publishers. Many of his finest watercolours were made for publication, and by the 1820s his activities had transformed the topography industry, creating an intense new demand, and motivating a brilliant school of engravers. He was not the first painter to realize the value of the print market, but few others manipulated it so successfully.

His architectural training was of great value in this field, and at about the same time as he entered the

Academy he had taken lessons in perspective drawing from the younger Thomas Malton, a draughtsman noted for his fine delineation of buildings, especially of London. Turner was later to claim him as 'my real master'. Familiarity with the language of architecture was crucial to the perspective lectures he was to give to the Academy, as well as to his later paintings, with their inspired reconstructions of the buildings and cities of antiquity, but meanwhile, it was typical that he should decide to harness his architectural skills to the art of topography.

Like other branches of art, topographical drawing was learned by copying as well as practice. By 1792 or 1793, Turner was visiting the physician Dr Monro and drawing in his evening 'academy'. A talented amateur draughtsman and sensitive collector, Monro encouraged young artists to visit his Adelphi home to study and copy works by established artists such as Thomas Hearne, Edward Dayes and John Robert Cozens, a fine watercolourist whose mental disturbance had placed him under the doctor's care. Hearne and Dayes represented the peak of conventional topographical watercolour, while Cozens displayed a more personal and evocative approach to pure landscape. Turner and his contemporary Thomas Girtin, a fellow student at the Monro house, were to take the best from both traditions, transforming the art of watercolour for ever.

But meanwhile, they did what they were told. They 'went at 6 staid til Ten. Girtin drew in outlines and Turner washed in the effects . . . copying the outlines or unfinished drawings of Cozens etc. etc. . . . Dr Monro allowed Turner 3s 6d each night.' It was humdrum work for Girtin, already an accomplished painter, but for Turner it was an important and liberating experience. Although some artists saw topography as a constraint, he was already coming to recognize that it could be elevated to a higher level by imagination and technical skill.

The topographer, unless he chose (or was commissioned) to work from drawings by others, spent much of his time travelling. His working life was divided between sketching tours to gather material, usually in the form of outline sketches, and his studio where he worked up his subjects in colour and with appropriate landscape and narrative effects. He had to be prepared to travel great distances – Hearne to the Leeward Islands, William Alexander to China. Sometimes these journeys were made with a patron or sponsor, perhaps a Grand Tourist in Italy or a scientist or geographer in less familiar parts of the globe.

By the early 1790s war with post-revolutionary France had restricted foreign travel, which had the effect of renewing interest in the riches that lay closer to hand. Before starting at the Monro 'academy', Turner himself was already travelling in the West Country, the Midlands and Wales, and had begun to receive commissions and work up his material into finished watercolours for the Academy. In 1799 he was offered one of the most prestigious commissions for the topographer – that of making drawings for Lord Elgin on his proposed trip to Athens. This would have made full use of his architectural skills, but by now Turner saw himself as something much more than a conventional topographer. He was attracting attention as an oil painter and, sensing his value, demanded the very high annual salary of £400, while refusing to be bound by Elgin's (quite usual) wish to keep all the drawings for himself. The more amenable Italian, G. B. Lusieri, was hired instead.

While building a career as a topographical landscapist, an artist could supplement his income by teaching drawing, most often to amateurs of leisure and means, and Turner began taking private pupils in about 1794. By 1798, however, he was 'determined not to give any more lessons in drawing. He has only five Shillings a lesson', though in fact he was to continue teaching very favoured friends and patrons like Sir John Leicester. By this time teaching fees, even if he charged any at all, were not a significant part of his income; probably they were absorbed in other charges made to his patrons for the pictures they bought.

FIRST SUCCESS IN THE ACADEMY

The various opportunities Turner was seizing outside the Academy were to be of lasting benefit to his art as well as to his pocket. By 1796 he felt ready to venture

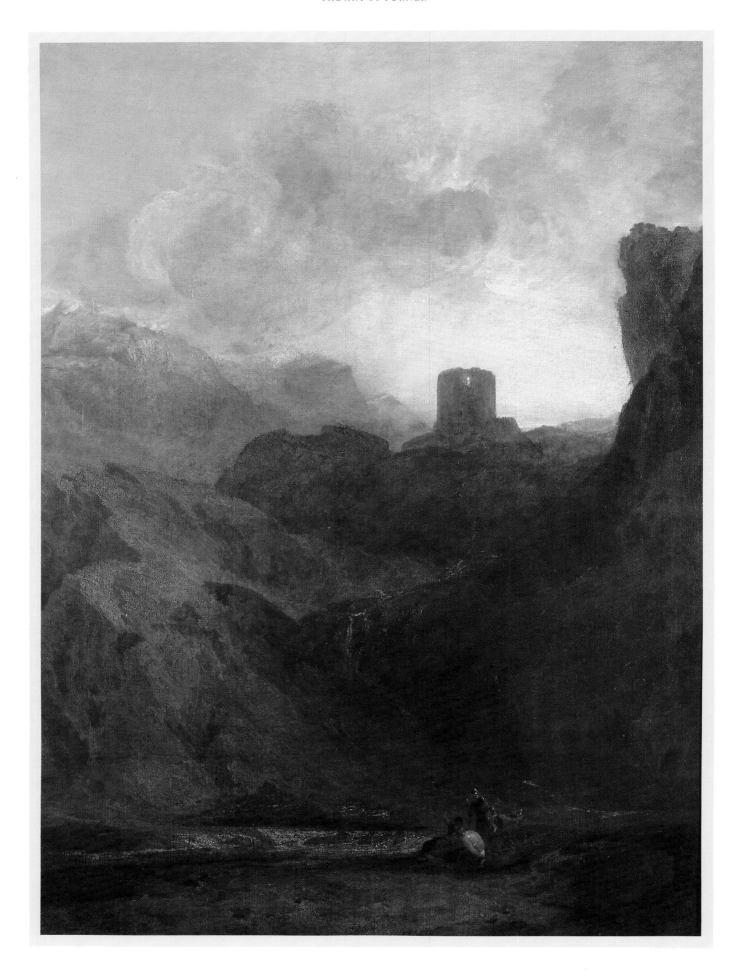

an exhibit in oil, *Fishermen at Sea*. This departure from the field of topographical watercolour announced his determination to broaden his art and to attract new attention, and he maintained this expansionist zeal in the following years, progressively taking on almost every branch of art save portraiture and sculpture. He was anxious to prove himself, to challenge not only his peers but also the old masters – and he also quite simply wanted to be noticed. It was on the walls of the Academy that reputations were made, patrons wooed and won, and professional status earned. With a reputation in the making on its crowded walls, a young painter could seek election to membership, first as Associate and then as full Academician – essential rites of passage into the professional world. Teaching or drawing and working for the engraver might well pay more regularly, but they did not provide the standing that Turner craved.

Besides establishing a body of work, lobbying was crucial. Turner understood this better by 1799, having failed to be elected Associate the previous year, and after calling regularly on Farington and offering presents of watercolours from his sketchbooks to two other Academicians, Hoppner and Robert Smirke, he was elected. He could now begin to participate in the institution's affairs.

DOLBADERN CASTLE, NORTH WALES

J. M. W. Turner, oil, Royal Academy
1800. Royal Academy of Arts, London.
Turner exhibited this ambitious exercise in
the 'Sublime' with five lines of poetry,
presumed to be his own:
How awful is the silence of the waste,
Where nature lifts her mountains to the sky.
Majestic solitude, behold the tower
Where hopeless OWEN, long imprison'd, pined
And wrung his hands for liberty, in vain.
In the coming years he showed a number of
pictures with passages of his own poetry.
'Dolbadern' was presented to the
Academy as Turner's Diploma Work in
1802, following his election as
Academician.

In 1802 he was admitted as an Academician, but a final duty now awaited him: the presentation of a diploma picture for the Academy's collection. This, like many practices, followed the French Academy tradition, but was more loosely applied. Some founder Academicians had got away without submitting pictures at all, and there had never been any question of election being conditional upon completion of a prescribed subject, as was the case in Paris. The French system ensured a representative example of each artist's work while in London the choice was up to the painter, and could sometimes be eccentric. Nor did a picture have to be specially painted for the occasion, and Turner offered one of two years earlier, *Dolbadern Castle*. With its acceptance – after Turner had briefly suggested an alternative – his education was symbolically complete.

THE ACADEMY UNDER CHALLENGE

At this time the Academy was scarcely happier than in Turner's student days, beset by the internal disputes that were to lead in 1805 to West's temporary resignation as President, and under suspicion for the supposedly democratic, even republican tendencies of some of its members – an especially sensitive issue in wartime. Turner, who was now elected to the Council, did not attend meetings during most of 1804 after arguments with fellow members whom he did not think were taking their business seriously enough.

Morale was low, and there was a tendency to look elsewhere for some of the activities and opportunities the Academy supposedly provided. In October 1802 an organization called the British School was formed in London by the artists' colourman George Field and a marine painter, J. T. Serres. Supported by Academicians as well as patrons and headed by the Prince of Wales, it exhibited and sold works by 'the most eminent and departed British Artists'. Financial troubles soon led to its downfall, but it briefly offered an acceptable supplement to the Academy's exhibitions.

At that time there were almost no other opportunities for an artist to show his work, unless he was prepared to take the risk of a one-man show, as Fuseli

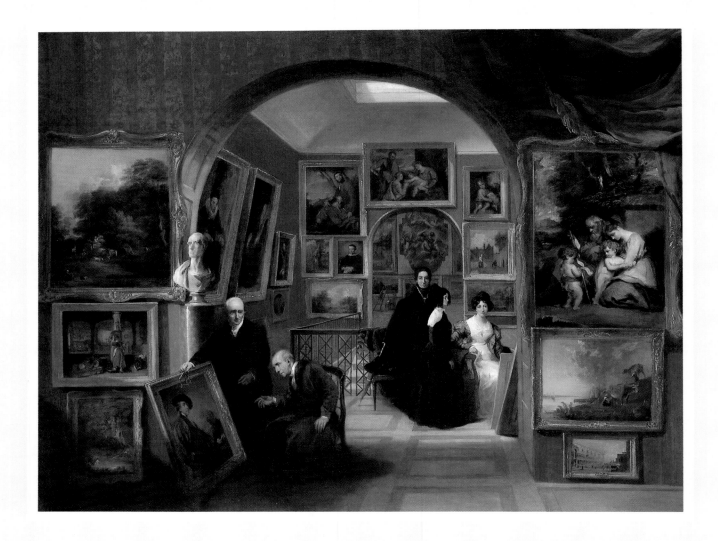

LONDON EXHIBITION
GALLERIES

*W*hen Turner was young the Royal Academy
provided the capital's only effective exhibition space
for living artists. During his lifetime other organizations were
established for the display of modern art. The British Institution
held shows both of living artists and old masters, and collected
their work, originally with the object of contributing to a
national gallery. Turner contributed The Goddess of Discord
to its opening exhibition in 1806. Its debt to the historical
'Sublime' of Poussin was in keeping with the traditional taste
of the Institution's aristocratic directors, but its elements of
fantasy would not have endeared it to them. The Institution
was sometimes seen as a threat to the Academy and to artists
associated with it. A less controversial innovation of the period
was the establishment of exhibitions specifically for watercolours.
These views by Davis and Scharf show the dense hanging
that prevailed in both oil and watercolour exhibitions.

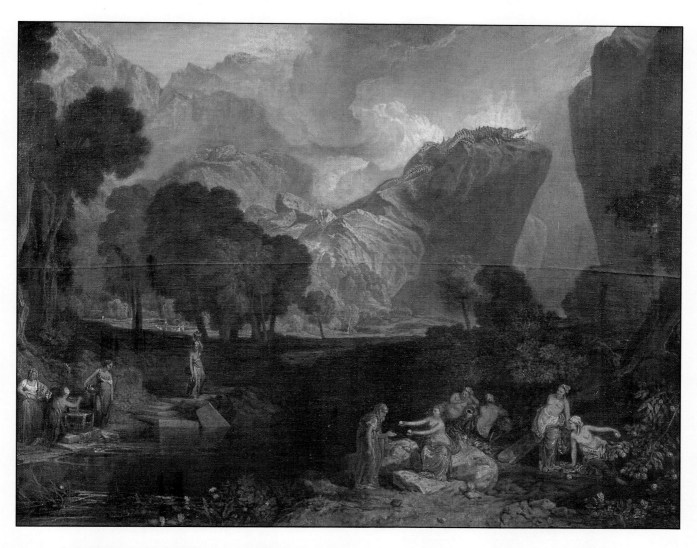

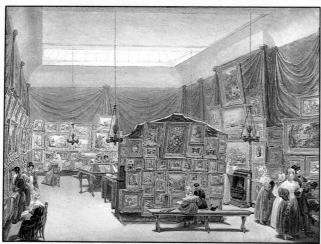

ABOVE:

THE GODDESS OF DISCORD CHOOSING THE
APPLE OF CONTENTION IN THE GARDEN OF
THE HESPERIDES

J. M. W. Turner, oil, exhibited 1806.
Clore Gallery for the Turner Collection.

LEFT:

INTERIOR OF THE GALLERY OF THE NEW
SOCIETY OF PAINTERS IN WATER-COLOURS,
OLD BOND STREET

George Scharf, 1834, watercolour. Victoria
and Albert Museum, London.

did in 1799 with his Milton Gallery of pictures illustrating the poet's work. An alternative was for an artist to display his pictures in a gallery of his own, a course which Turner took in 1804, opening a gallery attached to his house in Harley Street. For several years he exhibited most of his pictures there, and in 1804 itself sent only token contributions to the Academy – in Farington's words to 'keep his name in the lists'. He was not alone in such a bold exercise in self-promotion – West added a fine gallery to his Newman Street house – but only the most successful painters could hope to recoup the outlay involved. Turner's prices for pictures were now at the upper limit for the day: by 1804 he was asking up to 400 guineas for a large picture, though he did not always obtain the full amount. By 1808 he was receiving almost £1,500 from the sale of pictures from his gallery, and his total income was probably nearly £2,000, a large sum at the time.

In 1805 Turner exhibited only at his own gallery, partly no doubt to distance himself from the disputes then taking place in the Academy. That year saw the establishment of two new organizations devoted to the promotion of modern art and artists: the Society of Painters in Water-Colours and the British Institution. These were very different in purpose and politics, the first being run by artists for artists, like the Academy, while the second was far more ambitious in its scope, and administered by connoisseurs and patrons. Both organizations broke the Academy's monopoly, but the Institution was seen from the first as a threat to artistic freedom.

The aims of the Society of Painters in Water-Colours were limited but laudable. In November 1804, an old friend of Turner's, the watercolourist and drawing master William Frederick Wells, had realized an ambition to found a society for his fellow draughtsmen. Watercolours, though now very popular with the collecting public, had always been poorly displayed in the Academy, clustered in one room and overshadowed by oils. Only Academicians who worked in both media, like Turner himself, could be sure of the few good positions. In order to serve the professional watercolourists, the Society excluded

members of the Academy, but there was no sense of rivalry, and in fact its exhibitions complemented the Academy's. The first, in April 1805, was a huge success, attracting over 12,000 paying visitors and a number of purchasers.

The Institution, initiated by one of the subscribers to the earlier British School, Thomas Bernard, claimed similarly practical and generous motives: to 'encourage and reward the talents of the artists of the United Kingdom, and to open an exhibition for their productions'. Bernard was joined by a group of the most prominent connoisseurs and collectors including Sir George Beaumont, Richard Payne Knight, J. J. Anderstein, Sir John Leicester and Lord Egremont. These were noblemen and gentlemen who, for the most part, collected both old and new art, and were, with certain exceptions, well disposed to living painters. Leicester and Egremont, indeed, were among the most generous patrons of their day, the former even hoping that his private gallery might help to form a national one.

Having raised £7,000 by subscription, the founders bought for £4,500 the Pall Mall premises of the Shakespeare Gallery whose proprietor, Alderman Boydell, had gone bankrupt. These provided three exhibition rooms which were redecorated for a further £800. The first exhibition in 1806 was an almost complete triumph – though William Daniell thought his own and other landscapes suffered from inadequate lighting, and there was general objection to the 'abominable scarlet paper' with which the rooms were hung. Almost at once, because of the prestige of the organizers, the Institution exhibitions became landmarks of the fashionable season, attracting up to 2000 people at brilliant soirées.

Turner was one of many artists who seized the opportunity of exhibiting, while West, who was considering offering the Institution a choice from twenty-two of his own works and was already on the point of resigning his Academy honours, declared that he 'looked to the new Institution for *everything,* and that the Royal Academy would be left a mere drawing school'. Initially, the Institution seemed full of promise. It hoped that the government would spend £3000

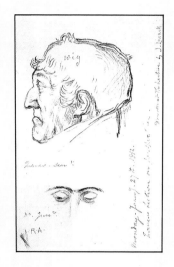

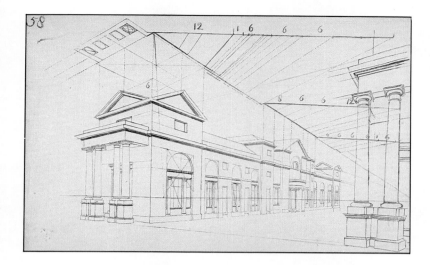

TURNER'S PERSPECTIVE LECTURES

*T*hese large coloured drawings of Nicholas Hawksmoor's church of St George's, Bloomsbury, and the Palladian Pulteney Bridge at Bath, are among the many designs Turner made to illustrate his lectures as Professor of Perspective at the Academy. Besides such elaborate renderings, he prepared many diagrams. The drawings were admired even if the lectures themselves were difficult to hear or understand. The lectures were 'more for the Professors of Painting and Architecture, the word "Perspective" hardly mentioned'.

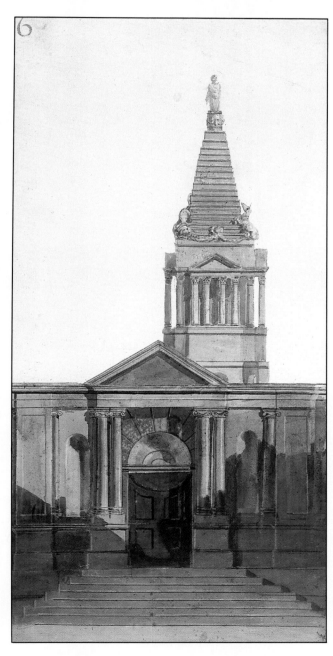

a year purchasing modern pictures towards a National Gallery, and planned to set aside £1000 of its own funds for the same purpose. It was also generous with prizes and encouragements, and held regular loan exhibitions of old masters which provided artists with the opportunities for study they had so long desired.

But even as they fell for these seductions, many artists were uneasy. Whatever the limitations of the Academy, it was at least their own, while the Institution was controlled by men who held the purse strings and could thus dictate artistic taste – 'not patrons of artists, but breeders of artists' as Turner's young friend Augustus Callcott put it. Beaumont and Knight particularly were already well known as among the most opinionated critics and arbiters of taste in London.

In the coming years, relations between the Academy and the Institution were to become tense, but the threat from outside did at least have the effect of regenerating the Academy's spirit of solidarity, and Turner's return to the fold, in a more reasonable mood, was part of a wider rallying to its cause after 1806. West, after his temporary resignation, was re-elected President that December, to remain in office until his death in 1820. The Academy also needed to replace the deceased Edward Edwards, its Teacher of Perspective. There had originally been a professor of Perspective, Samuel Wale, but on his death in 1786 the post had been downgraded for lack of a suitable candidate. The only requirement was six lectures a year, on geometry, linear and aerial perspective, but in 1806 the post again proved difficult to fill, and Turner volunteered 'if no one else offered'.

He was formally elected on 2 November 1807. His offer had partly been a gesture of loyalty to the Academy, but he must also have felt that he had much to offer from his early training in architecture and topography, besides his growing appreciation of landscape and light. Nevertheless, he asked for time to prepare, and it was not until January 1811 that he gave his first course of lectures. Two years earlier he had initiated improvements to the lighting of the lecture room, while the Professor of Architecture, his friend Sir John Soane, had remodelled the seating.

Turner's lectures were splendidly illustrated with large drawings and diagrams, but his delivery was notable for its awkwardness and inaudibility. Although he by now had ambitions as a poet, often exhibiting his pictures with verses of his own, he had little skill as a prose writer, and unlike a number of his fellow teachers at the Academy, did not publish his lectures. He took his post seriously, however, reading widely for his lectures, and becoming extremely proud of the initials P. P. He did not resign until 1837.

At the end of 1811 Turner was elected a Visitor in the Academy Schools, along with other painters including his friend Callcott. This involved practical intervention in day-to-day teaching – his real forte. He had first applied for such a post in 1802, and wrongly believed that his failure arose from some Academy ban on landscape painters. This was not the case, and in years to come Turner was to be remembered as one of the most innovatory and dynamic teachers of figure drawing the Academy had ever had.

WINDS OF CHANGE

Meanwhile, another challenge to the Academy was emerging in the person of Benjamin Robert Haydon. A master of self-promotion, with a powerful belief in his own genius, Haydon dedicated himself to history painting on the grandest scale, regardless of the tastes of patrons. He combined Reynolds's ideas with Barry's ambitions, with more than a touch of the latter's paranoia – if professional conspiracies had not existed, Haydon would have invented them. He was a passionate espouser of causes, a gifted writer and journalist with many friends in the London literary world; his nuisance value was limitless, and he was a dangerous enemy.

Haydon's early pictures, despite their straining heroics, caused a huge stir, but in 1809 a misfortune – or at least a misunderstanding – occurred that was to blight his entire career and estrange him from the Academy for life. When his exhibit for that year, *The Assassination of Dentatus,* was moved from a prime to a slightly less prominent position, Haydon imagined

AN UPROAR IN ST JAMES'S STREET

*Haydon's School, caricature print. British
Museum, London.*

a plot, engineered by West and his jealous colleagues, and embarked on a long campaign against the Academy. Some of his criticisms of its teaching were perfectly sound, but as he later admitted, his journalistic streak encouraged him to exaggerate them so much that he damaged his own case.

However, Haydon also took practical steps, setting up his own school in 1815, and running it very effectively until 1823. As an antidote to what he saw as the exhausted methods of the Academy, he laid stress on drawing from the human figure and the dynamic ancient types of the Elgin marbles – whose importance he had recognized from their first arrival in London in 1806 – rather than from the standard repertoire of casts. These studies were backed up by investigations of anatomy and by model books including *Haydon's Drawing Book,* published in 1817 and 1819. Only when proficient were his students allowed even to consider learning to paint, and Haydon was happy to release them to the Academy when the time was ripe.

He had really intended to revive the Renaissance artist's workshop, training a team of assistants to help him with grand public schemes of fresco and decoration. His pupils, who included one of the most successful of popular Victorian painters, Edwin Landseer, as well as Turner's friend Charles Eastlake, repudiated this aspect of the school, but certainly benefited from Haydon's sound teaching in drawing. Turner was among the distinguished visitors who saw its effects for themselves in a hugely popular exhibition of the pupils' copies from Raphael in St James's Street in 1818.

Haydon's School was not quite the only private one formed in these years – another had been opened the previous year in Bloomsbury by Henry Sass who, like Haydon, was a better teacher than a painter. His

methods were more conventional and depended heavily on cast copying, but not all Haydon's ideas were original either. Anatomy, for example, was studied by his pupils in the anatomy theatre of Charles Bell, a Scottish surgeon, draughtsman and a lover of painting who had first begun to teach art students in Edinburgh. Having moved to London, he applied in 1806 for the Professorship of Anatomy at the Academy and, although unsuccessful, he published in the same year a highly influential *Essay on the Anatomy of Expression in Paint*.

Expression had long been part of Academy training, but it had traditionally been frozen into set categories, such as 'Horror' or 'Joy'. Now it was studied from life and related to the underlying structure of the body, for only thus did the artist attain what Bell called the 'true spirit of observation'. Haydon and his friend David Wilkie had been among the Academy students who came to Bell to copy skulls and skeletons and to draw from the figure in motion. Wilkie's paintings, with their wonderful variety of human types and expressions, were perhaps the finest tribute to Bell's teaching, but Haydon embodied many of the latter's ideas in his own programme.

Whatever Haydon liked to claim, the breath of science was now beginning to blow through the Academy itself. The chair for which Bell had applied had gone instead to Anthony Carlisle, another surgeon-anatomist, the sometime friend of Barry and future friend of Turner. He too placed stress on lively comparative methods, and if anything his lectures were more dramatic than Bell's, involving athletes, Chinese boxers and soldiers in demonstrations of the body in motion. The essayist William Hazlitt, who like Haydon was only too ready to criticize the Academy, nearly fainted in a lecture when Carlisle passed round the heart and brains of a man on dinner plates, and there was once a riot when the public besieged a lecture in which almost naked guardsmen were demonstrating the action of the body when firing a gun.

Turner, as far as we know, did not attend Bell's lectures; nor apparently did he own his book. Carlisle's teaching, though, was well known to him, and in

Rome in 1819 he saw an exhibition at the Venetian Academy in which the great Neoclassical sculptor Antonio Canova had arranged living models in 'classical' attitudes based on ancient sculpture. By the mid-1830s, when Turner's contributions as a Visitor in the Academy life school had matured into a system of teaching, such comparisons of art and nature were very much in his mind. His methods were greatly valued by his students, for he not only posed the models in the same positions as ancient statuary (as had always been the norm) but also set them beside casts of the originals so the two could be compared. Other teachers went in for more picturesque effects. Constable, first serving as a Visitor in 1832, set a female model in a Garden of Eden cut from evergreens from his Hampstead garden, while William Etty, a year later, made his own 'living picture' of a Venus sacrificing to the Graces, surrounded by fruit and burning braziers. But there was no substitute for the comparative discipline set by Turner, and Haydon's old pupil Landseer remembered him as 'the best teacher I ever met with'.

Turner's activities as Visitor had by this time supplanted his perspective teaching, and when in 1836 Haydon's continued barracking finally succeeded in turning the attention of a Select Commitee onto the affairs of the Academy, one of the criticisms heard was that Turner had not given his lectures for many years. This was undeniable, but it was also ironic that he was engaged instead in a kind of teaching of which Haydon, of all people, should have approved.

However the Committee reached no very damaging conclusions: it was generally admitted that the Academy was now doing a good job, and the Academy itself felt sufficiently confident not to overreact to potential challenges from outside. By the 1820s it was looking more kindly on the British Institution, and in 1825, when invited to assist in the Institution's new policy of hanging living artists with old masters in its own summer shows, the Academy politely declined to interfere. Nor was there any resentment when the Society of British Artists was founded in handsome rooms in Suffolk Street. This was particularly remarkable as the Society was the

TURNER AND THE ACADEMY LIFE CLASS

*D*uring the 1830s Turner served as a popular and innova-tive Visitor to the Life Academy. Just as his landscape art had by now been tranformed by years of intense and searching study of nature, so he insisted upon comparative study of living models and casts of sculpture, whereas students had formerly drawn from the two separately. One of his pupils recalled: 'When a visitor in the life school he introduced a capital practice, which it is to be regretted has not been continued: he chose for study a model as nearly as possible corresponding in form and character with some fine antique figure, which he placed by the side of the model posed in the same action; thus, the "Discobulus of Myron" contrasted with one of the best of our trained soldiers; . . . the "Venus de 'Medici" beside a female in the first period of youthful womanhood. The idea was original . . . it showed at once how much the antique sculptors had refined nature; which, if in parts more beautiful than the selected form which is called ideal, as a whole looked common and vulgar by its side.'

ABOVE:

THE LIFE CLASS AT THE ROYAL ACADEMY

J. M. W. Turner, a sheet from the 'Life Academy (1)' sketchbook, pencil, c. 1832. Clore Gallery for the Turner Collection.

LEFT:

FEMALE NUDE STANDING BESIDE A STATUE OF THE VENUS PUDICA

William Etty, chalks on brown paper, c. 1835. Courtauld Institute Galleries, University of London.

BELOW:

DESIGN FOR THE TURNER MEDAL

William Mulready, pen and ink, 1858. Royal Academy of Arts, London.

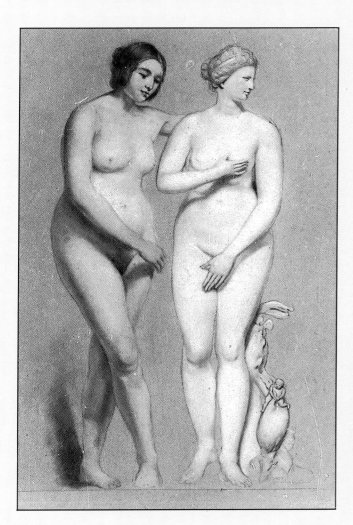

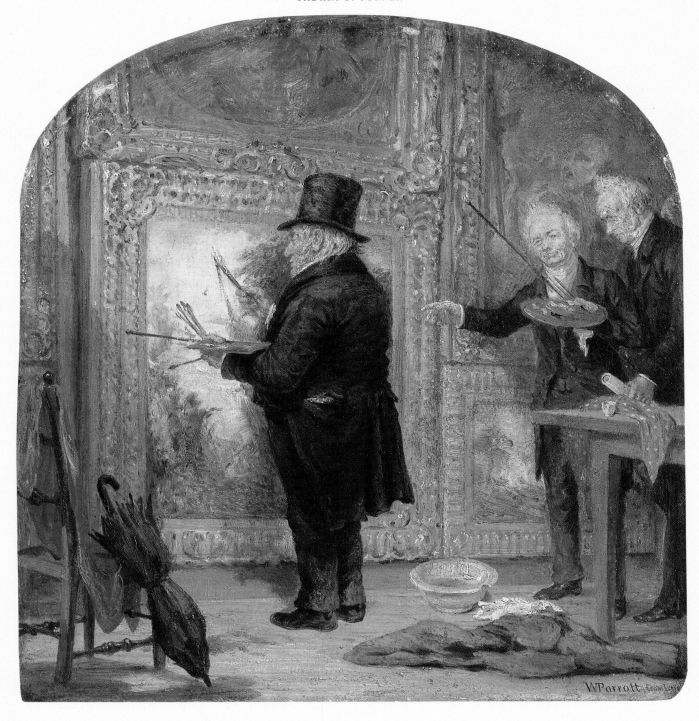

TURNER ON VARNISHING DAY

*S. W. Parrott, oil, c. 1846. Sheffield City
Art Galleries, Ruskin Gallery. In the
Academy, pictures were finished for
exhibition on 'Varnishing Day'. Turner
became legendary for his virtuoso
performances, which gave form to apparent
chaos with amazing speed.*

brainchild of Haydon's friend and publisher James Elmes, editor of the controversial magazine *Annals of the Fine Arts*. A prominent member of the Academy, the landscape painter William Hilton, Turner's friend and follower, gave full support to the Society, and his association with it did not prevent his becoming Keeper of the Academy in 1827.

The Academy was very well run during Turner's later years. Thomas Lawrence, a fine portrait painter and a conscientious administrator, had succeeded West and brought a new spirit into its affairs; and on his death in 1830 this was maintained by Martin Archer Shee.

Though Haydon dubbed Shee 'the most impotent painter in the solar system', Constable had reason to praise his 'chivalrous sense of honour', and it was partly because a number of Academicians recalled that Shee had long ago opposed the power politics and patronage practised by Farington, that they elected him in preference to Wilkie, a much superior painter but clearly someone less promising as a manager of people.

The art world of London had witnessed many changes since Turner's student days. Besides the growing number of exhibition facilities like the British Institution and the Society of British Artists, there was now a budding National Gallery – formed by 1824 of the combined collections of Beaumont and Angerstein.

By 1833 the government, impelled by the improving zeal then sweeping through the nation, was prepared – albeit in rather parsimonious fashion – to construct a proper building for the National Gallery in Trafalgar Square, and to attach to it purpose-built accommodation for the Academy.

Sad though it was to leave Somerset House, the Academy welcomed the chance to realize its long-held ambition of association with a public collection of master paintings.

The move was made in 1836, and Turner served on the committee that hung the first exhibition in the new premises the following year.

Since 1832 he had served on another consultative group to discuss the new building, and in 1833 had undertaken a wide-ranging tour of the art galleries of Europe. Aside from his failure to deliver his perspective lectures, he continued to serve the Academy in the life and painting schools, on the hanging committees, and as rigorous auditor of the accounts. Furthermore, since 1832 his will had included a proposal for the Professorship of Landscape Painting he had urged for so long.

Finally, from 1845 to 1847 he served as Deputy President of the Academy – with his friend George Jones as Acting President.

Turner had always seized every professional opportunity that came his way, making full use of the engraving and publishing industries, sending widely to exhibitions abroad as well as at home, or, in his last years, promoting his watercolours through Thomas Griffith, a lawyer, collector and dealer. For a long time his large income had owed more to the various branches of his work outside the Academy than to his – relatively few – sales of pictures from its walls.

Yet it was always in the Academy, above all, that he cultivated his public persona. Throughout his life it had been his chosen theatre of activity – as teacher, administrator, painter and even almost as magician, for on the Varnishing Days, when exhibits were given their finishing touches prior to the opening, he had often given deliberate and conspicuous displays of technical pyrotechnics, sometimes working up slight sketches into finished pictures in the space of a few hours.

Though he always loved to indulge in bouts of friendly rivalry – and in his younger years there had been a harder edge of urgent competition – it was in the Academy that he felt truly at home among his 'brothers in art', an extended family, who by the end of his life, regarded him almost as an old master in their midst.

When the Academy's former student and long time antagonist, Haydon, took his own life in 1846, having conspicuously failed to turn the many changes of the past decades to anything like his own advantage, Turner's only comment said it all: 'He stabbed his mother.'

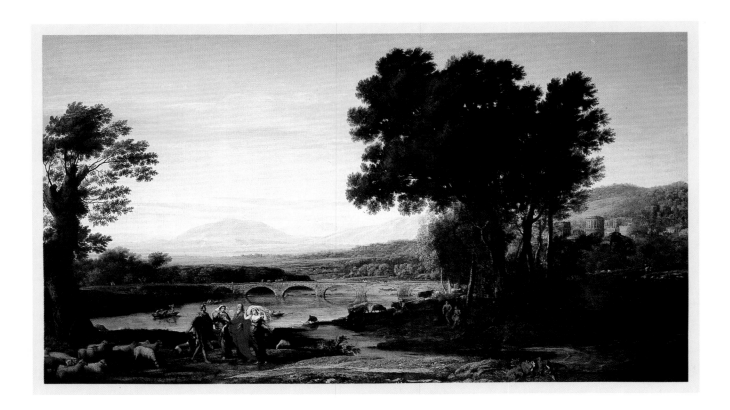

LANDSCAPE WITH JACOB AND LABAN

Claude, oil. National Trust,
Petworth House.

IN THE STEPS OF THE OLD MASTERS

*. . . it is generally acknowledged . . . that all the sublime
qualities which the poetic style of painting embraces, are
manifested in a superior degree in his landscape compositions
. . . Much as we esteem the works of Claude, of Salvator
Rosa, of the Poussins, or other justly celebrated Italian
masters, we can boast a painter whose pictures comprise
qualities of superior excellence to theirs . .*

THE REPOSITORY OF ARTS, JUNE 1815

There is a story of Turner looking at a print of *Shipping in a Storm* after the younger Willem van de Velde and saying, 'This made me a painter.' It was typical of him to single out, not only a subject dear to his own heart, but one treated by an earlier master. Throughout his life, the old masters were vital forces for him, to be discovered, studied, admired, and if possible surpassed. In all this he was a true disciple of Reynolds, who, in the words of a contemporary critic and commentator, 'considered art as an inheritance descending from father to son'.

The long and fruitful dialogue that Turner conducted with the old masters was really no more than an extreme example of an admiration and sense of continuity then felt by virtually all painters, collectors and critics. His relationship with the art of the past was not unique or solitary, and was often inspired and enriched by the work of his contemporaries; indeed his energetic competition with his colleagues was frequently sharpened by their mutual awareness of tradition.

Although in the 1790s there was as yet no truly public gallery, and the Royal Academy had turned down Reynolds's collection of old masters as a teaching resource, London was rich in opportunities for the student who knew where to look. Even if the grandest private collections were difficult of access,

the market in old master paintings was thriving, and entry to a modest private collection was sometimes all it took to open a new world. In Dr Monro's house, Turner not only studied and copied watercolours by Cozens, but he also saw etchings and drawings by (or attributed to) Rembrandt – two of which he was to buy when Monro's collection was sold in 1833. He was also encouraged by the doctor and his neighbour John Henderson to explore the work of Marco Ricci, Canaletto and Piranesi as well as recent British artists.

Monro's company helped to encourage a curiosity about more recent painters, of the previous generation. He was, for example, a keen collector and imitator of the drawings of Gainsborough, whose work Turner came to know intimately. In Monro's circle, Turner developed that tendency to a liberal and eclectic mix of artistic impulses from past and present that marked his entire career, while having his first real taste of competition – another lifelong characteristic – with his contemporary, Girtin.

It was in watercolour, his first medium, that Turner first displayed his urge to surpass. By the late 1790s it came naturally for people to compare his work to Girtin's, though not always favourably: Hoppner reported the view that Girtin showed 'more genius' while Turner 'finishes too much'. But other artists he had studied also left their mark on Turner's water-

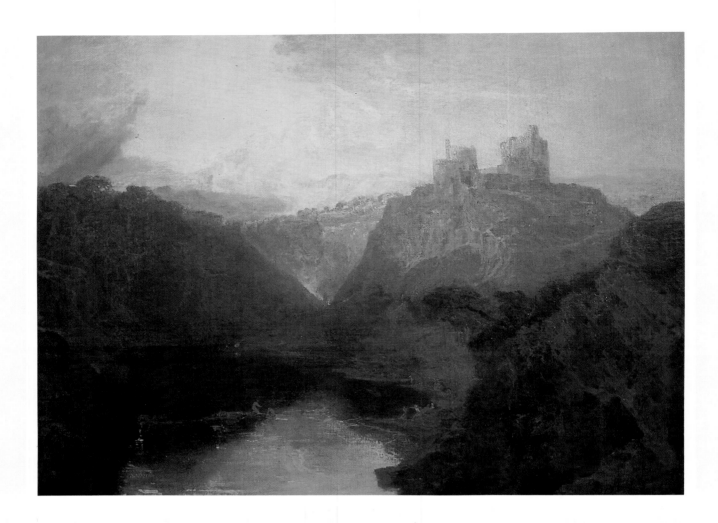

*KILGARREN CASTLE ON THE TWYVEY, HAZY
SUNRISE, PREVIOUS TO A SULTRY DAY*

*J. M. W. Turner, oil, Royal
Academy 1799. The National Trust, on
loan to Wordsworth House, Cockermouth.*

RIGHT:

LLYN-Y-CAU, CADER IDRIS

*Richard Wilson, oil, 1774.
Tate Gallery, London.*

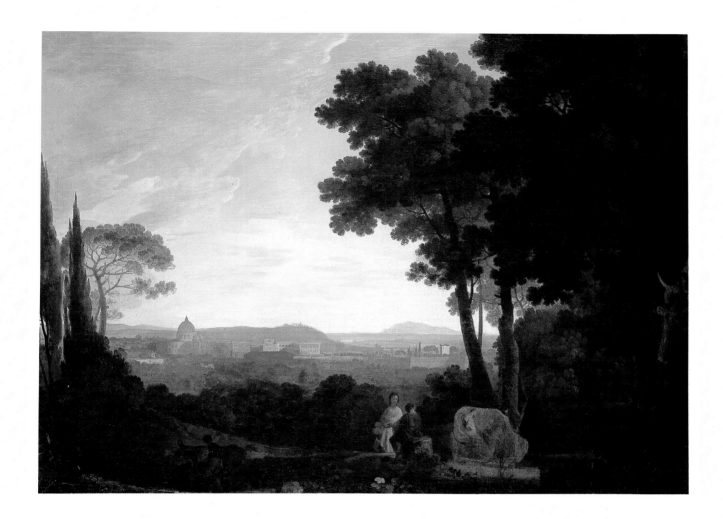

TURNER AND
RICHARD WILSON

*T*urner came to admire Wilson at the outset of his career. Wilson, who had died neglected, was then unfashionable, but Turner responded instinctively to his formal and Claudean paintings of Italy with their subtle lighting effects, and his more robust and naturalistic treatments of the scenery of Britain and his native Wales. Wilson was the presiding genius behind Turner's first Welsh tours and of the Welsh subjects he began to show at the Academy in 1799. Turner visited the painter's first home at Penegoes in 1798 and later reminisced of 'the days of my youth when I was in search of Richard Wilson's birthplace'. He copied and collected examples of his work.

ROME: ST PETER'S AND THE VATICAN FROM THE JANICULUM

Richard Wilson, oil, c. 1753.
Tate Gallery, London.

RIGHT:

SHIPPING IN A STORM

Elisha Kirkall after Willem van de Velde, mezzotint, 1724. Paul Mellon Centre for Studies in British Art, London.

BELOW:

THE WHITE HOUSE AT CHELSEA

Thomas Girtin, watercolour, 1800. Tate Gallery, London. Turner's affectionate rivalry with Girtin was cut off by the latter's tragically early death in 1802. In 'after life', Turner is said to have remarked, 'if Tom Girtin had lived, I should have starved'.

colours of the period: from Piranesi he took a grandeur of scale in architectural subjects, while picking up size and density of colour from the Swiss Abraham-Louis Rodolphe Ducros, whose huge watercolours he encountered on a visit to Sir Richard Colt Hoare at Stourhead in 1795.

Meanwhile, more recent painters pointed the way to greater masters of the past. Through Reynolds's paintings threads could be traced from the painters and sculptors he had studied in Italy, and in Reynolds's contemporary, the Welsh landscape painter Richard Wilson, Turner found a particularly powerful example of how it was possible to approach an earlier master through a nearer one – Wilson's work opened the doors to the discovery of Claude.

Wilson, the home-grown master of 'classical' landscape in the Claudean tradition, was the predominant influence on Turner's early development as an oil painter. Through him, Turner mastered a broad handling, sober colouring and compositional order that tempered the topographical exactitude he had learned as a draughtsman. Wilson was the first of many artists who seemed almost to possess Turner's being, and with whom he conducted a conspicuous dialogue in paint. It was Wilson who lay behind the Welsh subjects in oil and watercolour that Turner began to show at the Academy from 1799, and Turner was even more impressed by Wilson's vision of Italy, expressed in a series of pictures ultimately based on Claude but imbued with his own nostalgic retrospection. Turner adopted Wilson's message, that landscape could possess its own high seriousness and moral tone, and he inherited Wilson's ambition to tread in the footsteps of the great Claude.

In his last years, Wilson had told Sir George Beaumont that he had learned everything from Claude, 'the only person that ever could paint fine weather and Italian skies'. But he added that at least one of Claude's pictures made his heart ache, for 'I shall never paint such a picture as that, were I to live a thousand years'. In a similar spirit, Turner felt 'both pleased and unhappy' when in 1799 he stood before the two great Claudes from the Altieri Palace, *Landscape with the Father of Psyche sacrificing to Apollo* and *The Landing of Aeneas*. These had just been bought by Turner's patron William Beckford, and were on show that May in his London house in Grosvenor Square. Turner was now exhibiting *Caernarvon Castle,* his first essentially Claudean work, although admittedly in watercolour. Fittingly, this was bought, at a higher price than the artist was inclined to charge, by another passionate admirer of Claude, the merchant and collector John Julius Angerstein, whose new acquisitions were hung in the gallery of his house in Pall Mall. Here the collector is said to have come upon Turner standing before his two Claudes, *The Embarkation of the Queen of Sheba* and *The Mill,* in tears of frustration 'because I shall never be able to paint anything like that picture'.

However, Turner was probably seeking attention more than comfort: his outburst could not have occurred before 1803, for it was only then that Angerstein bought the pictures, and this was the year he exhibited his most elaborate challenge to Claude to date, *The Festival upon the Opening of the Vintage at Macon.*

COLLECTORS AND CONNOISSEURS

Beckford's exhibition of the Altieri Claudes, and Angerstein's later purchase of his, were only two of the more momentous events of a period of extraordinary activity in the art market, when works of art were pouring into England on an unprecedented scale, despatched from the Continent in the wake of the French revolution. In his *Memoirs of Painting,* the dealer William Buchanan devoted no less than 200 pages to the most important of all the pictures to come to England at this period, those from the marvellous collection of the duc d'Orléans. These were dispersed in two epic sales.

The first, devoted to Dutch and Flemish pictures, was held in 1792 at the old Academy Rooms in Pall Mall, and did much to encourage English taste for these schools. Indeed the pictures fitted in perfectly with new enthusiasm for what was described as the 'Picturesque'. The taste for the order, harmony and perfect balance of classical landscapes such as Claude's

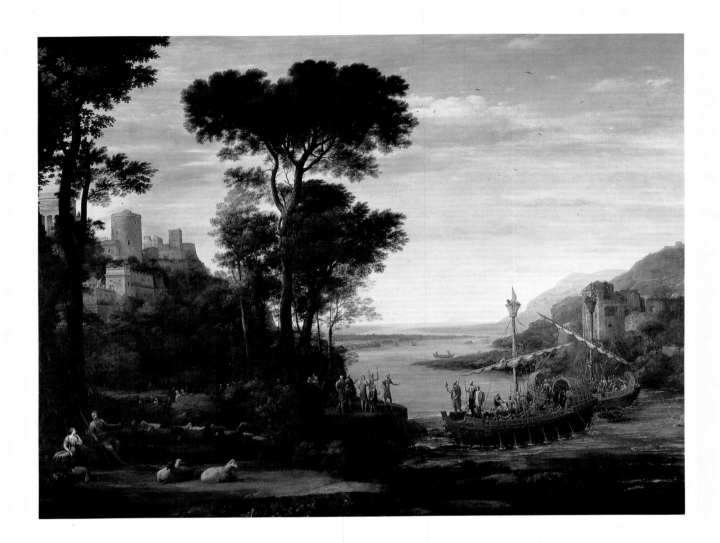

THE LANDING OF AENEAS

*Claude, oil. The National
Trust, Anglesey Abbey.*

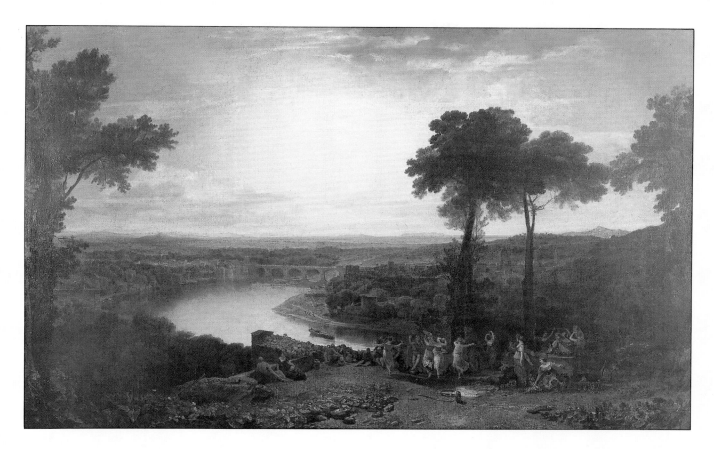

TURNER AND CLAUDE

*I*t was partly through Wilson that Turner approached the
revered figure of Claude, whose classical vision of landscape
had long represented an ideal of perfection for painters and
their patrons. Claude's pictures were lavishly represented in
British collections, and continued to be acquired avidly in
Turner's time. The Landing of Aeneas *was one of two from
the Altieri collection in Rome shown in London in 1801 having
been bought by William Beckford; to Turner it seemed to pose
an insuperable challenge, although in* Caernarvon Castle *he
had just rendered a notably Claudean vista in watercolour. His
first display of the Claudean grand manner in oil came in*
Macon, 1803. *This scene was based partly on a free recollection
of his continental trip in 1802, and on Lord Egremont's Claude,*
Jacob and Laban *which he adapted more closely later, but
now probably knew from an engraving.* Macon *was bought
by Lord Yarborough, who had helped to finance the 1802 trip
and sponsored Turner's passport. Some observers were not
convinced that the picture ranked with Claude; one critic spoke
of its* 'bastard grandeur' *and Sir George Beaumont dismissed
it as* 'borrowed from Claude but the colouring forgotten'.

TOP:

THE FESTIVAL UPON THE OPENING OF THE
VINTAGE OF MACON

*J. M. W. Turner, oil, Royal Academy
1803. Sheffield City Art Galleries.*

ABOVE:

CAERNARVON CASTLE

*J. M. W. Turner, watercolour,
Royal Academy 1799. Private Collection.*

ABOVE:

LIMEKILN AT COALBROOKDALE

J. M. W. Turner, oil on panel, c. 1797.
Yale Center for British Art, New Haven.
Turner could have seen the industrial landscape of Coalbrookdale on his way to or from Wales in 1795. This study echoes the tenebrist effects of the Rembrandt he could have seen at Stourhead that year.

RIGHT:

LANDSCAPE WITH THE REST ON THE FLIGHT INTO EGYPT

Rembrandt, oil. National Gallery of Ireland, Dublin. Turner probably saw this small night scene on a visit to Stourhead in 1795. Its sombre chiaroscuro and picturesque effects are matched in his work in the later 1790s.

was now being offset by an anti-classical aesthetic of variety, contrast and untamed rustic charm propounded by writers like Uvedale Price, Richard Payne Knight and the Rev William Gilpin.

In the English painting of the mid- and late 1790s, there was an upsurge of these characteristics, owing an obvious debt to the northern schools. In spite of Turner's love for Claude, it was partly because he was also affected by this new spirit that he had initially

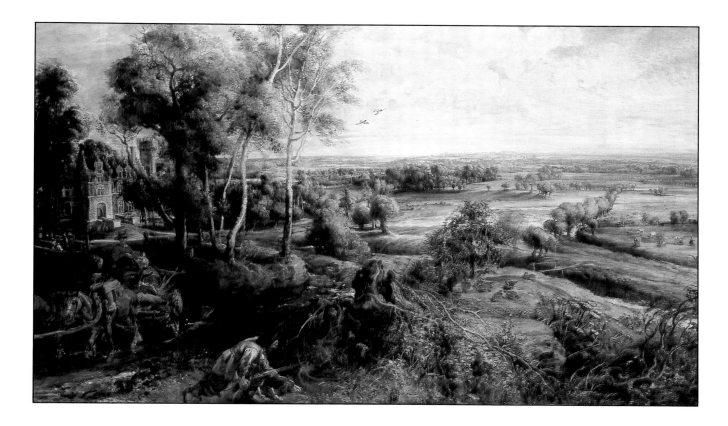

preferred Wilson's broader and more spontaneous manner in his later English and Welsh subjects to the more smoothly painted surfaces and elevated subjects of the earlier pictures. Gainsborough's rustic landscape likewise had powerful appeal, and Turner may be said to have fallen under the spell of Rembrandt even before that of Claude. Besides the Rembrandt prints and drawings that belonged to Dr Monro, the *Landscape with the Rest on the Flight into Egypt* was one of the works that Turner saw on his visit to Stourhead.

The Italian and French portion of the Orléans collection was not dispersed until 1798. It was exhibited for six months in the Lyceum in the Strand, and in the Pall Mall rooms of Michael Bryan, one of the most prominent and reliable of the new breed of art dealers who emerged in these years, author of an invaluable *Dictionary of Painters and Engravers*. Bryan had arranged prior sale of the finest pictures to a group of noblemen including Turner's patron-to-be the Duke of Bridgewater and his nephew, Earl Gower, the future Marquess of Stafford and Duke of Sutherland. The remainder were sold during the exhibition.

The decade saw other important sales in London,

of pictures from Italy, the Low Countries and Spain as well as from France. The influx was hardly checked by the war, and agents and dealers like James Irvine and Robert Fagan remained active on the Continent on behalf of colleagues in Britain. Angerstein's collection was formed substantially between the early 1790s and 1811, one of his first purchases being a landscape by Aelbert Cuyp, another of Turner's pantheon of past masters. Sir George Beaumont added a gallery to his house in Grosvenor Square in 1792, for a collection recently enriched by Claude and Poussin and soon to acquire a magnificent Rubens, the *Château de Steen*.

PORTRAIT OF JOHN JULIUS ANGERSTEIN

Thomas Lawrence, oil, c. 1790-5.
National Gallery, London.

PORTRAIT OF SIR GEORGE BEAUMONT

John Hoppner, oil. National Gallery,
London.

PORTRAIT OF PETER FRANCIS BOURGEOIS

James Northcote, oil. Dulwich
College Gallery, London.

COLLECTORS, DEALERS
AND CONNOISSEURS

John Julius Angerstein and Sir George Beaumont were among the most discerning collectors of old master paintings at the end of the eighteenth century and into the early nineteenth. Both were able to take advantage of the rich inflow of fine pictures to Britain in the wake of the French Revolution. Their collections, acquired for the nation by purchase and gift, formed the basis of the National Gallery. Both also bought modern pictures, of which Beaumont was a vociferous and sometimes prejudiced critic with considerable influence in the fashionable world. Beaumont was hostile to Turner, believing his departures from established conventions responsible for an 'influenza in art'.

While the National Gallery was in its infancy, the gallery at Dulwich College was very popular. It contained the collection put together by Noel Desenfans and the painter Sir Peter Francis Bourgeois for the King of Poland, on the London market in the late eighteenth century. Desenfans sold some at an exhibition in London in 1802 and left the remainder to Bourgeois, who left them to Dulwich, where they remain.

PORTRAIT OF NOEL JOSEPH DESENFANS

James Northcote, oil. Dulwich
College Gallery, London.

47

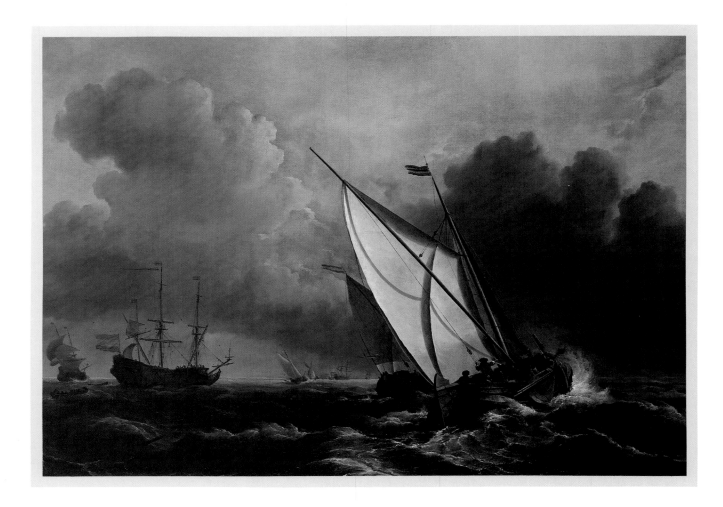

Splendid as their pictures were, and important as the nucleus of the National Gallery, both were quite modest collectors by the standards of a Bridgewater or a Beckford. The impact of this large-scale collecting on a young artist cannot be over-estimated. Not only did it raise consciousness of the traditions of the past, it also – if accidentally – created an economic climate that encouraged the buying of contemporary works. By the turn of the century the old master market had over-heated so much that even the richest buyers were finding the prices high, and it was partly because of this that many began to add modern pictures to their collections. Not unnaturally, they looked for works that would harmonize with their old masters, and for Turner this was a challenge to seize with enthusiasm. In 1801 the Duke of Bridgewater's commission for a companion to a Van de Velde marine he had bought from the Orléans collection, gave Turner the chance to paint his first oil in explicit competition with an old master.

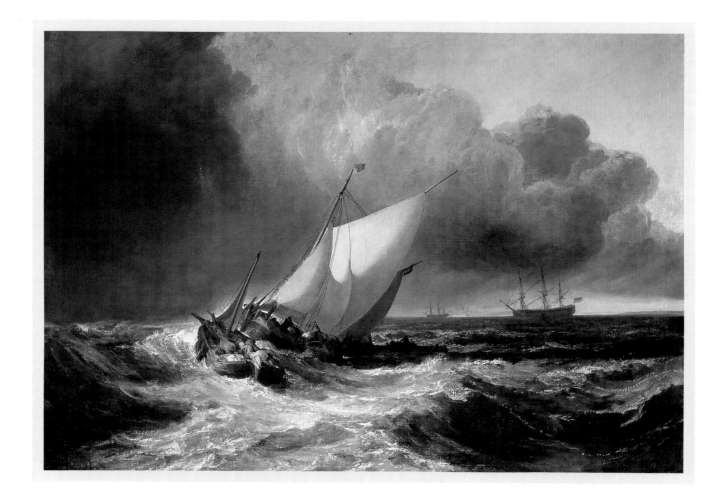

Turner was shortly to be accused of too slavish imitation of the masters, but in one particular case he behaved with more caution and restraint than many of his fellow artists. The old masters were then the major sources for technique as well as style, and when a mischievous hoaxer claimed to have rediscovered Titian's technique – admired for its rich texture and warm tones – a number of senior members of the Academy were fooled. Turner, de Loutherbourg and Fuseli were among the sceptics.

It was not that Turner was immune to Titian and the Venetian School, but he preferred to approach their methods through more rational enquiry. Thus, early in 1802, he began to obtain painting materials from the Italian colourman Sebastian Grandi, who had trained in the Venetian tradition and worked as a restorer on Venetian pictures then being imported by the painter–dealer, Alexander Day. These included some major masterpieces, among them Titian's *Venus and Adonis* that he sold to Angerstein and which, with

TURNER AND TITIAN

*T*he Venetian School, exemplified by Titian, had long been admired for its rich, deep colouring and painterly texture. In 1797 the 'Venetian Secret' had been offered by a quack, Thomas Provis, as a recipe for producing this old masterly effect, but after an over-enthusiastic reception from some artists, had been exposed as a hoax. Turner had not been duped and pursued a more pragmatic study of Titian. The dealer Alexander Day was importing distinguished Venetian pictures to London and employed Sebastian Grandi, Turner's colourman from 1802, to restore them. In 1801 Day exhibited Titian's Venus and Adonis in London, and sold it to Angerstein. Together with Titian's St Peter Martyr, an altarpiece that Turner saw in Paris in 1802, it was an important influence on Turner's work.

ABOVE:

VENUS AND ADONIS

Titian, oil. National Gallery, London.

RIGHT:

VENUS AND ADONIS

J. M. W. Turner, oil, c. 1803-5. Private Collection.

the same master's *St Peter Martyr,* was the inspiration for Turner's own *Venus and Adonis* of 1803–5.

Titian's happy union of landscape and subject in pictures like *St Peter Martyr* was the quality that most attracted Turner. Other masters who achieved the same combination in very different ways were Poussin and Salvator Rosa who, according to the canons of contemporary taste, represented opposite extremes of landscape painting: the former severe, formal, and classical in a more intellectual way than Claude, and the latter 'savage' and wild, fascinated by effects like stormy skies and lightning.

The quality most admired in Rosa, and certain works by Poussin, was the 'Sublime', a concept that was crucial to the Romantic movement. According to its dictates, nature was no longer well-ordered and composed according to classical canons; it was wild and unkempt, evocative and mysterious. The statesman and philosopher Edmund Burke, who had fully

expounded the idea in his *Philosophical Enquiry into the Origins of Our Ideas of the Sublime and Beautiful* in 1756, had claimed 'darkness, vacuity and silence' as its main qualities, and painting was moving towards spontaneous response to the grandeur of nature.

It was the obsession with the Sublime that sent even the most delicate of spirits in pursuit of mountains and waterfalls, just as it had despatched Turner to seek drama in the Welsh and Scottish scenery. His *Fifth Plague of Egypt,* painted in 1800, expressed idea through a historical subject, taking its cue from Poussin, while his *Jason* of 1802 was his homage to Rosa. That summer, he crossed the Channel to find the greatest of all Sublime landscapes in the Swiss Alps.

PARIS AND THE LOUVRE

Turner's first visit to the Continent was not entirely devoted to scenery; his second, and equally important destination was Paris and the Louvre, which had now grown into the greatest museum and picture gallery the world had ever known. The French Revolution had made London the major art market, but by 1802

ABOVE:

LANDSCAPE WITH MERCURY AND THE DISHONEST WOODMAN

Salvator Rosa, oil, National Gallery, London. The 'savage' landscape style of Rosa was considered the antithesis of Claude's cool and rational classicism; it helped to form notions of both the 'Picturesque' and the 'Sublime' through its bold presentation of untamed nature.

OVERLEAF:

THE FIFTH PLAGUE OF EGYPT

J. M. W. Turner, oil, Royal Academy, 1800. Indianapolis Museum of Art, Indiana. This powerful exercise in the historical 'Sublime', Turner's most imaginative composition to date, mounted a challenge to Poussin and Wilson. It was bought by William Beckford for Fonthill. The subject is actually the seventh plague.

CHÂTEAUX DE ST MICHAEL, BONNEVILLE,
SAVOY

J. M. W. Turner, oil, Royal Academy,
1803. Yale Center for British Art, New
Haven. Based on Turner's continental trip
in 1802, this also adopted the composition of
a picture by Poussin belonging to Desenfans
and now at Dulwich College.

WINTER: THE DELUGE

Poussin, oil. Musee du Louvre,
Paris. Turner was able to study this
quintessential example of historic landscape
in the grand manner in Paris in 1802.

a stream of masterpieces had been seized by Napoleon's armies and brought as trophies to the Louvre, where they joined the old royal collections.

Every artist and connoisseur who could afford the fare made straight for Paris that summer, and when Turner arrived in September, it must have seemed as if the Academy had decamped in force to the Louvre. Farington spoke for them all when he said: 'As I had seen nothing to which it could be compared, so I can say till this day I could but ill judge what had been done in Art.' It was all very different from the way pictures were usually viewed in London, 'in the promiscuous arrangement of an Auction room'.

It was the Italian pictures, including such works as Raphael's *Transfiguration,* Titian's *St Peter Martyr* and Correggio's *St Jerome,* that mainly engaged the British, including Turner, for as the connoisseur Sir Abraham Hume observed, 'We have nothing in England which can give an adequate idea of Italian Art.' But they were hardly less curious about their contemporaries in France, and may have found cause to appreciate their own advantages. In Paris painters could no longer become Academicians; only membership of the Institut de France was open to them, and the places available to painters were restricted to six. Moreover those accommodated in the Louvre buildings inhabited rooms 'in the rudest condition' off pitch-dark corridors.

French artists did, however, have one important opportunity as yet unavailable in London: that of hanging their works in a public gallery adjacent to the old masters. The display of the modern French school, arranged in September of that year in the *salon carré* at the end of the Louvre's main gallery, afforded a remarkable opportunity to see how living artists compared with or reacted to those of the past. In general, the British were disappointed: West declared that 'the French paint statues,' and Turner's reaction to modern French painting was equally unenthusiastic. Farington recorded that 'He held it very low – all made up of Art.'

Turner himself, however, was to attract similar criticism when, in 1803, fired with enthusiasm by his studies in the Louvre and eager to celebrate his election as Academician the year before, he began to exhibit a great series of pictures demonstrating his commitment to high art and to the old masters. His magnificent plunderings from the past, from Poussin, Titian or Claude certainly put him even more firmly on the map, but they were increasingly controversial. Reynolds's old pupil James Northcote thought Turner's work 'too much compounded of Art and had too little of Nature', being 'gathered together from various works of eminent Masters'. At the same time, Turner's increasingly interpretative approach offended the connoisseurs who took a purist view of artistic tradition.

COMPETING WITH THE OLD MASTERS

Such controversy was not really new. In the mid-eighteenth century, William Hogarth, that most English of painters, had suffered from the preference of the collecting classes for the old masters, and had turned to ruthless satire of them and their possessions. But even while he resented the competition of the 'dark masters', he could not help but be fascinated by the best of them. When he could, he tried to match them, thereby asserting that a living English artist could be the equal of a dead foreign one, and equally deserving of patronage.

Turner felt none of Hogarth's ambivalence, only an ambition to compete on the same terms. Unlike Hogarth, he was working at a time when thorough assimilation of the lessons of the masters was an established part of academic practice; and when collectors were beginning to buy modern as well as old pictures, some of Hogarth's battles had been fought and won.

Sir John Leicester, who bought his first Turner, *The Shipwreck,* in 1805, was collecting modern pictures with the selfless motive of forming 'a national gallery of British art'. Lord Egremont, who was later to be a constant friend and host, had also acquired a Turner, *Ships bearing up for Anchorage,* by 1805, and since Reynolds's day had bought English pictures to hang with his old masters at Petworth. But at a time when taste for contemporary art was almost entirely

COPY OF TITIAN'S 'ENTOMBMENT'

*J. M. W. Turner, 1802, pencil,
watercolour and scraping out on grey wash
preparation. Clore Gallery for the Turner
Collection.*

STUDIES IN THE LOUVRE, 1802

*O*n his return from Switzerland in 1802, Turner spent a period studying the great collection of pictures assembled in the Louvre as a result of the Revolution and of Napoleon's campaigns in Italy and Spain. He concentrated mainly on the Italian masters like Titian rather than on Claude who was richly represented at home. His 'Studies in the Louvre' sketchbook contains copies like these and passages of sensitive critical analysis. The Christ in Titian's Christ crowned with Thorns *he described movingly as 'the soul of the piece shrinking under the force of the Brutal Soldier, with filial resignation yet with dignity'. Among contemporary French painters he did not admire the severe neo-classicism of Jacques-Louis David, and preferred Pierre Narcisse Guérin,* whose Return of Marcus Sextus *was the only modern picture he copied in Paris.*

HOLY FAMILY

———

*J. M. W. Turner, oil, Royal Academy
1803. Clore Gallery for the Turner
Collection. In colouring and composition,
this picture was based on Titian.*

———

conditioned by that for the art of the past, even the most sensitive and well-intentioned collector could pose a threat to artists, and one such was Sir George Beaumont.

A passionate lover of painting and an amateur artist himself, Beaumont felt deeply on matters of taste, and after 1800 was unrivalled as an arbiter. More than any other painter, he loved Claude, but he would have him followed faithfully or not at all. Turner's Claudean pictures seemed to him a travesty, chiefly in their colouring, although he also had much to say about Turner's degree of finish and perfunctory handling of figures. Today we associate Turner's Claudean works with a dazzling richness of colour and blaze of sunlight, but Beaumont's opinions were mainly formed by the earlier essays in Claude's style, from *Macon* in 1803 to *Dido and Aeneas* in 1814, which were cool and silvery in tone. Moreover, Beaumont, like everyone else in those days, saw Claude's work through the rich brown varnish that then coated most old master pictures, so it was Turner's misfortune to be first too cool and then too bright for Beaumont's conservative taste.

The first objection gave rise to Beaumont's long-

THE DELUGE

J. M. W. Turner, oil, c. 1805. Clore Gallery for the Turner Collection. Possibly exhibited in Turner's Gallery in 1805, this is another monumental essay in Poussinesque 'Sublime'.

sustained attack on Turner as a 'white painter', but he was not the only artist, nor the first, that Beaumont described in this way. This dubious honour seems to have gone to a young landscape and marine painter, Augustus Callcott who, after Girtin's death in 1802, was to become Turner's closest professional associate and rival. Callcott would prove almost a match for Turner in imitating and interpreting the old masters. Partly from Claude, but also from Dutch masters like Aelbert Cuyp, he had learned how to achieve hazy and subtly atmospheric middle distances in his landscape and marine pictures. Their pale and cool colouring was quickly criticized by Beaumont, and he stepped up his attacks when, in the next decade, Turner and Callcott competed amicably with each other in developing a type of pastoral landscape or

riverscape, usually taken from the Thames valley, that made effective use of diffused lighting and misty sunshine.

In this, both artists were capitalizing on the growing interest in Cuyp, who was becoming scarcely less of a passion with English collectors than Claude himself. Important pictures by him had been on the art market in the 1790s, among them the *Herdsman with Cows,* clearly the source for a number of pastoral landscapes by Callcott, and *The Passage Boat,* a great example of Cuyp's other speciality, the tranquil marine, studied by both Callcott and Turner. In 1816, Callcott exhibited his undoubted masterpiece, *The Entrance to the Pool of London,* a picture that the painter Thomas Uwins considered 'as fine as anything Cuyp ever painted'. Turner, who 'would have awarded it a thousand guineas', was also fully aware of its debt to Cuyp, and having visited the painter's home town of Dordrecht in 1817, responded a year later with his own masterpiece of the tranquil marine, *The Dort,* perhaps the most brilliant of all his combined tributes to artists old and new.

While Callcott and Turner were demonstrating the impact of Cuyp and Claude, the landscape and animal painter James Ward was exploring the work of Rubens, and exploiting its possibilities for bold and dramatic handling and rich colour. Rubens, like Rembrandt, had been adopted by the proponents of the 'Picturesque', and Beaumont had spoken of the master in 'rapturous terms' since the days of the Orléans sale. Rubens was, however, a somewhat contentious case; Lawrence chastized his admirers for 'sensual taste', and Turner too had rather a blind spot for him, strongly criticizing his landscapes for taking

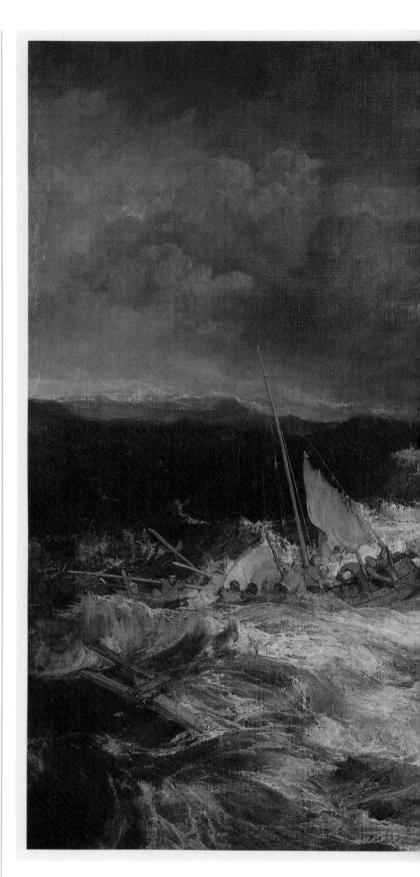

THE SHIPWRECK

J. M. W. Turner, oil, 1805. Clore Gallery for the Turner Collection. Exhibited in Turner's Gallery, this dramatic sea-piece continued his sequence of oils in the grand manner; this time he set himself to match the Dutch marine painters of the seventeenth century.

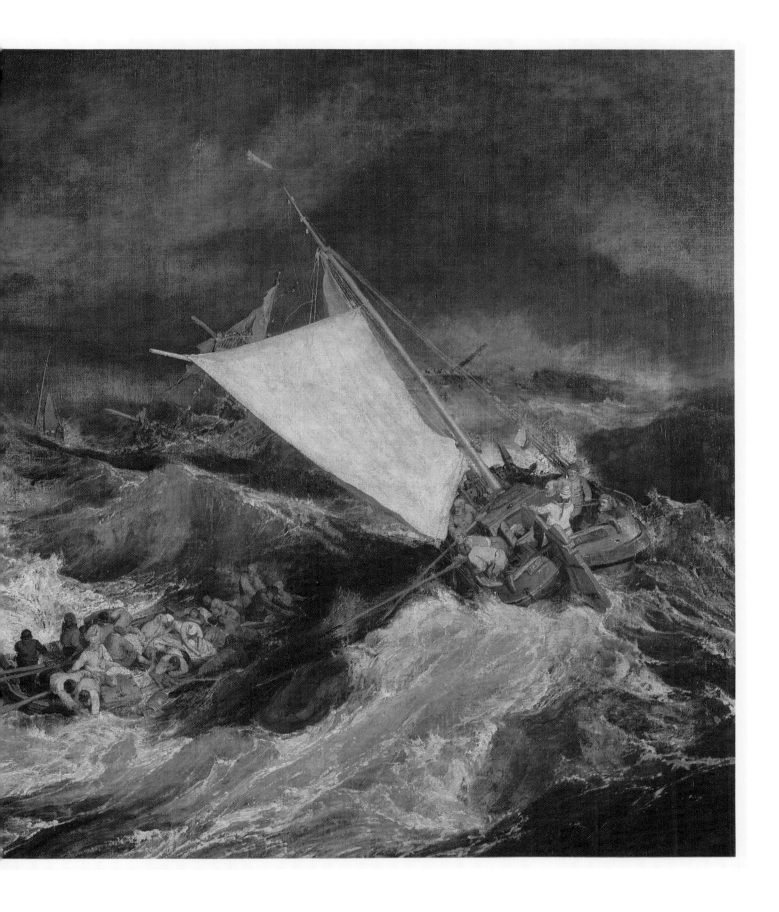

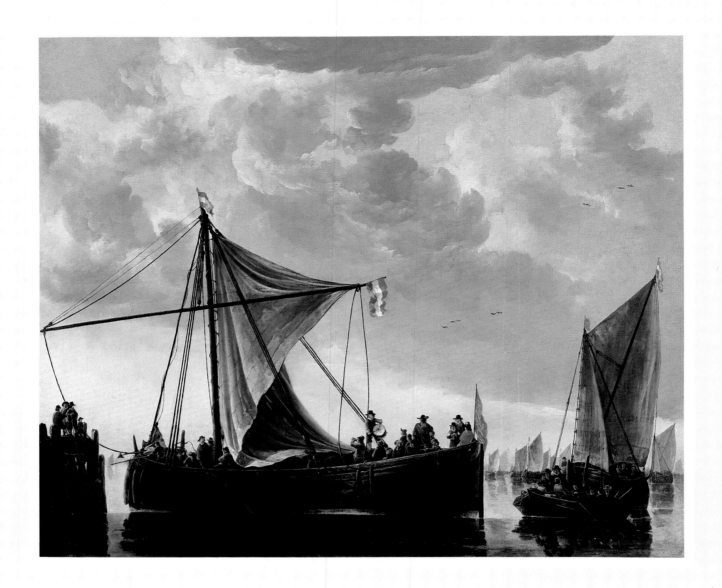

THE PASSAGE BOAT

Aelbert Cuyp, oil. Royal Collection.

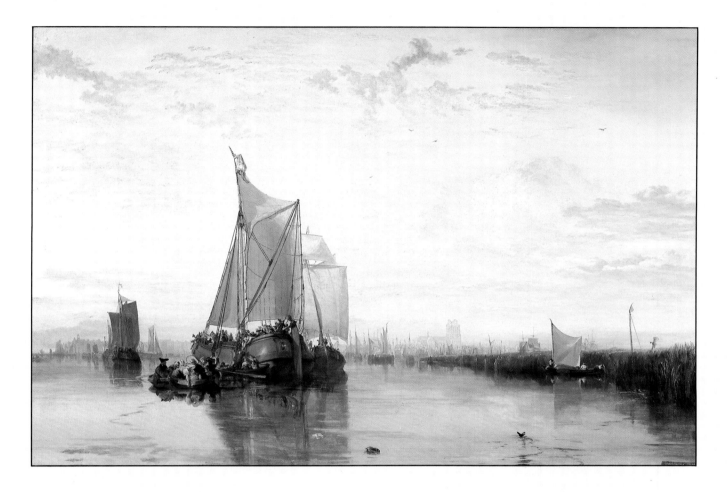

TURNER AND CUYP

The painter Aelbert Cuyp was prized for his mastery of tranquil pastoral subjects or riverscapes, and of subtly modulated atmospheric effects. Both Turner and his friend and admirer Augustus Wall Callcott had absorbed Cuyp-like atmospherics into their pastoral landscapes from about 1806–7. In 1814, the Prince Regent, who was very fond of Dutch pictures, bought Cuyp's river marine, The Passage Boat, and the following year Callcott embarked on a series of large marines with compositions and lighting based on the master. These he exhibited at the Academy to great acclaim. His masterpiece The Pool of London was shown in 1816. Turner's Dort, two years later, went still further in its dazzling reinterpretation of Cuyp's luminous effects of river and open sky. It was bought by Walter Fawkes.

DORT, OR DORDRECHT, THE DORT PACKET-BOAT FROM ROTTERDAM BECALMED

J. M. W. Turner, oil, Royal Academy 1818. Yale Center for British Art, New Haven.

THE FOREST OF BERE

J. M. W. Turner, oil, 1808. National Trust, Petworth House. Exhibited in Turner's Gallery and bought by Lord Egremont, this woodland scene is presented with unaffected naturalism. The trees recall Rubens but the golden light filtered through them owes more to Cuyp.

liberties with lighting that destroyed 'the simplicity, the truth, the beauty of pastoral nature'. As if to offer a corrective, Turner cast a Cuyp – like a glow over a very Rubensian cluster of trees in this beautiful *Forest of Bere* of 1808.

Ward, however, persisted in his Rubensian path, and when in 1814 he completed his own view of the lake in Sir John Leicester's park at Tabley, with Turner's two pictures of 1809 in mind, he did so in his own distinctive style. His darker, richer tones appealed to Beaumont, and his sombre, monumental masterpiece, *Gordale Scar,* exhibited in 1815 and painted partly to refute Beaumont's supposed remark that the place was unpaintable, was, like much of his work, calculated to impress the more conservative connoisseurs.

Meanwhile, the colour palette of Turner and Callcott continued to offend. In 1813, Callcott felt sufficiently goaded by the 'persevering abuse' from

Beaumont and his friends to refrain from exhibiting at the Academy; his reputation seemed so badly affected that it was impossible to sell his work. Turner had apparently planned to join the protest, but changed his mind and, the next year, adopted more subtle tactics in the connoisseurs' own arena, the British Institution.

The Institution's interest in the old masters had been controversial from the first. No sooner had the first modern exhibition come down in 1806, than the galleries were rehung with works by Rembrandt, Rubens, Murillo, Velasquez, Van Dyck, and Reynolds and Wilson who the organizers regarded almost as old masters themselves. Drawn from the founder-directors' collections, they formed the first of a long series of such loan exhibitions for the public to enjoy,

ABOVE:

A FOREST AT DAWN WITH A DEER HUNT

Rubens, oil. Christie's, London. In Turner's day this picture belonged to the Welsh landowner Sir Watkyn Williams Wynn.

TOP:

ST DONAT'S CASTLE, GLAMORGANSHIRE, WITH BULLS FIGHTING

James Ward, oil, Royal Academy 1803. Victoria and Albert Museum, London.

APULLIA IN SEARCH OF APPULLUS

*J. M. W. Turner, oil, 1814. Clore
Gallery for the Turner Collection.*

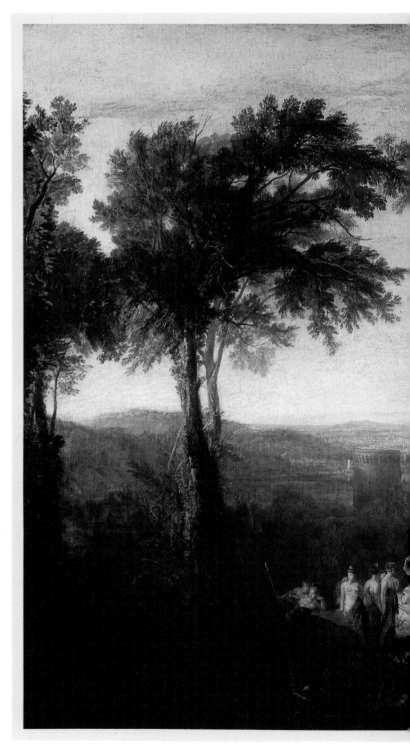

TWO VERSIONS
OF CLAUDE

*T*he stream of criticism Turner and sympathetic colleagues
like Callcott endured from Sir George Beaumont was
based on the baronet's failure to allow for individual interpretation
in an artist's response to the old masters. Turner's innovations
in colouring, and his sometimes perfunctory finish in some
parts of his pictures, offended Beaumont's conservative eye,
above all in pictures which took their inspiration from his
beloved Claude. The British Institution, of which Beaumont
was a Director, offered an annual premium for the best modern
landscape fit to hang as a 'companion' to Claude or Poussin.
In 1814 Turner submitted a picture that answered this require-
ment exceptionally literally, being practically a copy of a Claude
in the collection of another Director, Lord Egremont, to which
he had already referred in his earlier Macon. Submitted late,
Turner's picture was disqualified from a prize. Meanwhile at
the Academy he made the point that art was not about mere
imitation by exhibiting a Claudean work that was at the same
time a uniquely imaginative reconstruction of the ancient world,
Dido and Aeneas.

DIDO AND AENEAS

J. M. W. Turner, oil, Royal Academy
1814. Clore Gallery for the Turner
Collection.

LANDSCAPE WITH HAGAR AND THE ANGEL

Claude, oil. National Gallery, London.
Sir George Beaumont's favourite picture,
this was also much admired by Constable
who echoed its composition.

and for artists to copy – thus providing just the facilities that the Academy had long wished but failed to achieve. The problem was that they were not arranged by artists, to reflect artists' tastes, but by connoisseurs who might use them to direct the course of modern art. Further, artists were simply afraid of the competition. Who would buy their work whose taste was formed by Claude or Rubens – or even Reynolds, for it was in just this anxious spirit that many including Turner made their otherwise extraordinary objections to the Institution's proposal in 1813 to hold a retrospective exhibition of Reynolds, much as they respected Reynolds himself.

Among the Institution's encouragements to modern painters was a competition for a landscape fit to hang as a companion to a Claude or a Poussin, but in 1814 Turner sent in – late and without an apology – a picture that was almost a travesty of the Institution's historicism, *Apullia in Search of Appullus,* virtually a copy of a Claude that belonged to Egremont. Meanwhile he showed at the Academy a more characteristically subtle interpretation of Claude, *Dido and Aeneas.*

In mocking the Institution's traditionalism, Turner was not making fun of Claude himself, but of the slavish copying which repeated traditions without refreshing them. Others were less discriminating, and in 1815 and 1816 artists of the loyal Academy faction found less tactful means of protest in one of the most discreditable episodes in British art history. They or their sympathisers (the question has never been resolved) published two bitterly sarcastic spoof catalogues of the Institution's current old master exhibitions, which mounted a violent attack on Beaumont and his fellow connoisseurs while vigorously promoting the interests of living artists against the competition of the old masters. The latter were ridiculed in the cruellest satire, and distinguished masterpieces (some of them now in the National Gallery) were disparaged in order to press the claims of modern art.

The dust settled surprisingly quickly. Beaumont was chastened, while in 1816 the Academy took back some of the Institution's initiative by establishing a painting school where teaching was based on studying and copying old master pictures borrowed from the collection now established at Dulwich College. Meanwhile the Institution had already tried to reiterate its genuine concern for living artists by purchasing new work for a gallery of its own. In 1815 it attempted to buy a large marine by Callcott – apparently another of his tributes to Cuyp – from the Academy, and did purchase a work by Wilkie, now a successful and even more obviously 'old masterly' painter.

This Scottish painter had been Beaumont's protégé since his arrival in London in 1805. He had made his name with pictures of popular narrative – genre scenes – inspired by Dutch masters like Ostade and Teniers, but informed by his own acute observation of human character. This lively reinterpretation of a historical style proved instantly appealing, and from the moment his *Blind Fiddler* appeared at the Academy in 1806 Wilkie's reputation was made. By the time he died, on his way back from the Holy Land in 1842, to be commemorated by Turner in the marvellous *Peace, Burial at Sea,* his art had taken a very different turn, but it was his narrative subjects that first caught Turner's attention. The latter's *Blacksmith's Shop* was one of the first of several narrative subjects painted in direct response to Wilkie's challenge.

Wilkie's art never lost its 'old masterly' character, which made him the perfect modern painter for the patron of conservative taste. A more difficult case was the young John Constable. He had known Beaumont from boyhood, and had assiduously studied the connoisseur's collection. Nor did he ever lose his passionate love for the old masters, once declaring that 'a self taught artist is one taught by a very ignorant person'. But he insisted also on finding his own personal approach to nature, and painting it in nature's own colours; as early as 1802 he had renounced 'running after pictures and seeking the truth at second hand.' Influences from Claude, Cuyp and Rubens were assimilated into Constable's work, but all were seen 'with a fresh eye', to use Farington's perceptive phrase.

The result was that Constable spent most of his career rather on a limb, neither as honoured and successful as Wilkie, who received a knighthood from

Queen Victoria, nor as controversial as Turner. Beaumont, who often entertained him, never bought any of his paintings, and Academy honours came as slowly to him as they came rapidly to Turner and Wilkie. Constable took far more notice of Turner than Turner did of him, although in 1832 Turner did feel that his very quietly toned marine, *Helvoetsluys,* was overshadowed by Constable's unusually brilliant *Opening of Waterloo Bridge,* and added a touch of red to it to compensate. 'He has been here,' said Constable, 'and fired a gun'.

ITALY: OLD AND NEW MASTERS

Turner's years of travel after the renewal of peace in Europe inevitably reasserted the importance of the old masters for him – Cuyp in the Low Countries, Claude in Rome and the Campagna, Canaletto in Venice. As he moved around the Continent, he noted 'the first bit of Claude', or 'quite a Cuyp'. A trip to Italy was still above all a pilgrimage to the greatest of all masters, to the Classical traditions of antiquity and to the painters of the High Renaissance, and on his first visit in 1819 Turner was not so moved by the wonders of nature as to forget the study of art.

In Rome he made the established tours of the Vatican and the galleries of the great private palaces; in Venice he learned to appreciate Tintoretto's 'regulated Harmony of colour' even more than Titian's bold contrasts, and in Milan and Florence he examined early painters like Carlo Crivelli and Piero di Cosimo, then only beginning to attract the attention of the English critics. On his second visit in 1828 he paid more attention to these, after reading William Young Ottley, a pioneering historian of what was then known as 'primitive' art.

Yet, Turner's comments and copies were fewer than those he had made in the Louvre in 1802, as though he was now more certain of his purpose and could absorb the lessons more swiftly. Significantly, he carefully studied the Claudes in Italian collections, for it was through Claude above all that he would distill his own vision of landscape and antiquity.

As in Paris, Turner found in Rome a thriving community of working artists, not only Englishmen, but also a distinguished international group. As a German remarked about this time, 'Fish belong in water, artists in Rome'.

Among the English painters was the young Charles Eastlake, later celebrated as a historian and administrator but then a promising and well-connected historical, narrative and landscape painter who was developing a thoroughly international style. He lived very sociably at 12 Piazza Mignanelli, in the old artistic quarter of Rome, beside the Spanish steps, within a stone's throw of the former homes of Claude and Rosa. Also at number 12 lived Captain Thomas Graham and his wife Maria, who later married Turner's friend Callcott and who was to publish the first English life of Poussin in 1822. It was probably Eastlake and his friends who gave Turner the list of twenty modern painters working in Rome that he jotted in a sketchbook.

Modern painting in Italy fell into several fairly distinct categories. Firstly there was the Neoclassical style personified by painters like Pietro Benvenuti, whose work Turner was to see in Florence. Secondly there was a new strain of historicizing painting based on early Italian frescoes, practised by a group of German painters known as the Nazarenes. Expelled from the Vienna Academy during a Napoleonic purge, these young men had gravitated to Rome, where they had taken up residence in the abandoned convent at San Isidoro, adopting Roman Catholicism, monastic rituals and an archaic style. The third category was one that began to develop between these two extremes: a different and altogether more modern interest in the pictorial possibilities of the Italian landscape and its people. Italian peasants, the brigands who haunted parts of the country, and the religious processions that constantly filled the Roman streets, became accepted subjects for painting. Eastlake capitalized on them, as did other British painters bred in the new tradition of Wilkie, even before Wilkie himself arrived to paint pilgrims and peasants in 1825. Turner himself acquired a picture by an Italian exponent of this type of painting, Giacomo Berger, and the influence of the genre can be seen in one of the

DEDHAM VALE

*John Constable, oil, 1802. Victoria and
Albert Museum, London. An early
example of Constable's distinctive natural
vision, combined with an echo of Claude.*

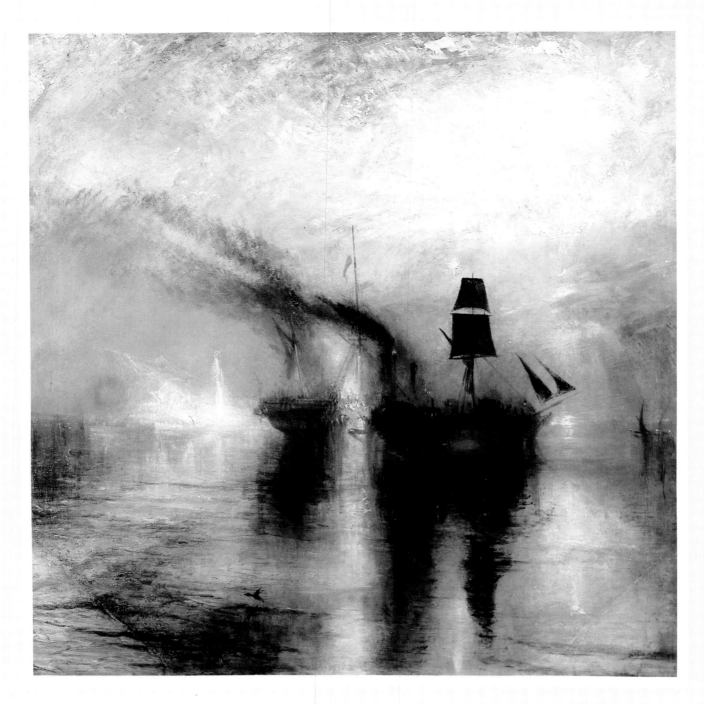

PEACE: BURIAL AT SEA

*J. M. W. Turner, oil, Royal Academy,
1842. Clore Gallery for the Turner
Collection.*

THE BLIND FIDDLER

*David Wilkie, oil, Royal Academy, 1807.
Tate Gallery, London.*

TURNER AND DAVID WILKIE

Of all his painter contemporaries, Callcott and Wilkie were the most fashionably successful. Both were to receive knighthoods, while Turner received no such honour. Wilkie made his name with scenes of popular narrative based on his own keen observation and on study, first through prints and then in the original, of paintings by Dutch seventeenth century genre painters like Ostade and Teniers. The Blind Fiddler, bought by Sir George Beaumont, was a huge success at the Academy in 1807. Turner's Country Blacksmith, exhibited nearby that year, together with his Sun rising through Vapour *also exhibited, was said to have been heightened in colour at the last minute to throw Wilkie's picture into 'eclipse'. Wilkie's pictures continued to be vastly influential on the course of painting and popular taste. Turner's* Peace: Burial at Sea *commemorates his colleague's shipboard funeral off Gibraltar. Wilkie had died on his way home from a trip to the Holy Land in 1841.*

ABOVE:

A COUNTRY BLACKSMITH DISPUTING UPON THE PRICE OF IRON

J. M. W. Turner, oil, Royal Academy 1807. Clore Gallery for the Turner Collection.

75

pictures he painted during his second visit, *Orvieto*.

Finally, there were a number of painters – the Frenchmen François Granet and Jean-Baptiste Camille Corot in Rome, and the Dutchman Anthonie Sminck Pitloo in Naples – who devoted themselves to a spontaneous record of the Italian landscape, often working, as Turner had done in England, in oil out-doors. In Naples they acquired a name, the 'Scuola di Posilippo'. It is with these pioneering spirits that we might expect to find Turner most closely associated, but links have proved elusive.

In fact Turner gained a reputation for shyness dur-ing his Roman visit; the sculptor Francis Chantrey, a fellow Academician, reported that nobody knew his address. Yet according to the poet Tom Moore, it was with Chantrey and the Italian Neoclassical sculp-tor Antonio Canova that Turner visited the Venetian Academy and the Academy of St Luke, and it was Canova, the latter's President, who recommended his election as honorary Academician. Turner's asso-ciation with the Academy of St Luke, to which so many great masters had belonged, gave him genuine pride, and when he exhibited *Rome from the Vatican* in London in 1820, his catalogue description of himself as 'Member of the Roman Academy of St Luke' underlined the sense of unbroken artistic tradition suggested by the presence of Raphael, quintessential genius of High Renaissance Rome, in the picture.

Just as Raphael was central to the cultural traditions of Rome, so was Canaletto inseparable from Venice, and when Turner came to paint his first Venetian oil, *The Bridge of Sighs*, in 1833, this painter too was given a place in the picture. Such references clearly announced that Turner's view of Italy was to be fun-damentally a traditional one, informed by the artists of the past. He did not include the figure of Claude in his Italian landscapes, but that would have been hardly necessary as his presence is felt behind almost every one of them.

Turner was more forthcoming among his contem-poraries on his second visit to Rome in 1828, exhibit-ing several pictures including *Regulus, Orvieto* and the *Vision of Medea,* but the exhibition proved an occasion of mutual suspicion between him and his Roman col-leagues. He had already pronounced 'the art at Rome at the lowest ebb', but the distaste was mutual. In the words of the sculptor Thomas Campbell, 'the Romans who had seen these pictures were filled with wonder and pity.'

CHANGING TASTES

This reaction was not entirely confined to the Roman artists. In Britain in the 1830s, Turner's art could seem both old-fashioned or insanely radical, depend-ing on the critic's point of view. A picture like *Regulus,* with its blaze of sunlight, offended the purists, while many people would have thought it rather odd to be painting in the style of Claude at all. Taste in art, both old and new was beginning to change.

The opening of the National Gallery, first in Anger-stein's old house in 1824 and in Trafalgar Square in 1838, institutionalized the taste of the generation that had acquired its pictures – and continued to run the British Institution. But although what might be de-scribed as 'National Gallery taste' continued to dominate the collecting habits of patrician collectors for some time, a new group of patrons was emerging, rich with new money from the commercial booms that followed the Napoleonic wars. They were un-interested in the Classical values of the Grand Tour, nor were they concerned with notions of artistic propriety or hierarchy. Instead they bought pictures they could easily understand, depicting humorous or sentimental stories from history or literature, some-times in period costume and almost always painted on a small scale and geared to residences that were comfortable rather than palatial.

A number of painters served the requirements of this new class – William Mulready, Thomas Webster, William Etty, C.R. Leslie – and their progenitor was Wilkie. The two collectors who typified this new breed, John Sheepshanks and Robert Vernon, whose collections are now in the Victoria and Albert Museum and the Tate Gallery respectively, were more adven-turous than most since they also bought Turner and Constable, but narrative pictures made up the bulk of their collections.

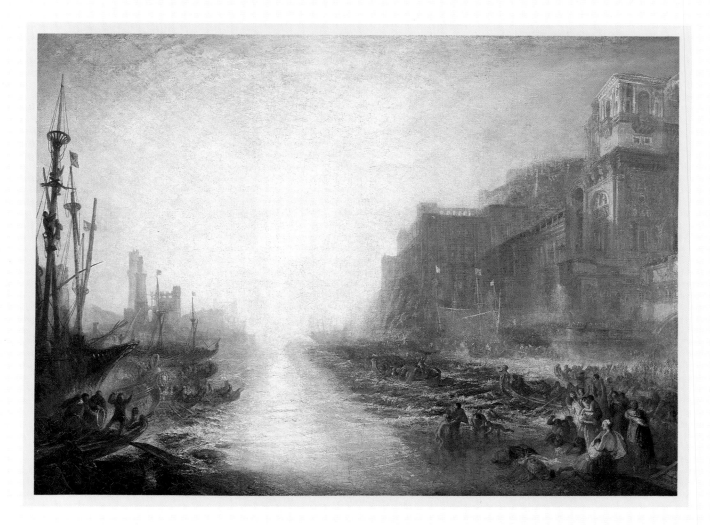

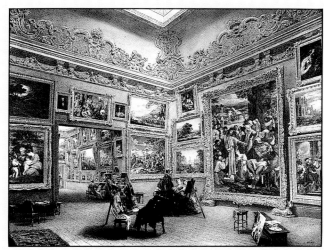

ABOVE:

REGULUS
——

J. M. W. Turner, oil, 1828, reworked and exhibited 1837. Clore Gallery for the Turner Collection.

RIGHT:

THE NATIONAL GALLERY AT 100 PALL MALL
——

Frederick Mackenzie, watercolour, Victoria and Albert Museum, London. Pending construction of a proper building, the gallery opened in 1824 in Angerstein's former house. It included Angerstein's pictures, bought for the nation, and Beaumont's, presented as a gift. 24,000 visitors visited it in the first six months. Angerstein's 'Raising of Lazarus' by Sebastiano del Piombo is prominent on the right.

——

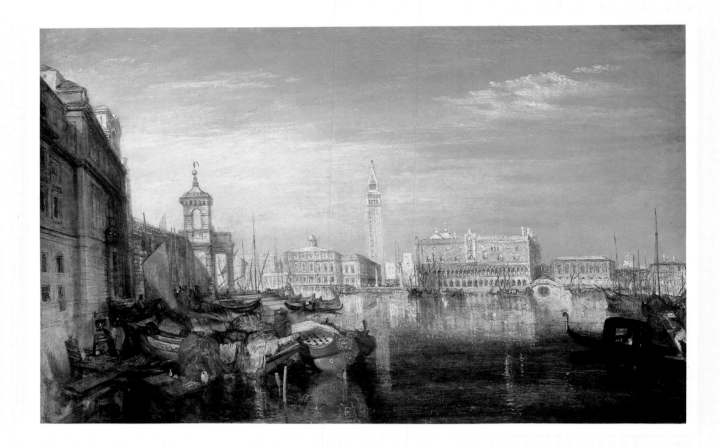

BRIDGE OF SIGHS, DUCAL PALACE
AND CUSTOM-HOUSE, VENICE:
CANALETTO PAINTING

J. M. W. Turner, oil, Royal Academy,
1833. Clore Gallery for the Turner
Collection.

LEFT: Detail.

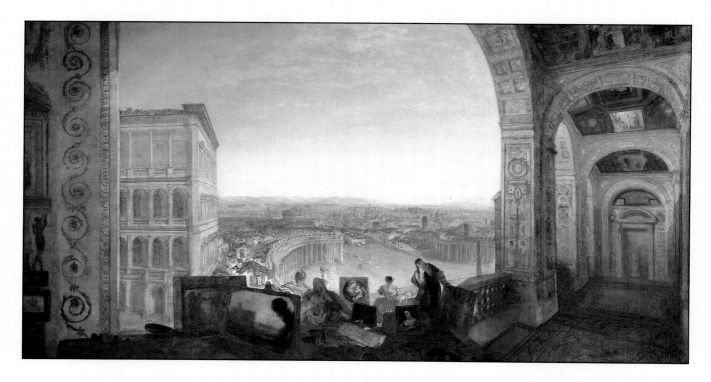

ITALY AND
THE OLD MASTERS

*I*t was always characteristic of Turner to approach new subjects and places through the eyes of other masters before developing his own transforming vision. His vision of Italy never lost its memories of Claude, through whose pictures he, like generations of painters and lovers of painting before him, had grown to love the country long before he could visit it himself. In Rome and Venice, however, other masters better expressed the essential spirit of place. Rome, the seat of the High Renaissance as well as of antiquity, was the city of Raphael; Venice had belonged to Canaletto as much as to Titian. Turner's first Italian oil, painted after his first visit in 1819 and shown at the Academy the following year, placed Raphael, with his mistress 'La Fornarina', and surrounded by examples of his art, at the heart of an all-embracing panorama of Rome and its setting among distant hills. Likewise, his first Venetian oil, painted partly in response to the Venetian subjects of his young contemporary Clarkson Stanfield, includes Canaletto at work on one of his own Venetian views.

ROME FROM THE VATICAN

J. M. W. Turner, oil, Royal Academy, 1820, Clore Gallery for the Turner Collection.

Wilkie, writing to Lady Beaumont after her husband's death, described the issue of his contemporaries' relationship with the old masters as 'the great leading question of modern art'. But Wilkie, who was now exhibiting sonorous works influenced by Titian and Velasquez whom he had studied in Italy and Spain, was running counter to trends he had himself helped to initiate. For most artists, it was clear that it was no longer possible to continue in the sort of closely dependent relationship with the masters that Turner had claimed with Claude, Poussin or Titian. The unbroken line of descent that Reynolds had taken for granted had been broken.

In this new climate, Turner's Claudean subjects, had they been stated in less vividly colouristic terms, would have looked old-fashioned to some artists. At the same time, the old patron classes, faced with sentimental genre painting on the one hand and the extravagant effects by which Turner projected past imagery into the style of the future on the other, longed for some restraint. Some found it in Callcott, who in later life seemed to provide a safe alternative, but others felt completely betrayed by modern art. Among them was Lord Francis Egerton, who admired Turner's early work – indeed he now owned Turner's early paraphrase of Van de Velde, *Dutch Boats in a Gale,* and lent it to the British Institution in 1837 – but hated his later pictures. In an article in the *Quarterly Review* he mounted a violent attack on this 'Paganini of the palette', while lamenting the fact that Britain now had 'no Ruysdael for our skies, no Cuyp for our sunshine'.

This at least was a familiar complaint. Indeed it had been anticipated, though more crudely, by an anonymous article (actually by the Rev. John Eagles) in *Blackwood's Magazine* the previous year. In this, Turner and many other painters had been slated for delighting in vulgar glare and glitter and ignoring the old masters' more sombre shadow and depth of colour. It was this attack that first rallied the young John Ruskin to the passionate defence of Turner that he was to maintain throughout his life.

In fact, painters were not losing their interest in the old masters; they were, however, beginning to look at particular kinds of masters – those with a painterly technique, painters of narrative and incident rather than history, of domestic rather than elevated landscape, painters of human mood and individual sympathy rather than idealized expression.

Rembrandt, for example, came to be appreciated at a much more significant level than just as a master of dramatic lighting or composition, and his understanding of human character was more deeply understood. Rembrandt and Antoine Watteau, another superlative colourist, whose paintings also showed deep psychological insight, were both the subjects of revivals in the 1820s and 1830s to which Turner contributed. His friend Samuel Rogers collected Watteau, who was also well represented in the Dulwich gallery. Both masters had much to offer to modern artists, and so did Venetian painting: Constable and the German connoisseur J.D. Passavant thought Veronese had been the prime source for pictures by C.R. Leslie, while Titian was manifestly the inspiration for the lavish and sensuous nudes of William Etty that were becoming popular in the Academy.

The paraphrasing of the past did not cease; it merely continued with greater freedom, unconditioned by old conventions. And so far from disappearing from painting, the old masters began to appear in it themselves. The presence of Raphael, Canaletto and Giovanni Bellini, or of Rembrandt or Watteau in Turner's later pictures sprang from an interest in the personal history of art quite different from the mainly stylistic concerns of his youth, but no less characteristic of its own period.

TURNER AND HIS CONTEMPORARIES

The Venetian school had long been admired for its painterly and tonal qualities, and the publication in 1829 of Sir Abraham Hume's *Notices of the Life and Works of Titian* gave a factual and biographical dimension to contemporary appreciation. In the same year, just back from Italy, Turner was able to see a number of pictures and sketches by Richard Parkes Bonington, the English painter who, after himself, had so far paid most attention to Venice. This artist had died, tragic-

VENICE: DUCAL PALACE WITH RELIGIOUS PROCESSION

Richard Parkes Bonington, oil, British Institution 1828. Tate Gallery, London.

ally young, the year before, and a large sale of his work was held in June 1829.

Bonington had spent most of his working life in France, but had visited Venice in 1826. His exhibits in London, often beach scenes, had already shown Turner's influence, and in the 1830s Turner was to repay the compliment in some open, richly coloured marine subjects of his own. Turner must also have noticed Bonington's Venetian exhibits at the British Institution in 1828, and in the sale were some small interiors with intimate historical scenes which reflected Bonington's study of the Venetian school in a narrative context.

Turner's interest was also caught by a commission from Lord Lansdowne to Bonington's follower, Clarkson Stanfield, for a set of Venetian scenes to hang in the dining room of his country house, Bowood, in Wiltshire – Eastlake contributed a Roman subject for the same room. Turner's *Bridge of Sighs* was partly a reminder to Stanfield that Canaletto had supplied Venetian views earlier, and rather better: the

master appears at work on a view that would have been almost exactly the same as Stanfield's.

Stanfield's precocious talents had been mainly in evidence in the 1820s in marine pictures which, like Turner's early work in this area, looked back to the Dutch painters of the seventeenth century. This had brought him into competition with Callcott who had also made rather a speciality of marine subjects in calm and stormy conditions, and when in 1826 Stanfield failed to complete a marine called *Throwing the Painter* (rope) in time for the Academy, Callcott beat him to it with *Dutch Fishing Boats running foul, in the endeavour to board, and missing the Painter Rope*. This was just the sort of joke Turner also liked to play, and

THE GOLDEN BOUGH

*J. M. W. Turner, oil, Royal Academy
1834. Clore Gallery for the Turner
Collection.*

the following year he responded with *Now for the Painter (Rope) Passengers going on Board.* Turner loved such competitive bouts with his colleagues, but the implied rivalry was usually affectionate. Stanfield became a friend and Callcott remained on very close terms, in spite of the fact that they grew apart as artists in their later work.

Claude and Cuyp remained gods for them both, but Callcott became much more cautious and respectful of tradition than Turner, and cooler and more sober in colour. Many considered that this gave him an advantage: Constable wrote in 1826 of Callcott's 'cool fresh breeze of European scenery, while in Mr Turner's pictures we are in a region which exists in no quarter of the universe', and *The Times,* ten years later, rudely contrasted Callcott's 'iced champagne'

to Turner's 'mulligatawny'. Certainly Callcott's late Italian landscapes, open, serene and palely glowing, must often have appeared a more palatable derivative from Claude than Turner's brilliant fantasies like *The Golden Bough,* exhibited in 1834.

Callcott died, to Turner's great sorrow, in 1844. One of his own last pictures had been of a sentimental episode in the life of a great artist, an intimate scene of Raphael and his mistress 'la Fornarina'. Turner had embraced the newly popular field of narrative historical subjects much earlier, and in 1827 he exhibited *Rembrandt's Daughter,* a paraphrase of the master's style depicting a domestic incident in his life – Rembrandt has burst out of the shadows to apprehend his daughter reading a love letter.

This romantic and manifestly fallacious conception may be related to the Rembrandtesque subjects Wilkie was to paint a little later, but its immediate inspiration was probably the work of Turner's friend George Jones, a historical and military painter who, since his election as Academician in 1824, had been much involved in Academy affairs. By the mid-1820s Jones was painting biblical subjects with Rembrandtesque

LADY IN VAN DYCK COSTUME

*J. M. W. Turner, oil, c. 1830-35. Clore
Gallery for the Turner Collection. A
spirited pastiche of the Van Dyck portraits
Turner saw at Petworth.*

83

SHADRACH, MESHECH AND ABEDNEGO IN
THE BURNING FIERY FURNACE

———

J. M. W. Turner, oil, Royal Academy
1832. Clore Gallery for the Turner
Collection.

———

THE BURNING FIERY FURNACE

George Jones, oil, Royal
Academy, 1832.
Tate Gallery, London.

TURNER, GEORGE JONES
AND REMBRANDT

*T urner had long admired Rembrandt, firstly for his chia-
roscuro contrasts of light and dark – the main basis of
his appeal to eighteenth century critics – but he had increasingly
come to appreciate his tenderness and human sympathy as a
subject painter. In the late 1820s and 1830s Turner was encouraged
to further consideration of Rembrandt by the work of his con-
temporaries; partly Wilkie, whose later work had deepened in
colour and texture under Rembrandt's influence, and more par-
ticularly his friend and fellow-Academician George Jones. In
1832 both Turner and Jones exhibited versions of* The Burning
Fiery Furnace *in friendly competition.*

85

shadows and compositions, and in 1832 Turner's habitual sense of friendly rivalry prompted him to send *Shadrach, Meshech and Abednego in the Burning Fiery Furnace* to the Academy in competition with Jones's own *Burning Fiery Furnace*. Turner's was a freely imaginative transcription, a variation on a theme of which his colleague gave a rather more literal rendering.

Turner's late return to Rembrandt had a more important effect than merely stimulating a small group of narrative or Old Testament subjects. Rembrandt's exoticism, chiaroscuro and innovative painting techniques were highly relevant to Turner's paintings of this period, particularly to the interiors, rich with pools of light and deep shadows, that are usually associated with his stays at Petworth with his old patron, Lord Egremont.

Petworth, described by Constable as 'that house of art', was calculated to inspire thoughts of masters of the past, while also bringing an artist into contact with colleagues who were likely to be staying there. Old masters and moderns hung together, providing a sense of continuity unmatched in a London painting room, and transmitting messages that could become interfused to remarkable effect. There Van Dyck joined Turner's pantheon of past masters, and he painted not only one outright pastiche but also a more elaborate historical picture, *Lord Percy under Attainder*. This contains figures based on Van Dyck's portraits grouped in a period interior in the manner of C.R. Leslie, who was also much at Petworth. To these impulses from past and present Turner added yet another, from Watteau, who is the subject of the companion piece to *Lord Percy, Watteau Study*.

There were no Watteaus at Petworth, but Turner had long loved his work, and with Rembrandt he was the last great master under whose spell Turner

fell in a lifetime of studying the old masters. Reynolds had also loved Watteau, and Turner's friend Samuel Rogers now collected the master. Moreover the painter and draughtsman Thomas Stothard had initiated a popular Watteau revival in small exhibition pictures, decorative drawings and illustrations, which Turner paraphrased in 1828 in *Boccaccio relating the Tale of the Birdcage*.

Stothard had illustrated an edition of Boccaccio's *Decameron* in 1825. Now, in *Watteau Study*, Turner depicted the artist himself – at work before an audience as Turner himself must often have worked at Petworth – surrounded by examples of his pictures from the Dulwich gallery and Rogers's collection.

LES PLAISIRS DU BAL

RIGHT: *Watteau, oil. Dulwich College Gallery, London. By the time this famous picture was acknowledged in Turner's Watteau Study, it was in the Dulwich Gallery. In 1831 it was copied in the Academy Painting School, which regularly drew on the Dulwich pictures.*

WATTEAU STUDY BY FRESNOY'S RULES

ABOVE: *J. M. W. Turner, oil, Royal Academy 1831. Clore Gallery for the Turner Collection. A tribute to Watteau, a version of whose picture Les Plaisirs du Bal, and another then in the collection of Samuel Rogers, appear in the background. Turner's picture also illustrates a colour theory drawn from the 'Arte Graphica' of C.A. du Fresnoy.*

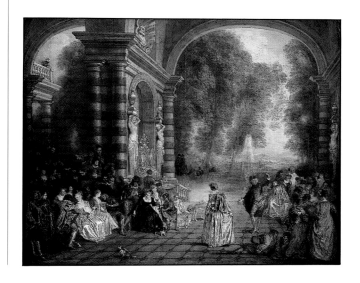

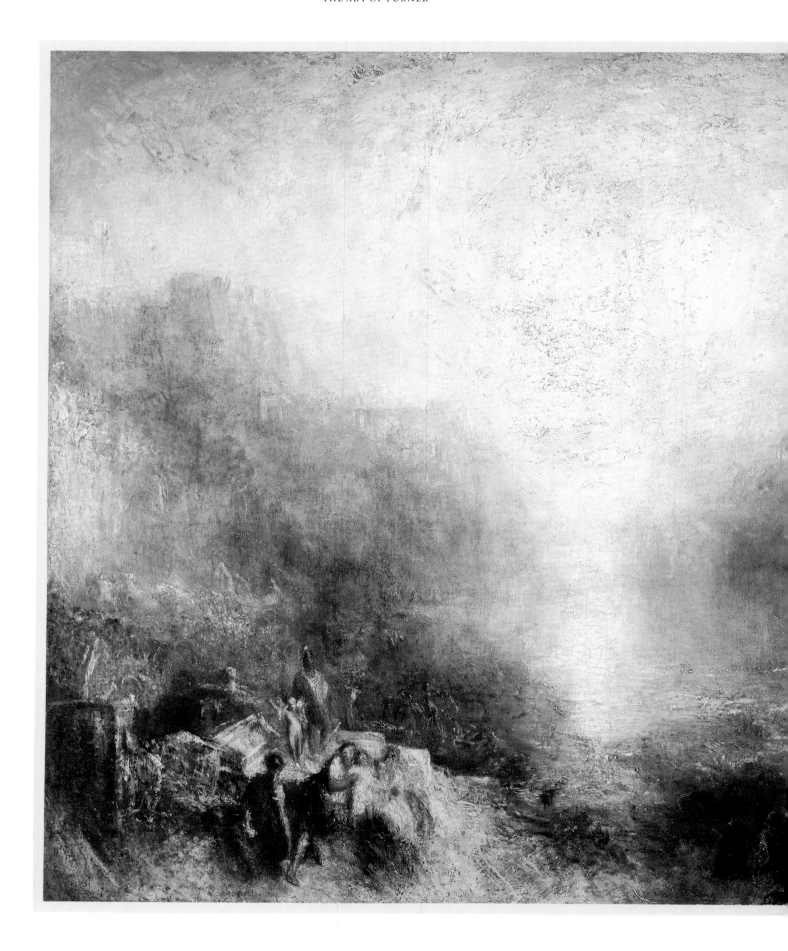

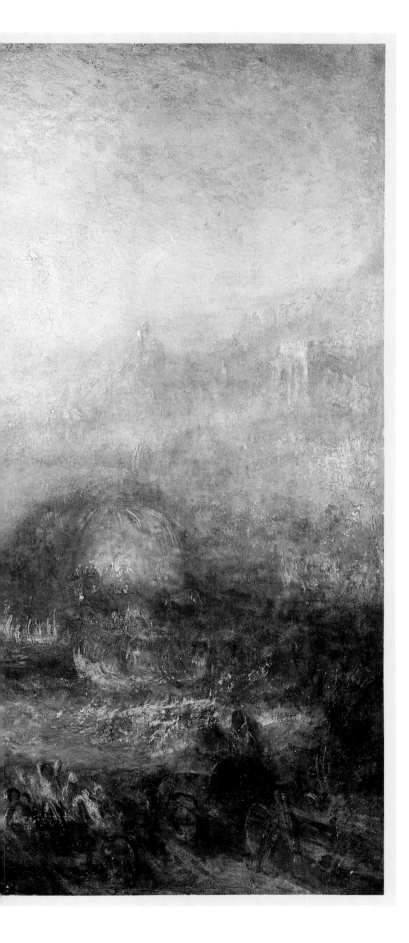

But Turner's purpose was also didactic. Like Reynolds who had himself owned a Watteau, he regarded the French master as a model colourist, who used Flemish principles going back to Rubens. *Watteau Study* was constructed along those colouristic lines, as an object lesson both in technique, and in the continuing relevance of the masters of the past.

No other old master, however, had exerted quite the inspiration that Turner drew from Claude. As late as 1850 he exhibited four classical seaports that for all their diffused and impressionistic detail, still acknowledged the tradition of Claude. It had been Claude's vision of antiquity above all that had shaped the imagery through which Turner was able to make the comparisons between the ancient and modern world that are so frequently suggested in his pictures. As with art, so with life: the past inspired the present, or offered a fitting parallel for its destiny. A Claudean Carthage, whether in the ascendant in *Dido building Carthage* (1815), or in its dotage in *The Decline of the Carthaginian Empire* (1817) was the most potent of Turner's chosen images for his own England. This was perhaps the greatest compliment he could pay to the master beside whom he arranged to hang his pictures in England's National Gallery.

Today, just as he wished, *Dido building Carthage* and his earlier union of Claude and Cuyp in the lovely tranquil marine, *Sun rising through Vapour,* both hang beside Angerstein's two Claudes, *The Embarkation of the Queen of Sheba* and *The Mill.* They are there in tribute and kinship.

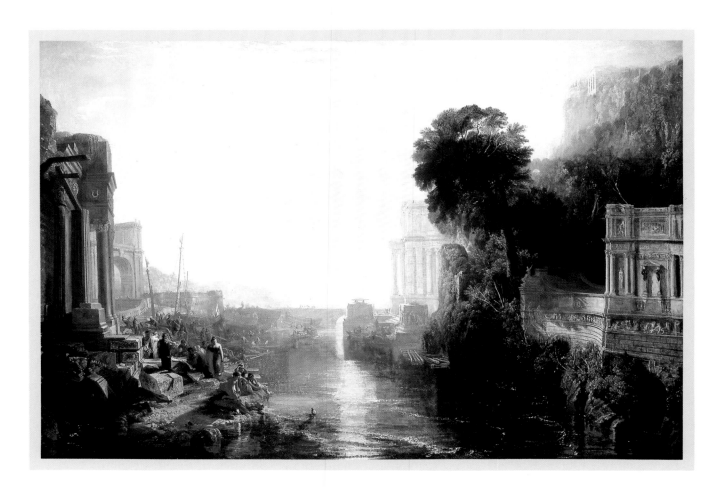

*DIDO BUILDING CARTHAGE, OR, THE RISE
OF THE CARTHAGINIAN EMPIRE*

*J. M. W. Turner, oil, Royal Academy
1815. National Gallery, London. This
reconstruction of an empire in the ascendant
was one of Turner's most magnificent
reinterpretations of Claude; the Times
observed his mind must have been
'saturated' with Claude when he painted it.*

RIGHT:

*SUN RISING THROUGH VAPOUR, FISHERMEN
CLEANING AND SELLING FISH*

*J. M. W. Turner, oil, Royal Academy
1807. National Gallery, London. Turner
had originally intended his Decline of the
Carthaginian Empire to hang with Claude
in the National Gallery, but in 1831 he
substituted this earlier masterpiece of
atmospheric marine painting.*

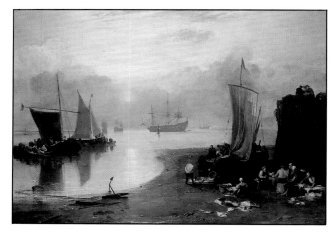

ABOVE:

*THE EMBARKATION OF THE
QUEEN OF SHEBA*

*Claude, oil. National Gallery,
London.*

LEFT:

*THE MARRIAGE OF ISAAC AND
REBEKAH*

*Claude, oil. National Gallery,
London.*

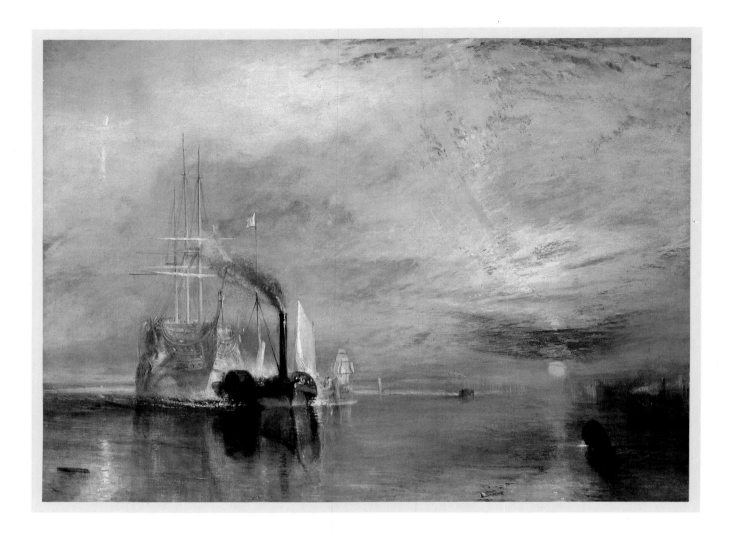

THE FIGHTING 'TEMERAIRE'

*J. W. M. Turner, oil, Royal Academy
1839. Turner saw the Téméraire, a veteran
of Trafalgar, being towed to the breaker's
yard by a steam tug when returning up the
Thames from one of his trips to Margate.
He described the picture as his 'Darling'.*

TURNER'S BRITAIN

. . . He must be a painter of the strength of nature, there was no beauty elsewhere than in that; he must paint also the labour and sorrow and passing away of men: this was the great human truth visible to him. . . . Labour; by sea and land, in the field and city, at forge and furnace, helm and plough. No pastoral indolence nor classic pride shall stand between him and the troubling of the world; still less between him and the toil of his country, – blind, tormented, unwearied, marvellous England.

JOHN RUSKIN *MODERN PAINTERS, V*

At the age of about thirteen, Turner was sent from London to Margate in Kent to stay with relatives of his mother and, briefly, to attend Mr Coleman's school. There he made some of his first stabs at drawing, with considerable success, producing his first rendering of sea-going ships.

Margate was to weave itself in and out of Turner's life. In his later years, it was a favourite place to catch what he described as 'a little change of fresh air', and served as the base for very productive trips around the Thames and Channel shores. Much had happened to Margate in the intervening years that was symptomatic of the wider transformation of Britain. With its fine arc of golden sand, its potential as a resort had been recognized ever since the 1750s, and the one-time fishing village had grown into a modern town, with stucco terraces lining the shore. Instead of reaching it by sail, in the crowded 'Margate hoy', visitors from London could take one of the new paddle-steamers.

None of this disturbed Turner at all: in his many late drawings of the Kentish shore he was able to concentrate on the essentials of sea and air, cloud and light. John Ruskin, usually his staunch supporter, was surprised at his devotion to such prosaic places. But it had always been Turner's particular genius to make great art from familiar experience as much as from specific pilgrimages to exceptional places like Venice and Rome or such natural wonders as the Alps, and it was on his return from a trip to Margate that he saw the scene that was to become *The Fighting Temeraire,* his great elegy for the days of sail.

Ruskin showed more sensitivity in a famous passage in *Modern Painters,* where he wrote of Turner's boyhood in Covent Garden and imagined the impact made by his walks down to the Thames, seething with shipping and the bustle of the docks and the wharves. Here was all the hectic activity of the heart of a great commercial nation, and Turner's lifelong fascination with the sea and ships could well have begun here.

THE POLITICAL AND SOCIAL BACKGROUND

Turner grew up in a Britain at war or recovering from wars. In 1775, the year he was born, shots were fired at Lexington and Bunker's Hill, announcing the American colonies' challenge to British rule. Aged six by the end of the American War of Independence, he may have comprehended something of the significance of the loss of the American colonies, and later heard something of the 'delirium of joy' that swept the country when Sir George Rodney defeated a French fleet in the West Indies on the 'glorious 12th April', 1782.

A STREET IN MARGATE LOOKING DOWN TO THE HARBOUR

———

J. M. W. Turner, c. 1786, watercolour. Private Collection. This boyhood drawing is Turner's first rendering of shipping.

———

This began a new phase in the hostilities with France, Spain and Holland that accompanied the American War, and the victory came not a moment too soon. Threatened by the French in the West Indies and India, by Spain at Gibraltar, and in home waters by the Dutch, Britain stood alone, her expanding empire threatened on all sides – in 1779, a French invasion had been a real possibility. Years later, in a series of great pictures built around ancient Rome or Carthage, Turner was to address the theme of the transience of empire; his generation understood all too well that the events of past history might provide a metaphor for their own time.

Meanwhile, peace could only be bought at a price. In 1783 the young William Pitt became Prime Minister, remaining in office for seventeen years. Concessions to America were made, a trade treaty with France was concluded, and reconstruction began at home. Besides taking practical steps, the British were able to draw on established reserves of national consciousness and confidence that had sprung from the very isolation that had recently left them so exposed. In spite of the recent humiliation, the nation still harboured an un-shaken belief in its own superior advantages, considering itself uniquely blessed both geographically and constitutionally; the British tended to feel a certain pity when they considered their European neighbours.

It was in the period between the American War and those with Napoleon – during Turner's boyhood and teens – that Britain began its transformation from a mainly agricultural nation into a massive manufacturing power. Considerable wealth was created and trade prospered; independent America was soon buying more from Britain than the colonies had ever done, and France too, in the intervals between her wars with Britain, was a ready buyer. The water supplies of both Paris and New York ran through cast-iron pipes from Coalbrookdale, where John Wilkinson was vigorously exploiting the manufacture of iron by means of coal fuel. Coalbrookdale epitomized the union of science, technology and entrepreneurial spirit that now laid the foundations of Britain's industrial supremacy.

EARLY WORK AND TRAVELS

Margate, and London's busy streets and crowded river were among Turner's first memories of his own country. Another was of Brentford, up river on the Thames, where he went to stay with a butcher uncle in 1785. There he attended John White's free school, and perhaps began to feel the first stirrings of a wider curiosity about his country's history and scenery. He is said to have coloured, for a friend of his uncle's, the rather feeble engraved plates in a typical topographical publication of the time, Henry Boswell's *Picturesque Views of the Antiquities of England and Wales*. Two years later he was copying other topographical subjects, including one of Michael 'Angelo' Rooker's designs for the *Oxford Almanack;* and perhaps the following year, he made copies from one of the more important works of the day devoted to English scenery, William Gilpin's *Observations on a tour in the mountains and lakes of Cumberland and Westmoreland.* Gilpin's influential writings did much to stimulate the growth of popular interest in English scenery that became even more intense in the 1790s when England was once again cut off by war.

In 1787 Turner made a drawing of Nuneham Courtenay near Oxford. Two years later he stayed again

BEDLAM FURNACE, MADELEY DALE,
SHROPSHIRE

Paul Sandby Munn, watercolour, 1803,
Tate Gallery, London. The industrial
landscape fascinated artists partly for
its symbolism of a new age.

NUNEHAM COURTENAY

J. W. M. Turner, watercolour, 1787,
Clore Gallery for the Turner Collection.
Turner may have based this view on a
print, but could already have travelled up
the Thames valley towards Oxford while
staying with his uncle at Sunningwell.

with his uncle, who had moved to Sunningwell, also near Oxford, giving Turner the opportunity to explore one of the finest of English provincial cities. Dominated by the University, Oxford had a splendid mix of ancient and new buildings, as well as what the Continental visitor C.P. Moritz described in his *Travels through Various Parts of England in 1782,* as 'one of the finest, the largest and most beautiful streets . . . in all Europe'. This was the High Street, a long sweep of spires and grand façades that Turner was to paint again, both in oil and in watercolour, responding to its beauty in both detailed treatments and abstract distillations of form and light.

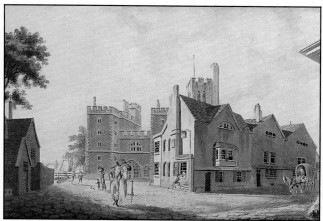

ABOVE:

WORCESTER COLLEGE, OXFORD

J. M. W. Turner, watercolour,
Ashmolean Museum, Oxford. Turner
made ten watercolours, at ten guineas each,
to illustrate the University calendar, the
'Oxford Almanack'. He delivered the final
drawings in 1804. The series shows him at
the height of his powers as an architectural
draughtsman and topographer.

LEFT:

ARCHBISHOP'S PALACE, LAMBETH

J. M. W. Turner, watercolour,
Royal Academy 1790. Indianapolis
Museum of Art. Turner's first exhibited
watercolour, this essay in London
topography evinced his early mastery of the
disciplines he had learned from Thomas
Malton.

COTE HOUSE, NEAR BRISTOL

J. M. W. Turner, watercolour, c. 1791.
Cecil Higgins Art Gallery, Bedford. The
seat of Captain Fowler, to whom Turner
was probably introduced by his Bristol host,
John Narraway.

THE AVON, NEAR WALLIS'S WALL

J. M. W. Turner, watercolour, 1791,
Clore Gallery for the Turner Collection.
One of the watercolours in his 'Bristol and
Malmesbury' sketchbook that Turner
planned to publish as 'Twelve views on the
River Avon'.

Oxford was the perfect city for a young artist who was learning the disciplines of architectural topography, and Turner's watercolours for the *Oxford Almanack,* ten of which were published between 1799 and 1811, can be seen as the climax of this phase of his work. The city's architectural splendours were more concentrated than London's and, like Cambridge, it offered a microcosm of architectural history from the sixteenth to the eighteenth centuries. Although the architecture of the capital was to be Turner's subject for his first Academy exhibit in 1790, a watercolour of *The Archbishop's Palace, Lambeth,* central London was to play strikingly little part in his art in the following years.

Lambeth was bought by a friend of Turner's father, John Narraway, a leather merchant of Bristol. In 1791 Turner went to stay with him, and used his house as the springboard for the first of a lifetime of tours – this time around Bristol and to Bath and Malmsbury. This trip introduced Turner to a rather different side of English life. Bristol was one of the largest cities outside London. Its shipping trade was somewhat in decline, but it had a varied range of trades, was still very prosperous, and had been much beautified in recent years. It supported a rich provincial society in which well-to-do merchants like the Narraways mingled with the local squirarchy.

The Narraways found Turner's silences, self-absorption and lack of social graces increasingly difficult, later banishing the self-portrait he made for them to the stairs, as John Narraway would not have 'the little rip in the drawing room'. But at first he amused more than annoyed them, and it was they who introduced him to some of the local gentry like Captain Fowler of Cote House and Lady Lippincote of Stoke House.

Turner made watercolours of both these houses, the first of a number of 'country house portraits' which were to become a staple of his art, and despite his unpolished manners he was later to find some of his most sympathetic friends among the landed gentry.

The Narraways christened Turner the 'Prince of the Rocks' from his fondness for exploring the Avon Gorge, the splendid wooded defile leading to the sea. This was perhaps the most dramatic scenery he had yet seen, inviting a developed pictorial treatment, and he was soon planning to capitalize on the vogue for engraved views by designing *Twelve Views on the River Avon,* to be engraved and published by himself.

In 1792 Turner stayed again with the Narraways before going on to South Wales. He was now making numbers of watercolours to sell, and chose his subjects with purchasers in mind – picturesque landscapes of waterfalls, cottages or the wooded landscapes of the Wye Valley, or architectural and antiquarian landmarks like Tintern or Llanthony Abbey, subjects perfectly geared to the ever-increasing market for topographical prints of British scenery.

By 1793 Britain was once again cut off by war from the rest of Europe, causing a boom in home tourism and views and guidebooks of topographical and antiquarian interest. Places became valued not only for beauty, but for their historical significance, their echoes of the past which contributed to a sense of nationhood and shared tradition.

LLANDEWI SKYRRID WITH SKYRRID MAWR

J. M. W. Turner, watercolour, 1792.
Clore Gallery for the Turner Collection.

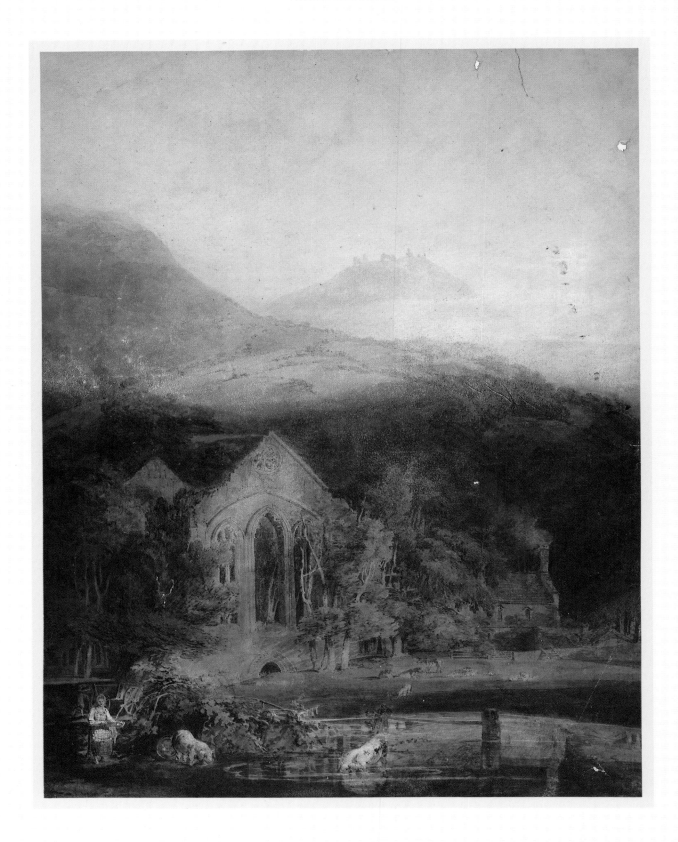

*RUINS OF VALLE CRUCIS ABBEY, WITH DINAS
BRAN BEYOND*
———

*J. M. W. Turner, watercolour, 1794-5.
Clore Gallery for the Turner Collection.*
———

In 1794 Turner made his longest tour yet, through East Anglia and the Midlands to Wales, gathering views of towns and antiquities, quite clearly with the print market in mind. Earlier that year, the first engraving after one of his drawings had been published. It was of Rochester Castle in Kent, on the way to Margate, and it appeared in one of the most popular topographical serials of the day, John Walker's *Copper-Plate Magazine*. Now he planned more views, and a number based on the 1794 tour were engraved in the next few years in Walker's publications. In 1795 he returned to South Wales, and following a commission from another engraver, John Landseer, for ten views, he visited the Isle of Wight.

GROWING PRESTIGE

Architectural antiquities were the real staple of the topographical industry. In 1793, 1795 and 1796 Turner exhibited at the Academy watercolours of such landmarks as Canterbury and Ely Cathedral, Westminster Abbey and Bath Abbey. By now, he had mastered the essential techniques and was displaying individual characteristics of his own. Private commissions were beginning to come his way, and in 1795 he received a very important one from the rich amateur Sir Richard Colt Hoare of Stourhead, Wiltshire, for a series of drawings of the Cathedral and other buildings in Salisbury, and two of Hampton Court, Herefordshire. The Salisbury drawings were to illustrate a history of modern Wiltshire that Hoare, a keen antiquary, planned to write.

This was probably the year that Turner visited Stourhead for the first time, and nothing he had seen so far would have prepared him for it. It was the first really grand house he stayed in, his first experience of an important estate and of the way of life of the landed proprietors who still held sway through much of the country. Here too all the cosmopolitanism and sophistication of the eighteenth-century Grand Tourists was carried to an exquisite extreme: in the house there were paintings by Claude, and the gardens, laid out by Colt Hoare's grandfather Henry, brought Claude to life in a series of perfect vistas around the lake.

WESTMINSTER ABBEY, ST ERASMUS AND BISHOP ISLIP'S CHAPEL

J. M. W. Turner, pencil and watercolour, Royal Academy 1796. British Museum, London. The soaring scale and bold shafts of light breaking the sepulchral shadows of the Abbey's ambulatory reveal Turner's increasingly imaginative and pictorial approach to topography. His name and date of birth appear on a slab in the foreground.

Then, as now, Stourhead was another world, and Turner must have drunk in all its echoes of a wider culture and a mythic past.

The Hoares were bankers, established in the city of London, though Colt Hoare himself, living like a nobleman and absorbed in his antiquarian pursuits, was distanced from the business that generated his wealth. So too was that far more extraordinary early patron of Turner's, William Beckford, whose intense aestheticism and implication in homosexual scandal

STOURHEAD, THE BRISTOL CROSS

J. M. W. Turner, pencil and watercolour,
c. 1797. Clore Gallery for the Turner
Collection.

FONTHILL

J. M. W. Turner, pencil and watercolour,
1799-1800. Clore Gallery for the Turner
Collection.

PROJECTS AND PATRONS

*T*urner's reputation as a topographical watercolourist was the first basis of his appeal to the patron classes. Sir Richard Colt Hoare of Stourhead commissioned him to make views of his estate and its marvellous gardens and ornaments, and continued to employ him to draw Salisbury and Hampton Court, Herefordshire, until about 1806. The Salisbury views were intended to illustrate the patron's proposed History of Modern Wiltshire. Hoare introduced Turner to the fabulously rich William Beckford, who ordered views of his 'Gothick' Fonthill Abbey while it was under construction in 1799. Beckford later commented on Turner's increasingly liberal approach to topography, complaining his views were sometimes 'too poetical, too ideal, even for Fonthill. The scenery there is certainly beautiful, but Turner took such liberties with it that he entirely destroyed the portraiture, the locality of the spot'. But Turner's early patrons were themselves influential in broadening his style, and were often generous in widening his horizons. Hoare showed him the master paintings at Stourhead in 1795, and encouraged him to paint in oil in the manner of his pictures by Wilson and Claude. Another patron, Lord Yarborough, whose Lincolnshire estate at Brocklesby Turner drew in 1797, sponsored his continental trip in 1802 and bought his Macon the following year. James Wyatt's neo-classical mausoleum at Brocklesby particularly impressed Turner.

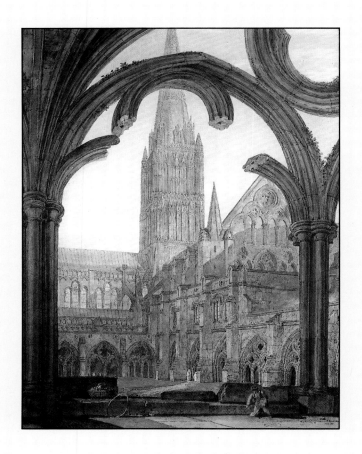

THE CLOISTERS, SALISBURY CATHEDRAL

J. M. W. Turner, pencil and watercolour.
Victoria and Albert Museum.

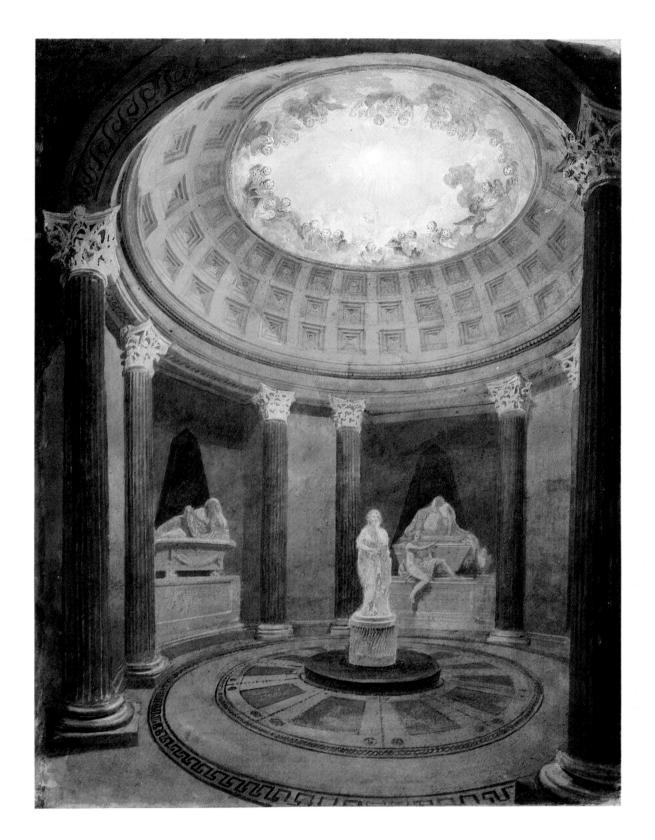

BROCKLESBY MAUSOLEUM

J. M. W. Turner, watercolour, 1818.
Clore Gallery for the Turner Collection.

kept him remote from both the fashionable world and the City enterprises and Jamaican plantations whence came his vast fortune. His 'Gothick' fantasy, Fonthill Abbey near Bath, was then nearing completion, and Turner was summoned to draw it in 1799.

Beckford's comparative loneliness ensured a welcome for the various artists who came to Fonthill during its brief heyday, but in general artists who were summoned on business to great houses were received more as skilled tradesmen than as friends. Turner had seen quite a number of these establishments by the end of the century. On his first tour of the north of England, to Yorkshire, the Northumberland coast, the valley of the Tweed and the Lake District in 1797, he stayed at Harewood in Yorkshire, making drawings for Edward Lascelles, six of which were completed by the following year. He was probably also at Lord Yarborough's seat, Brocklesby in Lincolnshire, and that autumn, he stayed with William Lock at Norbury Park in Surrey. Probably in 1799, on a tour of Lancashire and South Wales, he visited Thomas Lister Parker at Browsholme Hall near Clitheroe, and drew it for one of the plates in the Rev. Robert Dunham Whitaker's *History of the Parish of Whalley*. Turner's talents were now widely recognized among the patrician classes, but he had yet to develop the kind of intimate friendships with his patrons that he was to enjoy with Walter Fawkes at Farnley or Lord Egremont at Petworth.

TOWARDS PURE LANDSCAPE

Turner's reputation as an architectural topographer had formed the basis of most of these excursions and commissions, but his work of those years shows an increasing interest in pure landscape, and even his architectural subjects had begun to take on a more pronounced landscape quality. His 1797 tour had taken him to the Tweed Valley, and to the Lake District – already well established as England's answer to the beauties of Italy. Until at least the 1830s he would refer back to his sketchbooks of this year for subjects for watercolours, while Norham Castle, of which a watercolour was shown at the Academy in 1799, was

to be one of the recurrent themes of his art, reappearing through a prismatic filter of mist in an oil of the late 1830s.

It was however in North Wales in 1798, that he really began to exploit the breadth of handling and sensitivity to mood and atmosphere that his drawings had already begun to display. Confronted by the wild and mountainous scenery, he responded in some large experimental colour studies that were scarcely to be excelled in expressive power. The following year he made yet more, even more remarkable for their bold expression of geological texture and dramatic effects of light.

Turner's attitude to Wales, as to many of the places at home and abroad that he assimilated into his art, was highly coloured by the past. It was as though the very emptiness of the Welsh scenery left a vacuum for the imagination to fill from historical association. Apart from Richard Wilson (see Chapter 2), there were few pictorial precedents to consider, for unlike the Lake District, Wales had not then been established as a region that perfectly expressed an aspect of contemporary taste.

It was Turner's generation which put Wales on the map as a landscape that epitomized the 'Sublime', and their guides were literary and historical – Thomas Gray's well-known ode, *The Bard* (1757) and two sagas of ancient Wales, *The Triumphs of Owen* and *The Death of Moel,* both dealing with a heroic age of Welsh nationalism; and the *Tours in Wales* published by the antiquary, Thomas Pennant, in 1773, with topographical illustrations after Moses Griffith.

Inspired by the vivid historical images conjured up by Gray, by Pennant's more factual narrative, and by Wilson's classical and historical landscapes, Turner projected past history into his Welsh drawings, and planned some large exhibition watercolours on the subject of the extermination of the Bards of Wales by Edward I of England. The theme was apposite at a time when Napoleon was overrunning Continental Europe – his army had invaded Switzerland in 1798 – and threatening England. Whatever Turner's political views, it is hard to believe that he did not consider the contemporary relevance of his chosen historical

DOLBADERN CASTLE

J. M. W. Turner, pencil and watercolour,
c. 1797-8. Clore Gallery for the Turner
Collection.

themes. Most of these large watercolours were never finished, but Turner's diploma picture for the Academy, *Dolbadern Castle,* a consummate statement of the Sublime, was shown in 1800 with lines of poetry evoking the notion of Liberty that so exercised the minds of the Romantics.

A COUNTRY OF CONTRASTS

Turner's lines had begun 'How awful is the silence of the waste', and apart from the wild splendours of its scenery, his main impression of North Wales may well have been of its remoteness and the timeless quality of life away from the major cities. Exploring

CAERNARVON CASTLE

J. M. W. Turner, watercolour,
1799-1800. Clore Gallery for the
Turner Collection.

WALES, 1798–1800

*T*urner's first sight of the mountains of North Wales in *1798 was a revelation, as striking as his experience of the Alps in 1802. The dramatic and lonely scenery called forth a wholly new approach and demanded a new sense of scale. Besides pencil studies, he made large watercolours back in London, experimenting with new combinations of media and a broad, expressive handling, and striving for pictorial structures in the grand manner, thus departing from the conventions of topographical drawing. In 1799 he pursued these concerns still further, sometimes working with colours on large sheets of paper in the open air before elaborating his designs to achieve expressive power as yet unmatched in his work. He was also meditating on themes from Welsh history. Of a projected group*

of exhibition watercolours on the theme of extermination of the bards of Wales by Edward I of England, Caernarvon was the only one to be completed. It was shown at the Academy in 1800 with poetry perhaps by Turner himself, describing a bard's lament as the invading army approaches:

> *And now on Arvon's haughty tow'rs*
> *The Bard the song of pity pours*
> *For oft on Mona's distant hills he sighs,*
> *Where jealous of the minstrel band,*
> *The tyrant drench'd with blood the land,*
> *And charm'd with horror, triumph'd in their cries,*
> *The swains of Arvon round him throng,*
> *And join the sorrows of his song.*

106

on the pony he had borrowed from Mr Narraway, he must have felt himself entering a different age. The majority of people in the British Isles then lived lives bounded by their own communities. To such people, war would have seemed very remote, but it was already proving a vast engine of change within Britain.

Civil liberties were curtailed, bad harvests had raised bread prices and caused a serious shortage, and taxation had climbed – as a barber, Turner's father must have felt the effects of new taxes on shops and hair powder. The mood of the country was nervous and uneasy, but with the hardships and restrictions ran a parallel trend of improvement and development – and of patriotism. Volunteer groups were flourishing, and patriotic pamphlets and popular entertainments matched seditious ones. Trade and commerce had been maintained despite hostilities, and the navy, which continued to increase substantially throughout the war, was remarkably successful in keeping the sea lanes open to the merchant marine – Napoleon's soldiers wore British greatcoats and shoes, and even such luxuries as old master paintings continued to flow into British ports.

At home communications were improving, aided by road and canal building, and the war gave a boost to the new industries. South Wales, geographically close but in other ways a world away from the solitude of Turner's mountain scenery, was the home of the three largest iron works in the kingdom. In 1798 Turner visited Richard Crawshay's Cyfarthfa works, and made a series of detailed pencil drawings in connection with a commission from the iron-master Antony Bacon. It was perhaps on this trip that he made a study of a tilt-forge, of the kind then used for iron-welding and, probably on his northern tour of 1797, he had made a watercolour of a foundry. Indus-

IRON FOUNDRY

J. M. W. Turner, watercolour, c.1797.
Clore Gallery for the Turner Collection.

INTERIOR OF A FORGE

*J. M. W. Turner, watercolour, 1796-7,
from the 'Wilson' sketchbook. Clore
Gallery for the Turner Collection.*

INTERIOR OF A FORGE

J. M. W. Turner, watercolour,
1796-7, from the 'Wilson' sketchbook.
Clore Gallery for the Turner Collection.

trial activity had already appeared in the paintings of artists like Joseph Wright of Derby. Turner was equally alive to both the pictorial potential of furnaces and machinery and to their significance for his own time.

The human element in landscape never ceased to fascinate him and it was central to the way he constructed his art. As he travelled around Britain in the 1790s, the characteristic activities of its people took their place in his drawings, not as decorative accessories but as necessary components, lending an informative, descriptive dimension even to antiquarian topography.

Probably at Margate, around 1796, he had made a group of watercolours of fishermen that defined aspects of their work with remarkable precision; at Llanstephen in 1795 he had drawn stokers firing a kiln; and in his 'Wilson' sketchbook alongside interpretations of Wilson's ideal landscapes, he had made some delightful studies of people at work. When he first went to Scotland, in 1801, he kept a sketchbook expressly for figure studies, as he did again in Switzerland the following year.

Farington, who had already been to Scotland, had found it a better country for the artist than Wales, and the trip was extremely productive. Though it did not inspire any large watercolours of quite the dramatic breadth of the Welsh subjects of 1798-9, it did spur Turner to a more subtly expressive approach and to new technical developments, both in pencil and pure watercolour. The sketchbooks from the Scottish trip show a new freedom and rapidity of touch, marking Turner's final emancipation from the topographical approach of his early years.

But he was also responding anew to the gentler landscape of Southern England. Earlier, in 1798, he

EDINBURGH FROM CAULTON HILL

J. M. W. Turner, watercolour,
Royal Academy 1804. Clore
Gallery for the Turner Collection.

SCOTLAND, 1801

*I*n Scotland in 1801 Turner continued the process of liberation
from topographical convention that had been so dramatically
apparent in his recent work in Wales. He was now deliberately
categorizing his responses, separating sketches of characteristic
local figures, composition studies and renderings of particular
places into different sketchbooks. He was continuing to develop
new technical solutions. From this tour derives a set of distinctive,
large pencil drawings, finished in some detail; similar drawings,
though smaller, were made during or after his continental tour
in 1802, but this type of drawing was not to be repeated. The
large panorama of Edinburgh, with its Claudean lighting and
wealth of human interest, was finished for exhibition at the
Academy in 1804.

ABOVE
INVERARY

*J. M. W. Turner, pencil, 1801. Clore
Gallery for the Turner Collection.*

LEFT
THREE SCOTSMEN IN TARTAN

*ABOVE: J. M. W. Turner, watercolour
1801, from the 'Scotch Figures' sketchbook.
Clore Gallery for the Turner Collection.*

had enjoyed exploring the Medway valley with the Rev Robert Nixon of Foots Cray, Dr Monro had a cottage in Surrey and another friend, the water-colourist William Frederick Wells, had one in Kent. From visits to Wells in 1799 and 1800 sprang a series of bold and brilliantly coloured oil sketches, quite probably done out of doors, of the dense beech-woods at Chevening and Knockholt. These woods still re-main, and the bold dappled yellow light so vividly captured by Turner is hardly an exaggeration when the trees are in their autumn beauty.

THE THAMES

The period up to 1802 had seen Turner's most inten-sive exploration of his own country, but in the years immediately following the resumption of war after the Treaty of Amiens was abandoned, he was less active on this front. His ambitions were now concen-trated within the Royal Academy, and in 1803 and 1804 on constructing and exhibiting in his own gallery,

and his work confined him to London.

Such explorations as he did make were within the London area, and especially in the Thames valley for which he retained particular affection since his early days in Brentford and Oxford. Now able to consider a country retreat, he rented in 1804 or 1805 Sion Ferry House at Isleworth, and between 1806 and 1817 he kept a house near his old friend de Loutherbourg in Hammersmith. Also, in 1807, he bought a plot at Twickenham, planning to build a house near Rey-nolds's at Richmond, 'that he might live in sight of Sir Joshua's house upon the hill'.

The Thames, from Windsor to the mouth of the estuary, now became a special focus of his attention, and not only because it lay conveniently to hand. Britain's greatest river, whose upper shores had been home to poets like Thomson and Pope and painters like Hogarth and Reynolds, and whose estuary, where it met the Medway at the Nore, was the nation's largest naval base and a crucial line of defence for the capital, was a fit subject in time of war. The massive concentration of Thames subjects in Turner's art be-tween 1805, when he showed a view of Windsor Castle at his gallery, and 1810, was as much an appeal to patriotism as a display of his gifts as landscape and marine painter.

A series of oils, mostly exhibited in his gallery, were centred on the Nore, and showed fishing boats or merchantmen juxtaposed with the reassuring pres-ence of the navy, now confirmed in its supremacy after the Battle of Trafalgar in 1805. The Thames poets were acknowledged, in *Pope's Villa* and the classical *Thomson's Aeolian Harp,* for both of which Turner had written some poetic reflections of his own, and focal points of national consciousness such as Windsor, Eton and Greenwich were also repre-sented, the last carrying with it some further lines, expressing his somewhat ambiguous commentary on the London of his day.

Over nearly all of the upper Thames subjects, Turner cast a hazy, golden light borrowed from Cuyp or Claude that renders them serene and timeless – and thus as it were safe from conquest. His sketchbooks of the time show that he was meditating the apothe-

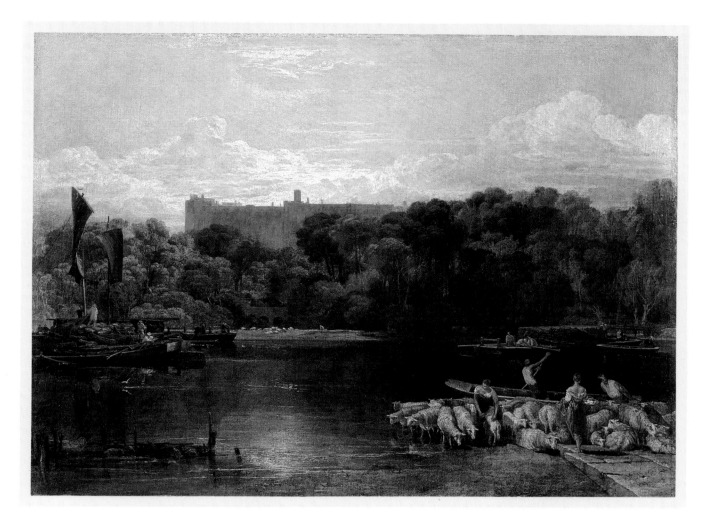

WINDSOR CASTLE FROM THE THAMES

*J. M. W. Turner, oil, c. 1805. The
National Trust/Tate Gallery, Petworth
House. Bought by Lord Egremont having
probably been exhibited at Turner's
Gallery in 1805, this dignified and elegaic
composition was based on a drawing in
Turner's Studies for Pictures, Isleworth
sketchbook. Its horizontal design and dry
paint was intended to evoke Poussin. It was
one of a series of Thames subjects exhibited
in this decade.*

osis of the rustic Thames into the more exalted realms of antiquity and mythology inspired by Claude and Poussin. But he also loved the river for itself, and not much later than these grandiose imaginings, made a series of oil sketches and watercolour studies, sometimes from a boat on the Thames or the Wey, that match their high aspiration with a vivid naturalism.

In 1819 Turner exhibited his consummate statement of his patriotic and personal feelings for the Thames in *England: Richmond Hill, on the Prince Regent's Birthday*. The view is the one Reynolds would have seen from his Richmond house and, treated as a Claudean panorama, it stands for all that Turner saw as best and brightest in his own country.

POETS OF THE THAMES

*T*urner's love of the Thames valley was deepened by its
associations with the past. His own ambitions as a poet
naturally inclined him to the two great poets of 'Augustan'
Britain, Alexander Pope and James Thomson, and in 1808
and 1809 he showed at his Gallery pictures intended to keep
their reputation alive. Distressed by the demolition of Pope's
house at Twickenham in 1807, Turner drafted a poem lamenting
the loss of a national monument. It was not published to accompany
the picture, but Thomson's Aeolian Harp *was exhibited*
with lines To a gentleman at Putney, requesting him to
place one in his grounds. *An Aeolian Harp, a musical*
instrument that produces sound when the wind blows through
its strings, was a symbol of lyric poetry and especially of the
poetry of landscape, as Turner's verses proclaim:

> Th'Aeolian harp, attun'd to nature's strains,
>
> Melliferous greeting every air that roves
>
> From Thames' broad bosom or her verdant plains...

Thomson's Seasons, *the quintessential landscape poem of the*
eighteenth century and a constant source of inspiration for
Turner, is acknowledged in the closing lines of Turner's poem.
His picture, for all its Claudean nobility of composition, is
also profoundly naturalistic in its rendering of the Thames.
Turner has brought together old masters of painting and poetry
in a work that reconciles nature and the ideal.

ABOVE:

THOMSON'S AEOLIAN HARP

*J. M. W. Turner, oil, exhibited
1809. Manchester City Art Galleries.*

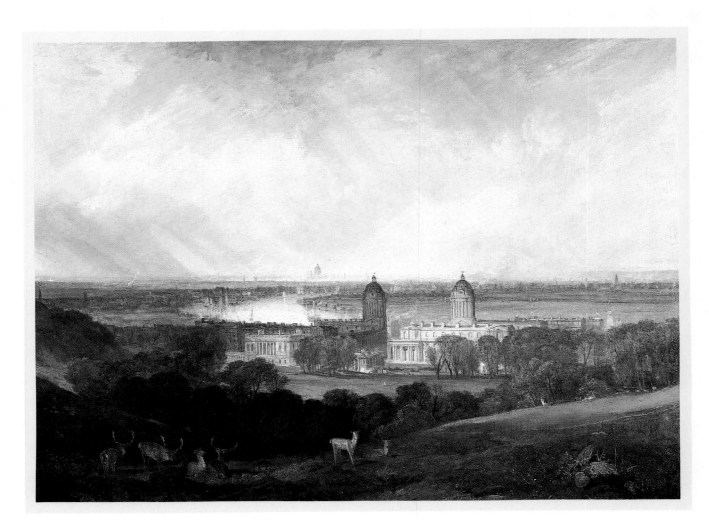

ABOVE:

LONDON

J. M. W. Turner, oil, exhibited
1809. Clore Gallery for the Turner
Collection. This painting was exhibited in
Turner's Gallery with lines of his own
poetry.

RIGHT:

THE 'VICTORY' RETURNING FROM
TRAFALGAR

J. M. W. Turner, oil, exhibited
1806. Yale Center for British Art, New
Haven. Probably shown at Turner's
Gallery, the picture was bought by Walter
Fawkes. Turner went to draw the Victory
as she entered the Medway but has
transposed the scene to the Isle of Wight, off
the Needles.

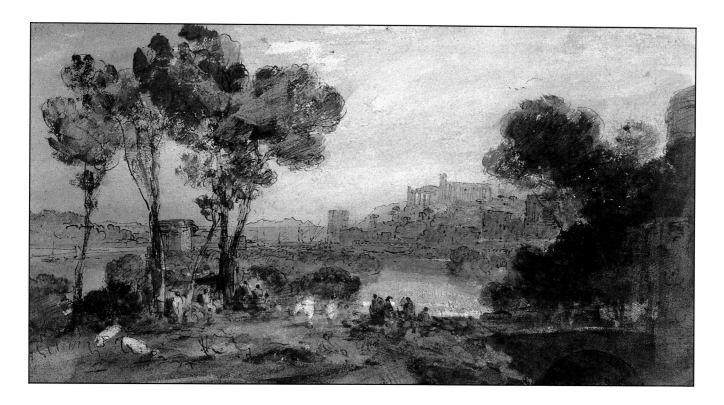

The same year, he rendered the view from his old Isleworth house in a plate for the 'Elevated Pastoral' category of his *Liber Studiorum,* the series of characteristic landscape types which he had begun to design in 1806 while staying with his friend Wells.

FURTHER TRAVELS, AGRICULTURE AND THE GREAT ESTATES

In the summer of 1807, Turner went to Spithead to witness the arrival of two Danish ships taken at the Battle of Copenhagen. A painting of this cause for patriotic celebration was shown at his gallery the following year, while at the Academy he exhibited *The Battle of Trafalgar,* for which he had assembled detailed information two years earlier, when Nelson's flagship *Victory* brought the dead admiral back to Sheerness in December. Also in 1807 and 1808, he resumed his wider travels around the country, visiting several of his patrons on their country estates, and probably returning to North Wales.

It was probably on a visit in the summer of 1807 to Cassiobury Park, Lord Essex's estate in Hertfordshire, that he began to consider the theme of the harvest. In 1809 he worked this up into *Harvest Home,* for which

DIDO AND AENEAS

J. M. W. Turner, watercolour and bodycolour, 1804-5, from the Studies for Pictures; Isleworth sketchbook. Clore Gallery for the Turner Collection. This sketchbook contains various juxtapositions of classical scenes and Claudean compositions, and more literal views of the Thames. Turner can be seen transforming nature into the stuff of art.

another painting of reaping, was doubtless intended as the companion piece. He had been showing a keen interest in ploughing methods in his Thames valley sketchbooks, and also in 1809 he even titled a painting of Windsor Castle *Ploughing up turnips near Slough.* Agricultural themes were also incorporated into his designs for the 'Pastoral' category of the *Liber Studiorum.*

These themes were in part an expression of the fashionable interest in the rustic picturesque and in the kind of popular genre inspired by Wilkie. But Turner may also have recognized a need for public reassurance as a time of acute food shortages caused

by bad harvests and rising prices. The hardships felt by the poor were in sharp contrast to the prosperity – albeit somewhat illusory – of the great estates whose supplies of wheat were in ever-increasing demand. In 1809, the year of *Harvest Home,* and again the following year, the harvests were bad.

To raise income and meet demand, landowners and farmers were frantically improving their land, and Louis Simond, travelling through England in 1810, noted that every gentleman's conversation was dominated by turnips, clover, enclosure and drains. Another topic much in the minds of the landowners was timber; the wood-cutting scenes in the *Liber Studiorum* probably reflect the desperate search for shipbuilding timber as imports from the Baltic dwindled – one ship of the line took 4000 grown trees.

Such matters must have been frequently discussed at Tabley in Cheshire, where Turner stayed in 1807 with his patron Sir John Leicester, and at Farnley, in Wharfedale near Leeds, which he visited for the first time this year. This was the home of Walter Fawkes, Turner's greatest patron – by the time he died he owned six of Turner's oils and over 250 watercolours. Fawkes, who had recently sat as Whig MP for the county of York, was an enlightened landowner, keen on agricultural improvement, as well as a talented historian, political commentator and naturalist. He was to remain Turner's friend, host and supporter for the rest of his life, and the Farnley estate became the subject of many splendid drawings.

Politics aside, Fawkes had much in common with Turner's other great patron, Lord Egremont, with whom the artist probably stayed for the first time in 1809. Besides being a munificent patron of the arts, he was also an innovative landowner and farmer, and his estate was as much a 'college of agriculture' as his house was a 'nursery of art'. Stimulated by his friend, the agricultural reformer Arthur Young, Egremont had become a member of the Board of Agriculture, and had been offered its Presidency in 1798.

He improved his land by enclosing, reclaiming and replanting it, was one of the first Sussex landowners to introduce a threshing machine and a light Suffolk plough, and took an active financial interest in canal development. In many parts of the country, enclosure

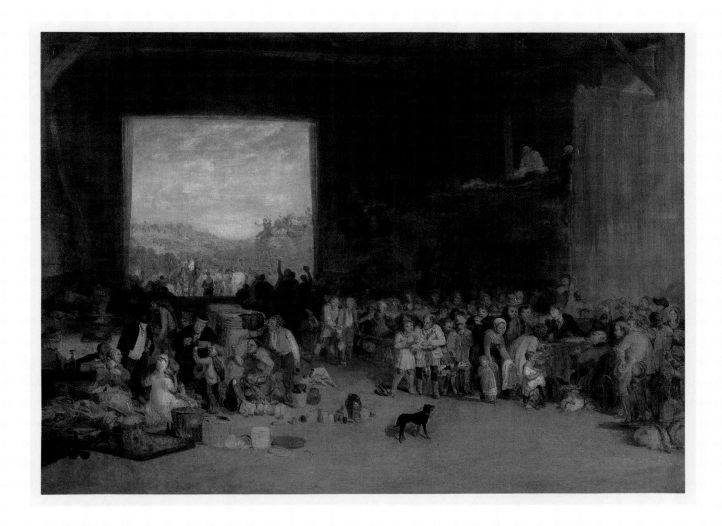

HARVEST HOME

*J. M. W. Turner, oil, c. 1809. Clore
Gallery for the Turner Collection. An
unfinished picture of a harvest feast, based
on drawings in Turner's 'Harvest Home'
sketchbook. This was probably the work
described by Lady Eastlake, after a visit to
Turner's studio in 1846, as 'in Wilkie's
line'. Besides Wilkie's influence, it displays
Turner's own sympathetic concern for
working people and his awareness of the
importance of the harvest in maintaining
food supplies in wartime.*

*ENGLAND, RICHMOND HILL, ON THE PRINCE
REGENT'S BIRTHDAY*

J. M. W. Turner, oil, Royal Academy
1819. Clore Gallery for the Turner
Collection.

THE ALCOVE, ISLEWORTH

J. M. W. Turner, drawing, c. 1815, pen,
ink and wash. Clore Gallery for the Turner
Collection.

TURNER'S THAMES

*T*urner had first explored the Thames west of London when a boy, staying with his uncle at Brentford or Sunningwell. The stretch of river around Richmond and Twickenham came to have the deepest meaning for him, and for a period he lived nearby, first at Sion Ferry House, Isleworth, and then at the cottage he built for himself, Sandycombe Lodge, Twickenham. Besides its poetic associations, this section of the river had been overlooked by Reynolds from his house on Richmond Hill. Turner's large painting exhibited in 1819

depicted Reynolds's view, and added patriotic festivities arranged with all the elegance of one of Reynolds's favourite painters, Watteau. Turner showed the picture with lines from Thomson's Seasons alluding to the Thames. Turner's own view of the Thames from his Isleworth house was included among his designs for the 'Liber Studiorum'; Sion Ferry House would be behind the trees on the right of this composition. The Ionic temple, which still stands, is a shooting lodge built by Robert Mylne for the second Duke of Northumberland.

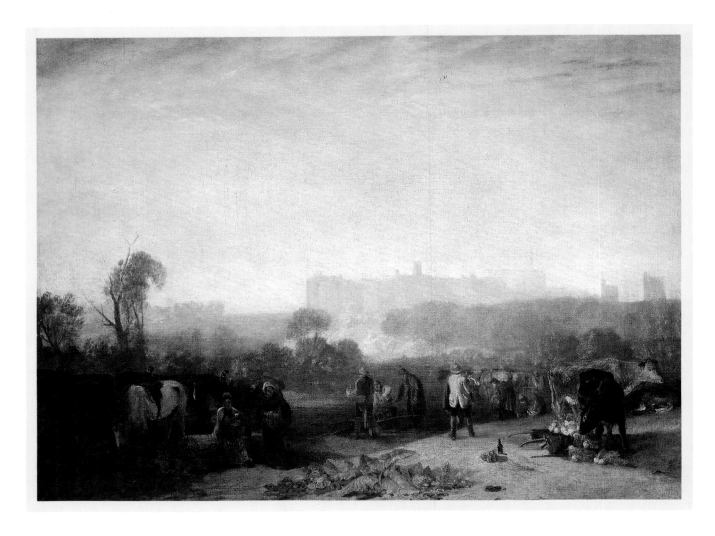

ABOVE:

PLOUGHING UP TURNIPS NEAR SLOUGH

*J. M. W. Turner, oil, exhibited
1809. Clore Gallery for the Turner
Collection. Exhibited in Turner's Gallery
with this documentary title rather than the
more general reference to Windsor Castle
that might have been expected, the picture
strikingly illustrates Turner's ability to
reconcile topical agricultural concerns and
everyday experiences with subtle
atmospheric effects drawn from Cuyp or
Claude.*

RIGHT:

PORTRAIT OF GEORGE O'BRIEN WYNDHAM,
THIRD EARL OF EGREMONT

*Thomas Phillips, oil. The
National Trust/Tate Gallery, Petworth
House. Turner's patron, friend and frequent
host is portrayed in his gallery at Petworth.
Besides his artistic interests, Egremont was
an enthusiastic and innovatory
agriculturalist who raised his land to
exceptional levels of productivity.*

PETWORTH, DEWY MORNING

ABOVE: *J. M. W. Turner, oil, Royal
Academy, 1810. The National Trust/Tate
Gallery, Petworth House. Based on a
sketch in a sketchbook used in 1809, this
'country house portrait' is presented
essentially as a pure landscape, in which, as
one critic wrote, 'the water is pre-
eminent...In clearness and brilliancy, we
have never seen it excelled'*

had impoverished the old land-labourers while en-
riching the great landowners, but Lord Egremont
never failed to offset this imbalance by philanthropy,
and by raising other crops like potatoes and rice when
bread prices rose. He laid on feasts for tenantry and
poor, supplied his district with a surgeon, a midwife,
a water supply and a gas works, and contributed to
the construction of the local hospitals. Turner was to

TURNER AND FARNLEY HALL

Turner had known the Yorkshire landowner Walter Fawkes since about the turn of the century. In Fawkes he found a friend who recognized his genius and could accept the outward man, sometimes awkward and inarticulate, on his own terms. Fawkes, moreover, matched what Constable called Turner's 'wonderful range of mind'. A responsible proprietor and reforming agriculturalist, he had wide literary and historical interests, compiling a Chronological History of Modern Europe; he campaigned for the abolition of slavery and for parliamentary reform, earning himself a reputation as a radical; he worshipped the memory of his ancestor, the Parliamentarian General Fairfax, preserving the relics of him at his house, Farnley Hall in Wharfedale, near Leeds. Fawkes collected Turner's work from 1803; in 1819 he exhibited his already substantial collection of Turner watercolours in his London house in Grosvenor Place, dedicating the catalogue to Turner 'first as an act of duty, and secondly as an Offering of Friendship; for, be assured, I can never look at it without intensely feeling the delight I have experienced during the greater part of my life from the exertion of your talent, and the pleasure of your society'. The collection included many continental subjects, but at Farnley, where Turner first stayed in 1808 and returned often afterwards, entering enthusiastically into the life of a country estate, he made the views known as the 'Wharfedales' recorded his host's Fairfax relics, and designs based on landmarks in British parliamentary democracy. Fawkes's greatest work by Turner was the Dort, seen hanging in the drawing room in Turner's watercolour. This elegant room formed part of the additions made by Carr of York to the house.

ABOVE LEFT:

FARNLEY HALL: THE DRAWING ROOM

J. M. W. Turner, watercolour, 1818. Private Collection.

ABOVE RIGHT:

FARNLEY HALL: THE 'NEW HOUSE' FROM THE EAST

J. M. W. Turner, watercolour, c. 1816. Private Collection.

RIGHT:

PORTRAIT OF WALTER FAWKES

Anon. British School, pastel, c. 1815. Private Collection.

ABOVE:

BOSCASTLE, CORNWALL

─────────

J. M. W. Turner, pencil and
watercolour, c. 1824. Ashmolean Museum,
Oxford.

RIGHT:

HYTHE, KENT

─────────

J. M. W. Turner, watercolour, 1824.
Guildhall Art Gallery, London.

─────────

THE 'SOUTHERN COAST'

Picturesque Views of the Southern Coast of England *was the first of a series of large projects for engravings on which Turner worked until the late 1830s. It was initiated by the engraver, publisher and printseller W.B. Cooke, who envisaged it as part of a larger scheme depicting the entire coast of the nation. Eighty views were engraved and published in sixteen parts, 1814 – 1826. Turner originally contracted to provide 24 drawings at £7.10 each, but as the superb quality of his designs became evident, his fee and proportion of the work – for which Cooke also employed other distinguished artists – rose. Cooke and his brother George, who had intended to engrave all the views themselves, were obliged to use other engravers to maintain publication schedules; through this and subsequent projects, a new school of engravers developed whose*

superlative skill was fostered by Turner's own punctilious supervision of the translation of his designs. The resultant prints were truly original works of art, not mere reproductions. Sadly, this and other large engraving projects ended in acrimony and financial failure, due partly to the volatile economic climate of the period but also to the Cookes' over ambitious approach. By the mid 1820s Turner had quarelled with them over payment and contacts ceased in 1827. Turner made several tours for Southern Coast, to the west country in 1811 and 1813, and to Kent and Sussex several years later. Throughout his forty watercolours for the series, he sought to develop and maintain a comprehensive view of the state of the country's coastal frontier, recording not only its scenic qualities but its defences, industries and activities.

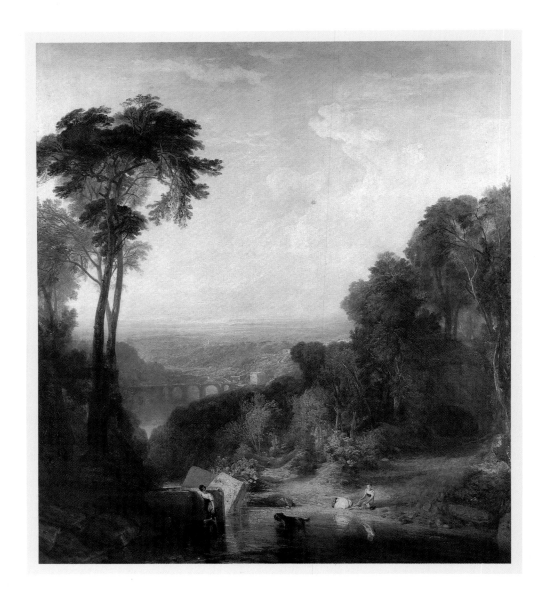

CROSSING THE BROOK

*J. M. W. Turner, oil, Royal Academy
1815. Clore Gallery for the Turner
Collection. As Richard Wilson had done
before him, Turner has recast an English
scene – the valley of the Tamar that he had
explored in the summer of 1813 – in
strikingly Claudian terms. Sir George
Beaumont considered the picture 'weak and
like the work of an old man, one who had
no longer saw or felt colour properly; it was
all of pea-green insipidity.'*

see at Petworth, not only great art but a microcosm of the improvements being enacted around the country.

In 1809, Turner visited Egremont's Cumberland estate, Cockermouth Castle and assembled material for two views of Lowther Castle, commissioned by the Earl of Lonsdale. Country house portraits remained a staple; his pictures of Tabley had been shown at the Academy in 1809, and the Lowther pair appeared the following year with *Petworth, Dewy Morning,* while *Cockermouth Castle* was show in Turner's Gallery. Probably in the same year, Turner visited Sussex land-owner, 'Jack' Fuller at Rosehill Park, Brightling, to begin work on a picture of the estate, and a picture of Major W.E. Woodgate's Somer Hill in Kent appeared at the Academy in 1810.

*THE PLYM ESTUARY FROM BORINGDON
PARK*

*J. M. W. Turner, oil, c. 1813. Clore
Gallery for the Turner Collection. One of a
group of brilliant oil sketches made from
nature in Devon in 1813. Turner observes
the abundant harvest that summer.*

BRITAIN ENGRAVED

It was possibly Fuller who commissioned the series of watercolours of West Sussex which were later engraved as *Views in Sussex.* Projects for engraving were again coming to the fore. In 1810 Turner had painted a view of the High Street, Oxford, for an engraving to be published by the Oxford framemaker James Wyatt, and a year later he was commissioned by W.B. and George Cooke for a series of *Picturesque Views on the Southern Coast of England.*

This was the first of the large schemes for engravings that dominated Turner's middle years, and from the first he regarded it as much more than just a series of views. Inspired both by wartime patriotism and by his own wide-ranging interests, he embarked on a marvellous series of watercolours, technically brilliant and richly layered with imagery, that provide an extraordinarily complete commentary on the maritime England of the day. The project, the first four parts of which appeared in 1814, was extensively researched from guides and gazeteers as well as his own

direct observation, and he drafted a long poem to amplify the meaning of the coastal subjects.

The material gathered on his drawing tours for *Southern Coast* also formed the basis for paintings, and it was on a Devon tour for the scheme in 1813 that he found the subject of his great upright landscape *Crossing the Brook,* a painting that transposes English scenery into a vista reminiscent of the Roman Campagna and the paintings of Claude. He also produced some wonderful open-air oil sketches of the rich summer landscape around Plymouth.

Turner's Devon sketches depict a lavish harvest. So it was in 1813, but this was a mixed blessing for farmers and landowners. Prices that had risen during times of shortage, as in 1809, now fell dramatically, causing the ruin of many yeoman farmers and the failure of country banks. Privation had similarly followed plenty in other areas of the economy in 1810 and 1811, when the freak boom created by the new markets opened up in Spain, Portugal and Latin America, to circumvent Napoleon's ships collapsed. Prices tumbled, bankruptcies were commonplace and there were demonstrations in the new industrial cities as hardship increased; in Birmingham, 9000 people were on poor relief in the summer of 1811. The year in which Turner began working towards *Southern Coast,* and assessing a crucial maritime frontier, was also the war's single most testing year for the British economy, when times were hardest in the cities.

The nation recovered from these crises. Trade revived, and it had also been in 1811 that Napoleon hopelessly overstretched himself by his invasion of Russia. A new alliance of Russia, Prussia and Austria and Britain now proved decisive, and Napoleon was finally defeated at Waterloo in June, 1815.

Understandably, peace in Europe redirected Turner's attention to the Continent. In the spring and summer of 1815, either by prior intent or happy coincidence, his exhibits at the Academy included a group of Continental subjects, the three Swiss watercolours for Fawkes's collection, one of which, *The Battle of Fort Rock,* alluded to the French invasion of Switzerland in 1796.

Several commissions, however, now recalled his

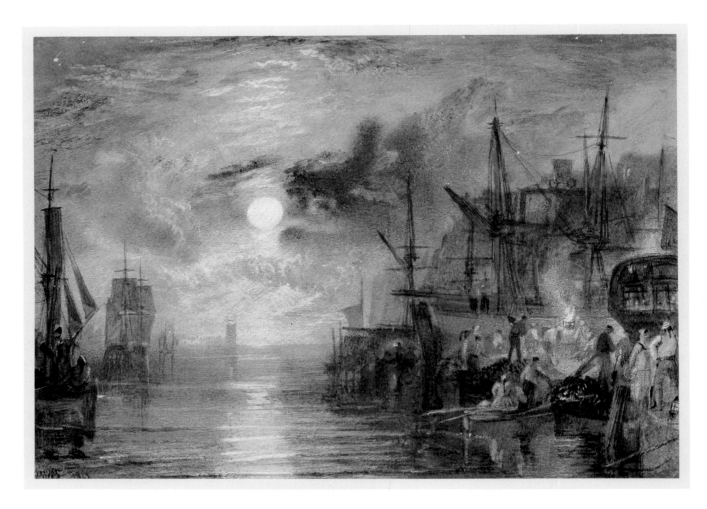

ABOVE:

SHIELDS ON THE RIVER TYNE

J. M. W. Turner, watercolour,
1823. Clore Gallery for the Turner
Collection. This night scene of Tyneside
coal-heavers was made for engraving, in
mezzotint on steel, in the Cookes' 'Rivers
of England' series. The series appeared
between 1823 and 1825. The deep shadows
and contrasted lighting in Turner's
watercolour show his appreciation of the
tonal potential of the mezzotint medium.

LEFT:

MARGATE

J. M. W. Turner, watercolour.
Ashmolean Museum, Oxford.

attention to British scenery and antiquity. In addition to the *Views in Sussex,* thirteen of which were probably finished in 1816 and six published between 1816 and 1820, Turner began, probably in 1815, to make for Fawkes a series of drawings of the relics of Fawkes's ancestor General Fairfax, designs illustrating the history of Parliament, and views of Farnley and its neighbourhood, which the patron called 'the Wharfedales'.

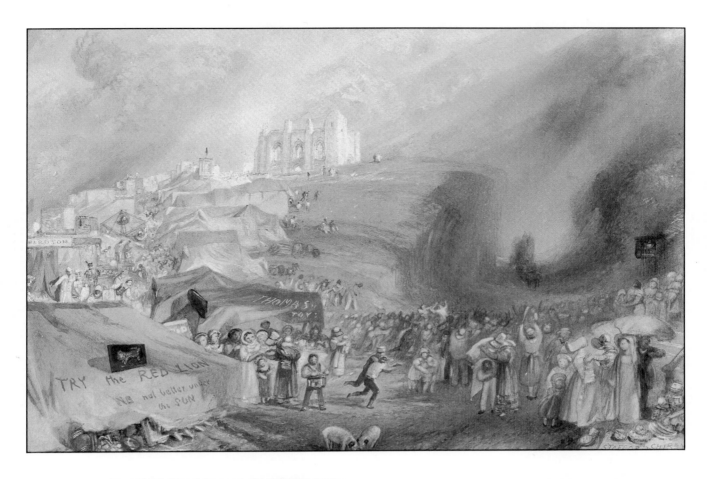

TOP:

ST. CATHERINE'S HILL, GUILDFORD, SURREY

J. M. W. Turner, watercolour,
c. 1830. Yale Center for British Art, New
Haven.

ABOVE:

COVENTRY, WARWICKSHIRE

J. M. W. Turner, watercolour,
c. 1832. British Museum, London.

PICTURESQUE VIEWS IN ENGLAND AND WALES

*T*urner's most complete visual record of his country and its people, and a fitting climax to a lifetime's accumulation of topographical observation, technical skill and interpretative power, was this great series on which he worked for ten years from 1826. 96 plates were published, engraved on copper, before the series, like most of the large engraving projects of these years, was abandoned unfinished. The project had been initiated by Charles Heath, underwritten by capital from co-publishers, Messrs. Hurst & Robinson. After their bankruptcy in 1826, a series of publishers assumed responsibility for it but none could make it pay, and in 1838, Messrs. Longmans terminated the publication. Meanwhile, both Turner's water-colours and the prints produced from them had won immediate recognition as masterpieces of inspired observation and graphic technique. Turner's vision had progressed far from the descriptive topography of his youth. His watercolours now deployed their medium with great breadth or with the minute precision of a jeweller, combining powerful atmospheric effects with intricate detail. Through all of them ran the linking theme of his concern for the relationship between humanity and its landscape.

RIGHT:

GEORGE IV AT THE PROVOST'S BANQUET,
EDINBURGH

J. M. W. Turner, oil, 1822. Clore Gallery
for the Turner Collection. One of the oils
Turner began to record the ceremonial
surrounding George IV's visit in 1822.

ABOVE:

LEEDS

J. M. W. Turner, watercolour, 1816. Yale
Center for British Art, New Haven.
Turner's many visits to Farnley between
1808 and 1824 gave him the opportunity to
study Yorkshire and other northern
counties. This watercolour of the rapidly
expanding industrial city of Leeds was made
to illustrate a history of the city.

In 1816, another commission, from Dr Whitaker for 120 drawings for a *History of Yorkshire,* took him to the north of England. A section on Leeds and its neighbourhood was published late that year with three designs after Turner. One of these was an impressive panorama of this burgeoning industrial city rich with human interest, anticipating the breadth of vision Turner was later to bring to his *Picturesque Views of England and Wales.* Lord Darlington now commissioned a view of Raby Castle, and Turner was also asked to produce some drawings for Robert Surtees's *History of Durham.*

The Raby picture was ready for the Academy in 1818, and that October, Turner travelled further afield, again to serve an author and engraver, having been commissioned to illustrate Walter Scott's antiquarian work, *Provincial Antiquities of Scotland.* This was published in 1826, and already by 1821 Turner had completed ten designs for plates and two vignettes. Scott bought the original drawings and hung them in the breakfast room of his house at Abbotsford.

Although their initial meeting in 1818 was not a success, it was Scott who turned Turner's interest back to Scotland. In 1822 Scott stage-managed the ceremonial arrangements for George IV's state visit to Edinburgh – one of a series of visits to the dominions to win over his subjects after the characteristically lavish coronation in London in 1821. The pictorial possibilities of this event attracted a host of artists to Edinburgh, among them Turner, who used up two sketchbooks on the festivities and began four pictures of them.

While sailing up the east coast to Edinburgh, Turner had been able to gather material for another two engraving projects launched by W.B. Cooke: *Rivers of England* and *Ports of England.* The *Rivers* was never published on the intended scale: between 1823 and 1827 only twelve of Turner's designs appeared, while of the *Ports,* only six of the twelve were published in his lifetime, between 1826 and 1828, and the remainder did not appear until 1856.

Southern Coast was now being drawn to a close with a final tour in the summer of 1824, and a complementary scheme, for *Picturesque Views on the East Coast of England,* was being discussed, although only a few of the proposed plates were ever engraved.

Much more significant, indeed most important of all Turner's works for the engraver, was the series of *Picturesque Views in England and Wales,* a scheme initiated in 1825 by the engraver-publisher Charles Heath. By the following year Turner had completed about twelve of the 120 commissioned, and the first part was published in 1827. This great project, which in the end amounted to ninety-six published subjects, continued to preoccupy him until the mid 1830s. It was a truly monumental survey of the England of his time – its scenery and architecture, climate, industry, and the character and habits of its people.

Turner's watercolours for the series are superlative examples both of his mature techniques and of his highly personal approach to topography, which now he saw as a pictorial and conceptual art rather than a purely descriptive one. Many of the designs were prepared by means of 'colour structures' or 'beginnings', and then elaborated with a wealth of imagery from his own observation and experience – and in some cases he was able to revise subjects he had drawn or painted years before. Like the *Ports* and *Rivers,* the *England and Wales* series was superbly engraved, by a team of young engravers who worked under his close and sometimes almost obsessive supervision.

England and Wales can be seen as Turner's own investigation into the 'Condition of England', and it was begun during the years when this very phrase was a watchword of politics. The war had impoverished the country, and in 1815 there was a vast national debt and serious unemployment – circumstances that contrasted bitterly with the conspicuous extravagance of the Prince Regent. Two years later the Regent's coach was attacked at the opening of Parliament, and in 1819 came the bloody dispersal of the gathering of thousands of workers from the cotton mills of Manchester and Lancashire that became known as the Peterloo massacre. 1819 was a black year. The classic serenity of Turner's *England: Richmond Hill,* in the Academy that spring, strikes, at least in retrospect, an ironic note. As significant as

PETWORTH, TILLINGTON CHURCH

*J. M. W. Turner, oil. Clore
Gallery for the Turner Collection.*

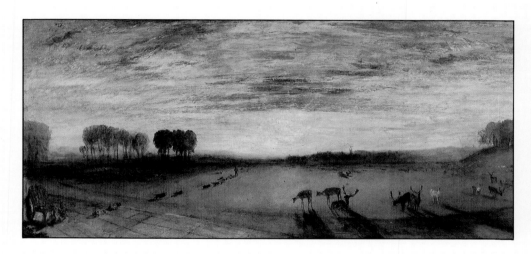

PETWORTH: THE BILLIARD PLAYERS

*J. M. W. Turner, watercolour. Clore
Gallery for the Turner Collection.*

AN ARTIST AND HIS ADMIRERS

*J. M. W. Turner, watercolour. Clore
Gallery for the Turner Collection.*

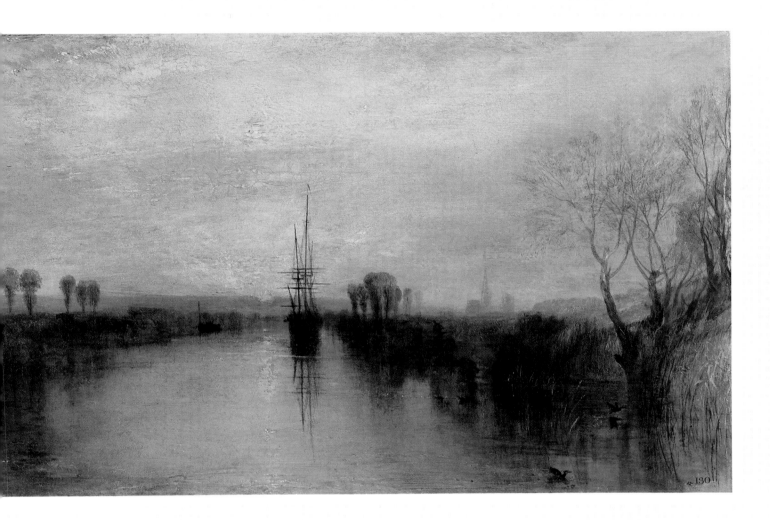

PETWORTH

*A*fter the death of Walter Fawkes in 1825, Petworth succeeded Farnley as a country house where Turner could relax and work in comfort and in easy-going surroundings. Lord Egremont entertained a number of artists, including Constable and Haydon, while Phillips, whose portrait of Egremont is reproduced, was effectively resident there. Turner set up his own impromptu studio in the Old Library, over the Chapel. The household was unconventional and bohemian, but Egremont was an efficient, conscientious and generous master of his estate. Turner made many wonderfully evocative colour sketches on blue paper of the splendid rooms of the house and the informal gatherings that took place in them. For the dining room he painted two sets of wide, horizontal landscapes; one remains at Petworth and the other, rather less finished and more spontaneous in feeling, is in the Clore Gallery. The subjects included an expansive view of the lawns at the back of the house looking towards Tillington church, and another of Chichester Canal in which Egremont had invested.

CHICHESTER CANAL

J. M. W. Turner, oil. National Trust/
Tate Gallery, Petworth House.

135

REFORM

*P*arliamentary Reform was a highly contentious issue in the late 1820s and early 1830s. Parliament, with its unrep-resentative system and gross anachronisms like 'pocket' or 'rotten' boroughs, was outdated and inequable, and took no account of the shifts in economic power from the rural areas to the towns and cities after the Industrial Revolution. George IV had no sympathy for the reform lobby, while the Tory ministry of Wellington was reactionary in such matters. In 1830, however, George was succeeded by a more liberal monarch, William IV, and Wellington fell, to be replaced by Lord Grey and a reforming Whig cabinet. After bitter argument at Westminster, and public riots around the country, the Reform Bill was carried in 1832. Turner's interest in the question must have been fostered by Fawkes, who sadly did not live to see Reform enacted. His frontispiece to Fawkes's 'Fairfaxiana' had paid tribute to the General's service for Parliament in the Civil War. Later, his watercolour of Northampton, made but not engraved for Pictur-esque Views in England and Wales, shows the excitement surrounding the election of a reforming M.P., Lord Althorp, in 1830. A banner in the foreground reads 'The Purity of Elections is the Triumph of LAW'.

TOP:

NORTHAMPTON

*J. M. W. Turner, watercolour,
c. 1830. Private Collection.*

ABOVE:

FAIRFAXIANA FRONTISPIECE (AT FARNLEY HALL)

*J. M. W. Turner, watercolour,
1815. Ashmolean Museum, Oxford.*

this patriotic and reassuring offering, was Turner's decision not to tour at home this year, but to leave for Italy in the summer.

By 1824–5 a package of banking, fiscal and customs reforms had created a boom, and there was a conspicuous surge of new building around the country. The King's speech in 1825 could claim there had never been a time when 'all the great interests of society were at the same time in so thriving a condition'.

This was the nation, suddenly transformed and still transforming, that Turner undertook to survey in unprecedented detail in 1825. Such a comprehensive view matched the mood of the time. Many writers and commentators, struck by the increasing complexity of British society, sought to discover a single pattern behind it, but they sensed, also, an inescapable connection between rising wealth and power, and greed and insecurity. Turner generally took a positive view in *Picturesque Views of England and Wales;* his brief called for beauties rather than penetrating analyses, and for more pastoral than urban scenes. Taken as a

THE BURNING OF THE HOUSES OF
PARLIAMENT

ABOVE: *J. M. W. Turner, watercolour,
1834. Clore Gallery for the Turner
Collection.*

whole, the series kept the nation in touch with its roots in a time of change and flux.

The events that were to follow might have been calculated to prove the wisdom of this approach, for in that same year the 'Condition of England' had abruptly tipped from boom to slump. In the autumn and winter, banks and shares failed, and many went bankrupt, including Scott, who would never entirely clear his debts. The Fawkes family may have been affected also, their losses probably compounded by Walter Fawkes's death in October – for Turner is said to have lent them a large sum. Turner's publishers were hit particularly hard. Such was his own prestige, however, that most of his projects continued.

The crisis of 1825–6 animated the passions for political and social reform that had rather slumbered during the boom years of the early 1820s. Whatever Turner's party affiliation, sympathy with Parliamentary reform is certainly to be found in his work of this period. Among the designs for *England and Wales* was a spirited account of the election at Northampton of Lord Althorp, leader of the House of Commons and the most popular Whig politician serving in Lord Grey's government. This administration, settled into power in 1830, three years after ill-health drove Liverpool from office, carried the Reform Bill in 1832, finally eliminating the worst injustices of the old parliament. The drawing was not published – perhaps it was thought too partisan.

LATER YEARS

Turner had last visited Farnley in November 1824, and the place it had occupied in his life as a grand home-from-home and a vivid inspiration for his art was taken over by Petworth, where he stayed in August and October 1827. Another house where he was welcome and could work was East Cowes Castle, the Gothic residence of the architect John Nash. He stayed there that year between his Petworth visits, and made some spirited oil sketches; two pictures of the Cowes Regatta, painted for Nash, were exhibited at the Academy the following year. In 1828 he was again at Petworth, and now began his series of pictures to hang in the dining room – views of the park and its lake, and of the Chichester Canal and the chain pier at Brighton in which Lord Egremont had invested.

1828 and 1829 found Turner in Italy, but it is probable that he also found time to visit Margate, and it may have been about this time that he began to stay with Sophia Booth in her lodging house overlooking the harbour and the pier where the London steamboat tied up. Steamers had revolutionized Turner's travelling, and it was on one of them, the *Maid of Morven*, that he visited Staffa and Fingal's Cave in the Hebrides in the summer of 1831. His magnificent painting shown at the Academy in 1832 recalled the occasion and the boisterous weather that had prevented his further progress to Iona.

Turner had once again been summoned to Scotland by Scott and the author's Edinburgh publisher, Robert Cadell, who had commissioned a set of illustrations to Scott's *Poetical Works,* and the trip provided an opportunity for an extensive tour of the Highlands and Islands. Turner's illustrations were highly successful, marvellously complete and atmospheric though on a minute scale, with vignettes and decorative borders expressing evocative and characteristic aspects of Scottish scenery and tradition.

Besides visits to Margate and Petworth, Turner did not go far afield in Britain in the 1830s, reserving his gradually fading energies for the Continent. 'Oh for a feather out of Times wing', he complained to Scott – himself ailing and approaching his death – when seeking advice on how much to see in Scotland. In October 1834 he was presented with a magnificent subject near to home when the old Houses of Parliament burned to the ground, which gave rise to several watercolours and two oil paintings. His last visit to Petworth was in November 1837, for Egremont's funeral. Labourers followed the hearse, while Turner led a group of artists before it.

Egremont's splendidly feudal funeral belonged to a vanishing England. The Reform Bill of 1832 had begun a major shift of power from the landowners to the urban middle classes. Lord Grey's ministry had been succeeded by others, led by Lord Melbourne and Robert Peel, also committed to change, but reform continued to be hindered by financial slumps. In 1837, the year of Queen Victoria's accession, 50,000 workers were unemployed or on short time in Manchester, and there were further severe crises in 1841, 1842, 1847 and 1848.

These were searing experiences that now affected all thinking people. Some drowned themselves in nostalgia – the classical ideals of Turner's youth were now more and more replaced by a yearning for the medieval and monastic – while others searched their souls. Turner began to paint themes of disaster and apocalypse, while writers and critics questioned the whole basis of British social structure. What had the

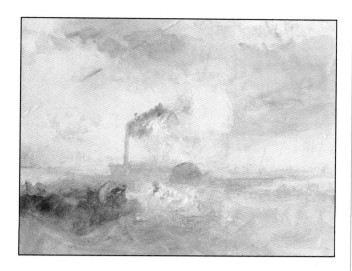

TOP

A STEAMER OFF THE SHORE

J. M. W. Turner, watercolour, c. 1843-5.
Clore Gallery for the Turner Collection.

ABOVE

STAFFA, FINGAL'S CAVE

J. M. W. Turner, oil, Royal Academy,
1832. Yale Center for British Art, New
Haven. Turner visited Fingal's Cave, a
wonder since its discovery in 1772, on a
steamer tour of the Highlands and Islands
after visiting Sir Walter Scott at Abbotsford
in 1831.

Reform Bill been for if it did not bring forth men who would organize things better?

Yet in truth, a new age of stability and prosperity lay just around the corner. Peel, who became Prime Minister in 1841 and remained until 1846, finally took a grip on the economy, and from 1844, presided over a vast expansion of the railway network that united the nation socially and geographically more than any legislation could. Though guns were placed in Hyde Park that summer, Britain's fabric was strong enough to avoid the revolutions that swept Continental Europe in 1848, and by 1850 the Annual Register could claim with some truth that 'the domestic affairs of the British nation presented a tranquil and, with partial exceptions, a cheering aspect'.

Turner had become increasingly reclusive in these years. When in London he had kept mainly to his house in Queen Anne Street, now becoming dirty and unkempt, breaking his solitude for spells at Margate with Mrs Booth, with whom he had formed a closer relationship after her husband's death in 1833. From there, he pottered around the Kent coast, and the many studies in oil and watercolour from the last ten or so years of his working life of beaches, breaking waves, storms, showers and sunshine over the water, as well as views of Margate itself, are the fruit of these trips. He usually ignored his fellow steamertrippers, preferring a solitary, elemental vision expressed with all the marvellous economy of his mature style, but the progress they enjoyed did not escape him. The vessels of the fast steamer service from Folkestone to the Continent, and Telford's splendid railway viaduct that brought its passengers to the pier, are clearly discernible through the iridescent mists and glittering showers of his late watercolours.

It was the revolution in transport that had done more than anything else to change the face of England since Turner's youth, and the greatest of all innovations was the railway. By 1847, 2000 miles of new track had been laid, and while the railway 'mania' brought its own problems in the shape of some lunatic speculation, it rejuvenated the nation. Its significance is clear from the literature of the day, and in *Rain, Steam and Speed,* in which an engine of the Great

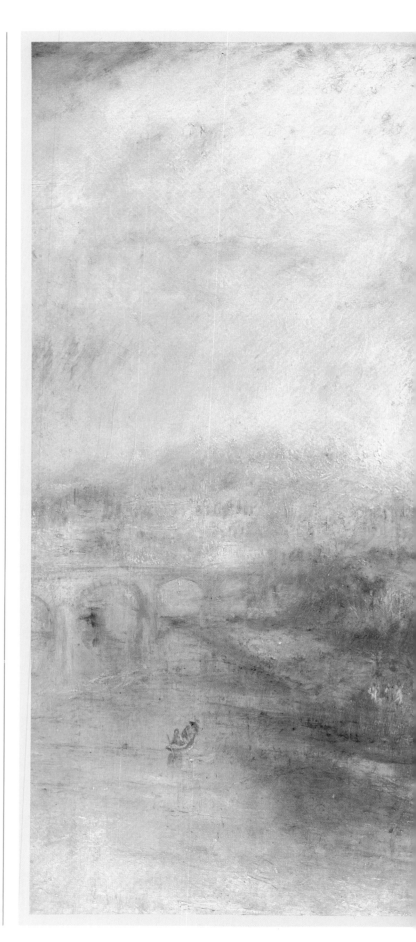

Western Railway forges towards us through a rainstorm, driving all before it, Turner created an icon of the machine age. Yet the picture is full of nostalgia for the country, and the classical culture of Turner's youth. The railway bisects the landscape as does the road in Poussin's *Roman Road* at Dulwich, and the just-perceptible group of dancing figures on the banks of the Thames echo the classical imaginings in his Thames landscapes of thirty years earlier.

By about 1847, travel, by rail, road or boat, was beyond Turner. He came to live at Chelsea, overlooking the river on Cheyne Walk, with Mrs Booth to look after him. For the appearance of the Covent Garden of Turner's boyhood we have only the evidence of the contemporary topographers whose subtle modulation of the truth he had first learned, and then so brilliantly surpassed. But for the Chelsea shore by which he died, looking at an early morning sun in 1851, we can turn to photographs. They show a humdrum urban scene, sprawling with wharves, small houses of grubby brick with smoky chimneys, and sprouting a crop of hoardings. It is not the pretty, well-tended Chelsea of today, but it is already a modern world, unmistakably our own.

RAIL, STEAM AND SPEED — THE GREAT
WESTERN RAILWAY

J. M. W. Turner, oil, Royal Academy 1844. National Gallery, London. In this view of a train forging through a storm across the railway bridge at Maidenhead, Turner contrasts the forces of technology and the elements, and adds a nostalgic echo of the pastoral and classical Thames of his youth in the distant ploughman and rustic dancers. A hare running before the train contributes its own poignant comment on the mixed blessings of the age of 'Steam and Speed'. The virtuoso atmospherics inspired the critic of 'Fraser's Magazine' to declare that Turner had 'out-prodiged almost all former prodigies. He has made a picture with real rain, behind which is real sunshine, and you expect a rainbow any minute.'

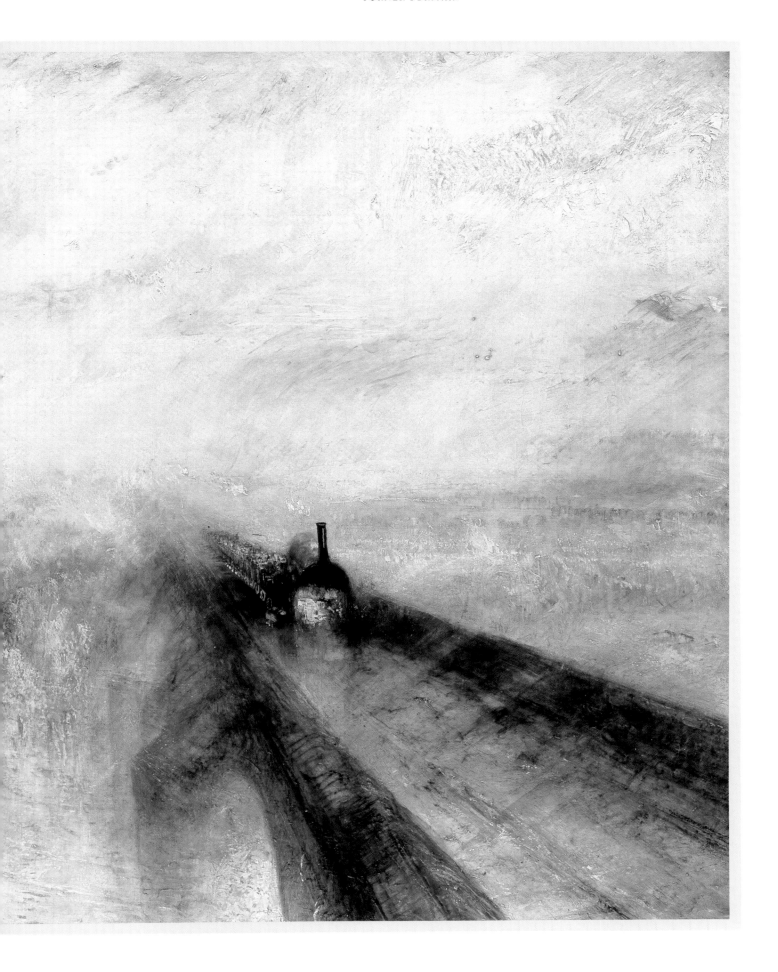

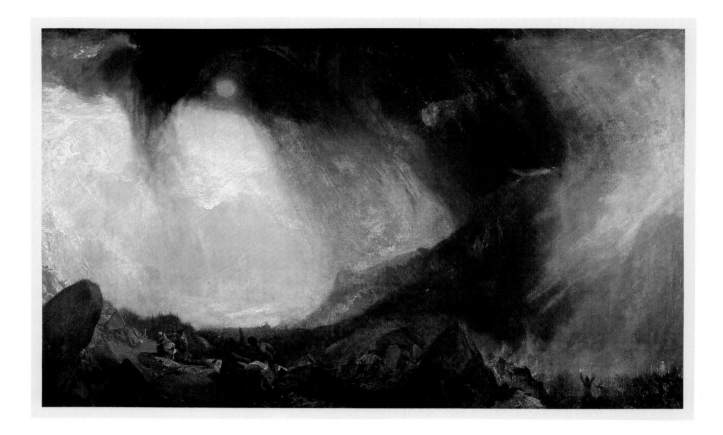

SNOWSTORM: HANNIBAL AND HIS ARMY
CROSSING THE ALPS

————

J. M. W. Turner, oil, Royal Academy,
1812. Clore Gallery for The Turner
Collection. This most impressive of
Turner's early essays in the historical
'Sublime', in which the contending elements
overshadow Hannibal's fateful progress to
Italy, arose partly from the recollection of
his own Alpine explorations in 1802, but
also from the more recent memory of a
thunderstorm seen while staying at Farnley
in 1810. Turner may also be implying an
analogy between Hannibal and Napoleon,
who like the ancient general, was now over-
reaching himself. Snowstorm *was the first*
picture with which Turner printed lines of
poetry in the catalogue with a credit to an
'MS' poem 'Fallacies of Hope'.

————

TURNER'S EUROPE

*I have fortunately met with a good-tempered, funny, little,
elderly gentleman, who will probably be my travelling
companion throughout the journey. He is continually popping
his head out of the window to sketch whatever strikes his
fancy, and became quite angry because the conductor would not
wait for him whilst he took a sunrise view of Macerata.
'Damn the fellow!' says he. 'He has no feeling.' . . . He
speaks but a few words of Italian, about as much French,
which two languages he jumbles together most amusingly. His
good temper, however, carries him through all his troubles. I
am sure you would love him for his indefatigability in his
favourite pursuit. From his conversation he is evidently* near
kin to, *if not* absolutely, *an artist. Probably you may know
something of him. The name on his trunk is,
J.W. or J.M.W. Turner!*

LETTER FROM **THOMAS UWINS** (QUOTING AN
ANONYMOUS SOURCE) TO JOSEPH SEVERN, DATED
NAPLES, 3 FEBRUARY 1829

No British artist has been more widely travelled in Europe than Turner, nor has any painter so completely stamped his own vision of the Continent on his contemporaries. As in Britain, it was a vision both immediate and nostalgic, decisive in its grasp of scenery and effect and always informed by direct experience, yet charged with emotions that sprang from a sense of history and association. There is a paradox here that was perhaps unavoidable for Turner's generation. While the far-ranging subjects of his art celebrate a new age of travel, his mind and eye were formed at a time when Europe, cut off by war, existed for the British more as an idea than a reality, a continent whose greatness seemed to lie in the past, in antiquity or the Renaissance.

After a glimpse of France and Switzerland in 1802, while it was under the domination of Napoleon, Turner's main experience of the Continent fell during the years between the Emperor's downfall and the revolutions of 1848, when the uneasy legacy of the Congress of Vienna kept countries and peoples divided or subjugated, pulled between the forces of reaction and resistance. Greece won freedom from Turkey but much of Italy failed to throw off the yoke of the Austrian Empire; Switzerland was not yet united; France was working out its post-Napoleonic destiny through experiments in monarchy; a United Netherlands was formed and broken; the German states and Prussia had yet to achieve their later harmony. Only Austria seemed secure, chiefly because the wily Prince Metternich kept the lid screwed down tightly on so much of the Continent. Britain had declined to join the Holy Alliance of Austria, Russia and Prussia, through which the Austrian Chancellor ran his repressive system; in practice British statesmen often colluded in its operations, while professing moral superiority or even indignation.

TRAVEL IN THE NINETEENTH CENTURY

An Englishman travelling through the Europe of this period was likely to feel a sense of superior advantage, which the discomforts of travel, at least early in the

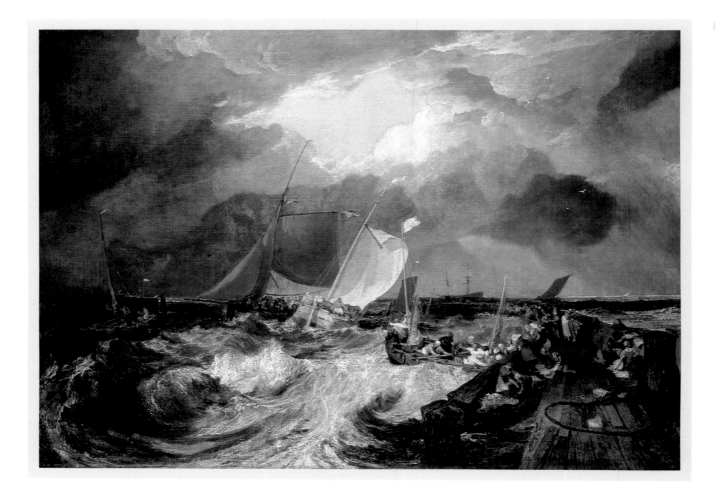

CALAIS PIER WITH FRENCH POISSARDS
PREPARING FOR SEA: AN ENGLISH PACKET
ARRIVING

J. M. W. Turner, oil, Royal Academy
1803. National Gallery, London. Turner's
title, referring to the French fishermen and
the English cross-Channel packet boat,
signals the documentary realism of this
memory of his own stormy arrival at
Calais, when he was 'Nearly swampt'. At
the same time the picture looks to the
quintessential old masters of marine
painting, Dutch painters of the seventeenth
century.

century, would undoubtedly have increased. When
Turner first crossed the Channel in 1802, he did so by
a heaving packet boat, and his experiences in France
and Switzerland were often uncomfortable. Napo-
leon was later to improve the roads and Alpine passes,
but even this could not alleviate the nightmare of
border controls, unpredictable stops and searches that
were likely to occur in a divided country like Italy.
Both inns and means of transport tended to deteriorate
the further the traveller journeyed south of the
Channel. After the horrors of a lumbering French
diligence – larger and more cumbersome than an
English mail coach – those who were bound further
must submit themselves to a series of vehicles adapted
to the Alps, where the weather could bring everything
to a halt, and to the dreadful inns of the Alpine villages
– the immaculate Swiss hotels of today were then
unimagined.

Worse could follow in Italy. Each stage of a journey
had to be separately negotiated with the owner of a

vehicle, necessitating constant bargaining. Inns were often infested with bugs, and journeys further south carried the risk of attack by brigands. Countless Grand Tourists had managed, of course, so later generations still dutifully beat the familiar path – 'yet it must be done', as Wordsworth said.

There were, of course, real delights as well, but in the light of the difficulty and unpredictability of travel, Turner's repeated wanderings around Europe, which went far beyond the immediate needs of new subjects and inspiration, seem all the more remarkable. It is hardly surprising that so many of his paintings and drawings document the experience of travel as much as they describe particular places. His stormy landing at Calais in 1802 when he tells us he was 'nearly swampt' is recorded, and probably not at all exaggerated, in *Calais Pier*.

His letters are full of graphic descriptions of the adventures of travel, none more dramatic than that he wrote to Eastlake after his return from Rome in 1829:

MESSIEURS LES VOYAGEURS ON THEIR RETURN FROM ITALY (PAR LA DILIGENCE), IN A SNOW DRIFT UPON MOUNT TARRAR, 22ND OF JANUARY, 1829

J. W. M. Turner, watercolour and bodycolour, 1829. British Museum, London. Another vivid personal record: the top-hatted figure closest to the foreground at right is presumably Turner himself.
BELOW: *Detail.*

145

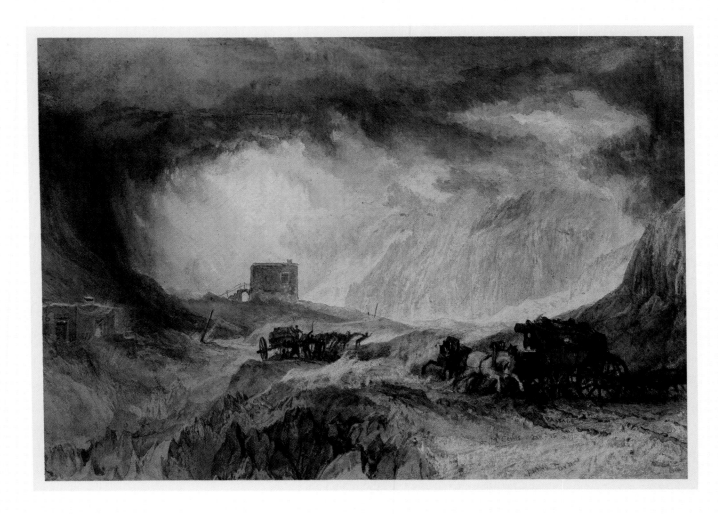

RIGHT:

VENICE: THE ARTIST'S BEDROOM AT THE EUROPA HOTEL

———

J. M. W. Turner, watercolour and bodycolour on buff paper, 1833. Clore Gallery for the Turner Collection. Turner drew the view from the window of this room many times.

ABOVE:

PASSAGE OF MONT CENIS

———

J. M. W. Turner, watercolour, 1820. Birmingham City Art Gallery

———

'Now for my journey *home*. Do not think any poor devil had such another . . . the snow began to fall at Foligno, tho' more of ice than snow, that the coach from its weight slide about in all directions, that walking was much preferable, but my innumerable tails would not do that service so I soon got wet through and through, till Sarre-valli the diligence zizd into a ditch and required 6 oxen, sent three miles back for, to drag it out; this cost 4 Hours, that we were 10 Hours beyond our time at Macerata, consequently half starved and frozen we at last got to Bologna, where I wrote to you. But there our troubles began instead of diminishing – the Milan diligence was unable to pass Placentia. We therefore hired a voitura, the horses were knocked up the first post, sigr turned us over to another lighter carriage which put my coat in full requisition night and day, for we never could keep warm or make our day's distance good, the places we put up at proved all bad, the diligence people had devoured everything eatable (Beds none) . . . crossed Mont Cenis on a sledge – bivouaced in the snow with fires lighted for 3 Hours on Mont Tarate while the diligence was righted and dug out, for a Bank of Snow saved it from upsetting – and in the same night we were again turned out to walk up to our knees in new fallen drift to get assistance to dig a channel thro' it for the coach, so that from Foligno to within 20 miles of Paris I never saw the road but snow!'

That year, Turner exhibited a watercolour of this incident. He delighted in weathering such storms and incorporating them into his art, but he was no less ready to preserve impressions of the quieter pleasures of Continental inns or cafés, or the airy splendour of his frescoed hotel bedroom in Venice.

In Turner's youth, such pains and pleasures were out of the question; war with France had effectively isolated the Continent from 1792, and a sense of it could only be obtained at second hand. Essentially, Europe was a cultural idea, a received vision drawn from literature, anecdote and art. For Turner, it meant Reynolds's descriptions of the art he had studied in Italy, the pictures of Claude, Poussin, Wilson, and the Dutch masters, or the drawings of J.R. Cozens,

and no doubt also the stories of patrons like Richard Colt Hoare and William Beckford. Their experiences and historical knowledge, and the many echoes of a classical European culture to be seen in their houses must first have been an inspiration, and then helped to give perspective to Turner's own Continental experience. He was, for instance, later to own an author's copy of Walter Fawkes's *Chronological History of Modern Europe* of 1810, while Fawkes acquired many of Turner's finest watercolours of Continental scenery as well as his great *Dort*.

FRANCE AND SWITZERLAND: 1802

France provided Turner's first and last sights of Continental Europe. Long before the Revolution, the country had aroused both curiosity and suspicion in British minds. History had done nothing to encourage friendship, and pre-Revolution France seemed extraordinarily different from England – subject to all sorts of extremes, backward, priest-ridden and autocratic. Long-standing prejudice combined with the more recent ideals of the Enlightenment to encourage a marked sympathy in Britain for the Revolution, which to some extent persisted even through the Terror, the execution of the King and the declaration of war on England in 1793.

Though now an enemy, as so often in the past, France still stood for many as a beacon of liberty, but English progressives saw Napoleon's rise to personal pre-eminence as a betrayal of the egalitarian ideals of the Revolution. Wordsworth, who had celebrated 'France standing on the top of golden hours', spoke for a disillusioned generation in his brutal satire on his fellow countrymen who flocked to Paris in 1802 when the Treaty of Amiens secured a lull in the war.

Lords, lawyers, statesmen, squires of low degree,
Men known and unknown, sick, lame and blind
Who crowd to bend the knee
In France, before the new-born Majesty.

Whatever the motives of the English visitors to Napoleon's France in 1802, they were present in large

numbers: the British envoy in Paris estimated 5000 in the city alone. For artists, as we have seen, the riches of the Louvre and the state of contemporary French painting were sufficient reasons for the trip, but there was also a number of independent radicals and a group of some eighty Whig members of Parliament, who having consistently opposed the war, wanted to see how the new France worked, and to take the temperature of liberty.

Few visitors were immune to the fascination of Napoleon himself – least of all artists who whether they personally considered him a Romantic hero or a tragic one, rightly recognized him as an icon of his time. West's failure to inform his fellow painters from London of the Consul's visit to the exhibition of modern painting at the Louvre, where they could have seen him with 'great convenience' caused 'much umbrage'.

Older and more seasoned travellers could compare the France they had known before the Revolution with its present condition. Most agreed there was some improvement in the state of ordinary people, and the obviously glaring divisions of the old Paris had given way to a greater uniformity. West recalled crowds of rich coaches with liveried servants, constant religious processions and 'the Mass of the people abject & wretched'. Farington, on the other hand, observed few changes outside the capital. Turner was in no position to make comparisons, having never been across the Channel before, and Paris was not in

TOP:

PARIS: THE LOUVRE FROM THE SEINE

Thomas Girtin, etching and wash, 1802. British Museum, London. Turner's early friend Girtin had visited Paris in 1801–2 armed with a special pass, planning to make a panorama of the city.

ABOVE:

LYON

J. M. W. Turner, pencil, 1802. Clore Gallery for the Turner Collection. Turner spent three days in Lyon on his way to the Alps in 1802. He found its buildings 'better than those of Edinburgh', and paused to make this drawing , looking across the Saone towards the Cathedral.

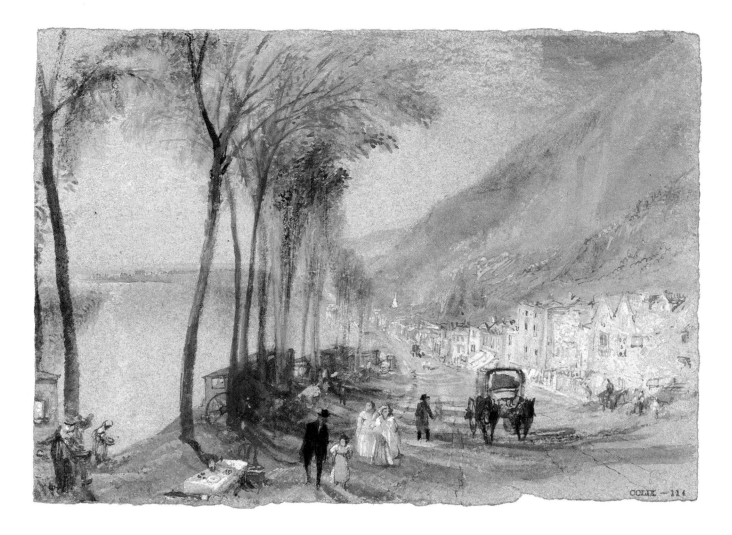

any case his primary destination. It and the Louvre were experiences he could defer.

First he had another object in view: the mountains of Dauphiné and Savoy, and of Switzerland itself. Pausing in Paris only to hire transport and, it seems, a Swiss servant for the journey as well as to buy some drawing paper – he obtained some that had originally been made for French banknotes as well as an elegant sketchbook or two – he set off across France. His travel arrangements were luxurious by the standards of the time, and by comparison with his own future travels, and were probably prompted and paid for by his travelling companions. Tradition has it that 'three noblemen' financed the trip.

He proceeded in comfort to Lyon, a journey of four days during which he made only slight outline sketches of the passing scenery which he found boring and 'bad'. At Lyon itself he stayed three days, stirred

THE SEINE, BETWEEN MANTES AND VERDUN

J. M. W. Turner, watercolour and bodycolour, c. 1832. Clore Gallery for the Turner Collection. One of the views engraved for Turner's Annual Tour – The Seine, *1835. Beside the main road from Paris, coaches or 'diligences' are pulled up in the shade of the trees along the bank of the Seine. Refreshments are on offer at cafés across the street.*

149

SWITZERLAND AND THE ALPS, 1802

*T*he dramatic scenery and weather effects of the Alps gave entirely new meaning to Turner's concept of the 'Sublime'. His explorations of the mountains, remote villages and wild passes of Savoy, Dauphiné and Switzerland, and of the still serenity of the lakes of Thun, Brientz and Geneva, enriched his powers of pictorial imagination and technique almost literally by the day. In 1802 the whole region was disturbed as it struggled to come to terms with its new status after Napoleon's invasion. Frustrated by the internal rivalries in Switzerland, Napoleon had recently withdrawn French troops, leaving his new subjects to argue among themselves; Turner witnessed the resulting anarchy that in 1803 compelled the Swiss to make fresh terms with their invader. Although he was certainly aware of Switzerland's 'very troubled state', he concentrated on the glories of the landscape, and in fact many of

the Alpine watercolours he made after his return to London are strikingly empty of figures or narrative, relying on scenic grandeur. During what must have seemed a fairly hurried tour, Turner laid up a considerable body of material, working in a variety of media and often bringing his drawings to a greater degree of completion than on subsequent travels. In a series of drawings on French, grey-toned paper, made in and around Grenoble and in the Grande Chartreuse, he worked in pencil, much as he had the previous year in Scotland, but then elaborated the drawings with chalks and white bodycolour; sometimes these drawings were also coloured. To capture the magnificent scenery around Mont Blanc and in the St Gothard Pass, he used large sheets, this time prepared with grey wash, and worked in watercolours and bodycolour; the incisive economy of his Mer de Glace superbly evokes the icy bleakness of the glacier, while the upright format of the Devil's Bridge emphasizes the dizzying perspective of this vertiginous pass.

BELOW:

*THE MER DE GLACE,
CHAMONIX*

*J. M. W. Turner, watercolour.
Clore Gallery for the Turner Collection.*

ABOVE:

THE DEVIL'S BRIDGE

*J. M. W. Turner, pencil,
watercolour and bodycolour on prepared
paper, 1802. Clore Gallery for the Turner
Collection.*

LEFT:

*THE LITTLE CHURCH OF ST
HUMBER, GRANDE CHARTREUSE*

*J. M. W. Turner, pencil
watercolour and bodycolour, 1802. Clore
Gallery for the Turner Collection.*

RIGHT:

THE LITTLE BRIDGE, CHARTREUSE

*J. M. W. Turner, watercolour.
Clore Gallery for the Turner Collection.*

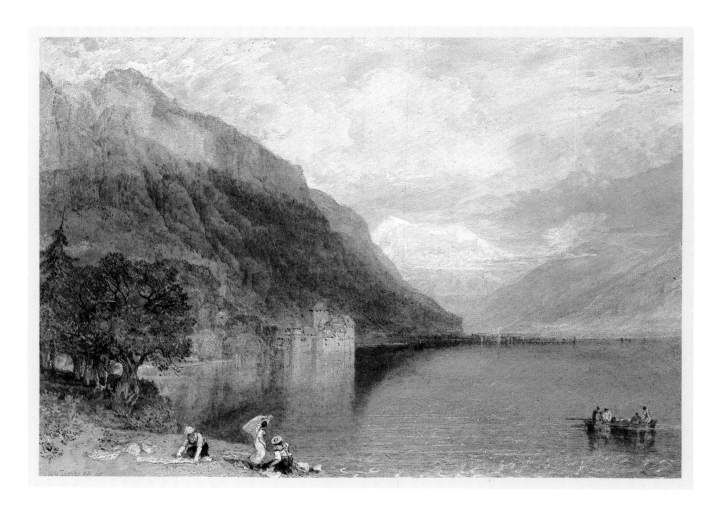

CASTLE OF CHILLON

J. M. W. Turner, watercolour, c. 1809.
British Museum, London. This serene
view of a castle with a grim history was
made on commission for Sir John
Swinburne.

by its fine buildings – 'better than those of Edinburgh'
– to make some large pencil drawings. Otherwise,
however, he 'did little there', for the city was 'not
settled enough' and was also too expensive.

At Grenoble, two days further on, Turner found
the charges more 'reasonable'. He paused to make
some fine finished drawings, excited by the brooding
presence of the mountains surrounding the city,
before moving on through the remote defile of the
Grande Chartreuse to Geneva, Bonneville and
Chamonix, where he climbed the Montanvert and
drew the Mer de Glace.

Then followed a fairly standard tour of Mont Blanc
and visits to Courmayeur, the Val d'Aosta and Aosta
itself, whence he regretted not having continued the
day's journey to Turin. Instead he crossed the Great
St Bernard to Martigny and travelled down the Rhône
valley to Vévay, whence he turned towards the lakes
of Thun and Brienz, making a circular tour through
Grindelwald and Meiringen, and continuing to Lucerne
and the St Gothard pass as far as the Devil's Bridge.
He returned through Zurich and Schaffhausen to
Basle and Strasburg, and was back in Paris at the end
of September.

In Switzerland, then a remote place, Turner often
experienced 'bad living & lodgings', and 'found the
Country in a very troubled state, but the people well
inclined to the English'. As elsewhere in Europe,
French invasion had brought mixed blessings and
mixed reactions.

The sacrifice of independence was accompanied by
improved administration, and in so far as the French

had seemed at first to bring the ideals of the Revolution, they were welcomed by many among the intellectual classes. Moreover, in a nation of many compartments, as Switzerland had once been, some units had enjoyed more power than others, and the unity imposed by Napoleon's legions appealed to the less advantaged. Thus, La Harpe, the liberal Swiss tutor and adviser to the Tsar Alexander I, welcomed the invasion because he resented Bern's control of his native Vaud. Yet by the same token, nationalist feeling was everywhere to contribute to Napoleon's eventual downfall, just as it was to shake the fragile structure of the Europe constructed after it.

French incursions had for the time being arrested Switzerland's development as a tourist centre, which had made a promising beginning in the second half of the eighteenth century. The tour of Mont Blanc had been quite fashionable with the English for some years, and it had been an Englishman, William Windham, who in 1741 had made a bold journey to the glaciers above Chamonix, thus alerting the Genevese to the potential of their own mountains.

By the 1790s Chamonix had acquired some of the characteristics of a modern tourist village, and travel literature had even begun to emerge. The Rev Charles Davy, an amateur of the arts who was a friend of the watercolourist Hearne, had translated a guidebook to the *Glaciers of the Dutchy of Savoy*, written by Marc Theodore Bourrit. The latter, a minor artist and self-styled 'historiographer of the Alps', had acted as guide for many of the English Grand Tourists who passed through on their way to Italy.

Another friend of Davy, the engraver William Woollett, had engraved the splendid Alpine watercolours made by William Pars in 1771, and these, together with those of J.R. Cozens that Turner had studied at Dr Munroe's home, must have helped prepare Turner for what he was to see.

Besides, his travelling companions probably knew the Alps already, and his patrons Fawkes and Beckford were also familiar with them. The former already owned a splendid series of Swiss watercolours by John 'Warwick' Smith, and the latter, inspired by Thomas Gray's *Ode on the Grand Chartreuse,* had

spent some time staying in the famous monastery whose wild surroundings Turner in 1802 found 'abounding in romantic matter'. Moreover, his Academy colleague Henry Fuseli was Swiss, and though he had spent most of his career in exile in London, he never lost interest in his country's history and legend.

LIBERTY, OPPRESSION AND THE FORCES OF NATURE

So powerful are the descriptions and images of Switzerland and the Alps in Byron's *Childe Harold's Pilgrimage,* the first canto of which was published in 1812, and so precisely do they seem to match Turner's vision, that it takes an effort to realize that Turner's first visit preceded the poem. Yet despite their differences in personality and social background, painter and poet were sufficiently alike in outlook and interests to recognize the significance and associations of many of the same places. Time and again we find Turner anticipating in his drawings the very scenes that Byron was to weave into his poetry.

Some of these were straightforward tourist attractions, while others, like the Chapel of William Tell near Brunnen on Lake Lucerne, or the Castle of Chillon on Lake Geneva, were pregnant with meaning. Such places were sacred to liberty, and in 1802, with the ideals of freedom that had given birth to the Revolution questioned as the Napoleonic writ began to run, they possessed particular poignancy.

Turner was not a particularly political animal, and there is no way of telling whether, as he passed near Fort de Joux in the French Alps, he knew that inside lay the captive Toussaint L'Ouverture, black leader of a slaves' rebellion in Saint Domingue (now Haiti), whom Napoleon had captured in January that year. For Wordsworth, who soon wrote a sonnet to Toussaint, Napoleon's suppression of the rebellion exposed the fundamental tragedy of the age: a movement that sprang from the pure ideals of the Revolution was destroyed by the very leader to whom it had given birth.

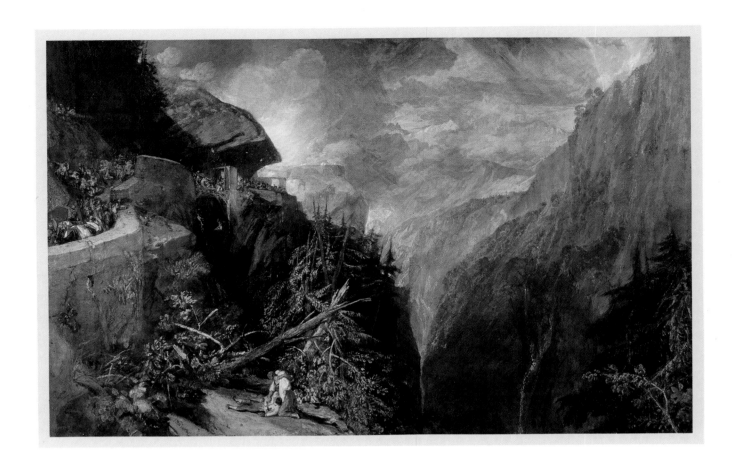

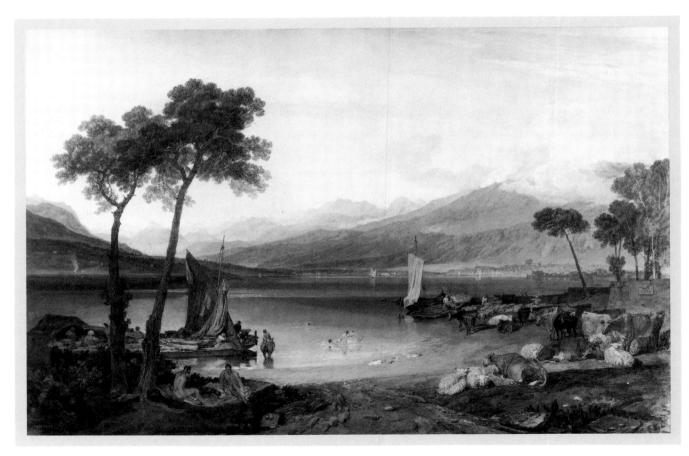

Turner, though not immune to his generation's tendency to meditate on liberty, preferred to do so through historical association rather than by documenting contemporary events. He was already familiar with the legends of William Tell and his adventures in pursuit of Swiss freedom, for about this time he was planning a historical picture of the great patriot's escape from the boat of his persecutor Gessler, the Austrian tyrant. His source was likely to have been Fuseli, who had himself drawn Tell's leap from his boat and painted another subject based on Swiss history, the oath of Rütli, sworn in 1307 near Brunnen to create the first Swiss Confederation against Austria.

Chillon had a blacker history, for here the Swiss-Genevan patriot Bonnivard had languished in captivity on the orders of the Duke of Savoy. Turner drew Chillon several times, anticipating Byron's *Childe Harold,* and his still greater sonnet:

Eternal Spirit of the chainless Mind!
Brightest in dungeons, Liberty! thou art
For there thy habitation is the heart

The theme of liberty was interwoven into Swiss history. The Alps had also witnessed heroic struggles against those who threatened the liberty of others, for below lay Italy, an eternal temptation to the invader. Already in 1802 Turner was thinking about the epic events he was to paint in his *Snowstorm, Hannibal and his Army crossing the Alps* (1812), and an episode in more recent history, when the French legions had been resisted as they bore down on Italy, was the inspiration for his *Battle of Fort Rock* of 1815. In the lines of poetry which accompany this, ascribed to his epic poem 'Fallacies of Hope', Turner developed a characteristic simile between human aggression and that of a natural force, in this case the River Reuss in spate, fed by winter floods:

The snow-capt mountain, and huge towers of ice
Thrust forth their dreary barriers in vain;
Onward the van progressive forc'd its way
Propelled, as the wild Reuss, by native glaciers fed.

For Turner, the Alps were the epitome of the Sublime, home to the most dramatic manifestations of nature and weather. Turner's earlier experiences in Wales and Scotland had but dimly hinted at the grandeur of such effects, but he rose magnificently to the challenge. His paintings of 1802 and afterwards were not only powerful images of nature, but also reminders of what was the finest or most terrible in human achievement. He did not often press the point by depicting specific incidents, as in *Hannibal* or *Fort Rock;* more often places could be expected to speak for themselves to an audience which would recognize, for instance, the literary associations of Lake Geneva.

Edward Gibbon had written his *Decline and Fall of the Roman Empire* there, and Jean-Jacques Rousseau his *Nouvelle Heloïse.* Voltaire and Madame de Stael had both lived there, and Byron, who enshrined their achievements in *Childe Harold,* stayed in 1816 at Cologny, two miles from Geneva. Nearby, at Montamegre, Shelley was also staying, both for different reasons exiles from London and the great world. Turner contributed no less than they to the genius of the place. The noble watercolour he made of Lake

Geneva for Fawkes about 1805, as potent in its serenity as his wilder images of the mountains beyond, is a visual parallel to Byron's later description of it in his tribute to Rousseau in *Childe Harold*:

> 'tis long
> And wonderful, and deep, and hath a sound
> And sense, and sight of sweetness; here the Rhone
> Hath spread himself a couch, the Alps hath rear'd a
> throne.

GREECE: LIBERTY LOST AND FOUND

If Turner can be said to have anticipated something of Byron's view of Switzerland and the Alps, there is also a sense in which he preceded the poet in his interest in Greece, although he never visited the country. By 1800, he had begun to read ancient Greek literature (later his friend Henry Trimmer would try to teach him Greek), and he had approached Ancient Greece even earlier through his interest in architecture.

A significant number of his early oils took up themes from Greek history, literature and mythology. For *Jason* of 1802, he read Apollonius Rhodius, and the same year he began sketching a subject of the doomed lovers Hero and Leander, from Nusaeus's poem, a theme that would finally mature in his great painting of 1837.

It was between 1809 and 1811 that Byron made his famous visit to Greece, swimming the Hellespoint, musing on departed glories and identifying himself with the Greeks' longing for freedom from Turkish rule. Meanwhile, in London, Turner had admired the Parthenon marbles – writing to Lord Elgin when they were displayed that they belonged to 'the most brilliant period in human nature' – and had in imagination been peopling the shady banks of the upper Thames with the gods and heroes of antiquity in his sketchbooks. In about 1810 he inscribed one sketch of a Neoclassical subject with the alternative titles 'Homer reciting to the Greeks his Hymn to Apollo' (a subject that Thomas Lawrence had painted in 1799) and 'Attalus declaring the Greek States to be free'. The latter seems a clear reference to contemporary

concerns, and an anticipation of Byron's espousal of the cause of Greek liberty, first proclaimed in *Childe Harold* and sublimated in his martyrdom at Missolonghi in 1824.

Childe Harold exemplified a particular British view of Europe, in which past and present were contrasted, and in which the state of liberty was used as the barometer by which nations were judged. This traditional theme was taken up afresh by other major voices of Turner's generation – by Samuel Rogers, Walter Scott and Thomas Campbell, all of whom Turner

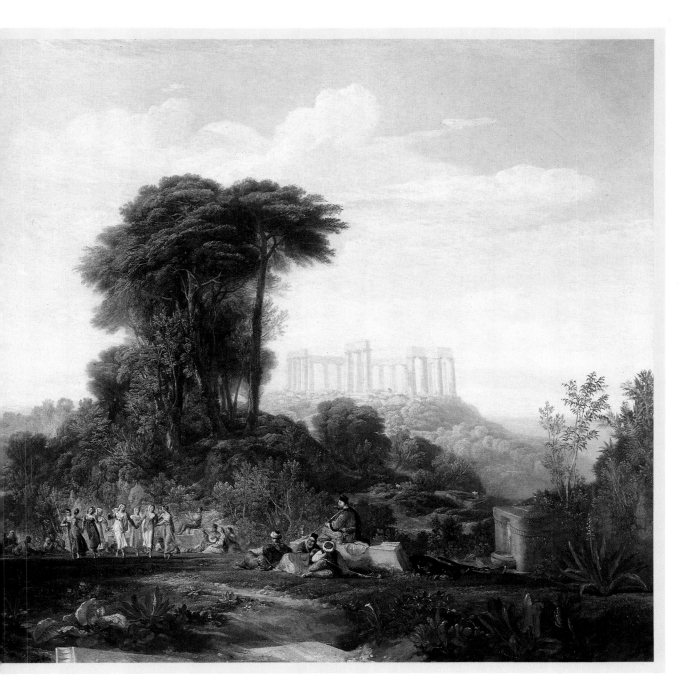

ABOVE:

*THE TEMPLE OF JUPITER PANELLENIUS,
WITH THE GREEK NATIONAL DANCE OF THE
ROMAIKA: THE ACROPOLIS OF ATHENS IN
THE DISTANCE*

J. M. W. Turner, oil, Royal

Academy, 1816. The Duke of

Northumberland. One of a pair of pictures

of the temple of Jupiter, first excavated

by an Anglo–German team in 1811

was to read and illustrate; and the cause of Greek independence became a particular issue for him when he illustrated John Murray's edition of *Byron's Life and Works* in the 1820s.

Meanwhile, in 1816, he took Greek subjects for two views of the Temple of Jupiter Panellenius, the first of a series of pairs of pictures contrasting ancient and modern life and culture. His literary sources for these did not come directly from Byron, but from the Yorkshire author Henry Gally Knight and from another poet, Robert Southey.

157

CONTINENTAL VIEWS: A NEW TASTE

While the English Romantics poured much of their creative energy into reflecting on the moral and spiritual condition of Europe, after Napoleon's downfall a more universal popular curiosity about the European scene began to make itself felt. As the middle classes followed in the footsteps of earlier Grand Tourists, and diverged more widely from the traditional itinerary whose main objects had been Rome and Naples, a new travel literature was born, and with it a new taste. Artists began to explore the picturesque, and more readily accessible, towns of northern France or the Low Countries, and Continental views appeared in ever-increasing numbers in the Academy and the exhibition of the Society of Painters in Water-Colour.

Publishers, never slow to exploit a new market, found large profits in illustrated travel books with literary contributions by leading authors and engravings after the best artists, often issuing them in the form of luxurious annuals to encourage regular collecting and present-giving. This industry, which began to flourish in the early 1820s and burgeoned in

THE FIELD OF WATERLOO

J. M. W. Turner, oil, Royal Academy,
1818. Clore Gallery for the Turner
Collection.

the next decade, came to occupy much of Turner's time. Many of his finest Continental views were made for projects of this kind, and his contributions, although by no means typical of their time, set the standards for his own engravers and for other artists.

Several artists in particular seem to typify the taste of the Annual reader. Samuel Prout, John Duffield Harding and Clarkson Stanfield all specialized in a certain kind of Continental view, taken in quaint old towns and concentrating on picturesque Gothic architecture or the costumes and habits of the populace. The latter were deliberately – and not a little patronizingly – presented to the British public as a survival from some earlier age, or as extras in a costume drama. Such was a vision that had an obvious and tantalizing appeal to the inhabitants of an increas-

ingly urban and industrial society. It was totally different from, but in its own way no less escapist than the nostalgic evocations of Classical antiquity that the eighteenth-century painters and draughtsmen had brought home for their patrician patrons.

Turner stood apart from this prevailing taste, retaining always a breadth of vision that owed more to the Classical tradition than to his first topographical training, and emphasized his concern for light, atmosphere and colour rather than complex surface detail. At the same time, he achieved a blend of past associations with current activities, so that his European views are no less evocative than his contemporaries', but belong distinctly to their own age.

WATERLOO AND THE RHINE

Turner's first visit to the Continent had been in every way exceptional. It had been planned hastily, and he had travelled in some comfort. His subsequent journeys were made more independently, though not of course completely alone as he used public transport, and he prepared himself for them by reading such guidebooks as he could find and by gathering advice from friends and colleagues. The sketchbooks he took with him were annotated in advance or during his journeys with addresses, itineraries and essential vocabulary.

His first expedition across the Channel after the end of the war was made in the autumn of 1817 to Belgium, Holland and the Rhine. He arrived at Ostend in August, and visited Bruges, Ghent and Brussels. His main destination was Waterloo, a place of huge significance for his generation – the field on which Napoleon's vision of empire had been destroyed and Europe's destiny had been decided. It had almost immediately become a place of pilgrimage and the subject of a large literature, while the British Institution had in 1816 set aside 1000 guineas to be divided among British artists who painted sketches of the recent triumphs of the British army.

Most powerful of contemporary voices was, of course, that of Byron who devoted the third canto of *Childe Harold* (1816) to the battle, and it was from this

that Turner took the lines he appended to his painting of the battlefield – no celebration of victorious arms but a tragic vision of their bloody aftermath. Byron's image – 'Rider and horse – friend, foe on one red burial blent' – became Turner's own; his picture, exhibited in 1816, is without either heroes or enemies, stressing not the glory but the futility of war. In ignoring the claims of national pride, it seems to proclaim a sense of a wider culture whose disintegration through war can only be cause for lament.

In 1817 Turner used – and lost during the journey – one of a recent crop of travel books, Charles Campbell's *Traveller's Complete Guide through Belgium and Holland, with a Tour in Germany*. This had been published in an 'improved' edition that year with quotations from recent writers on Waterloo, including Scott, Southey and Byron.

Byron had not paused in his third canto to consider the fate of Belgium after Waterloo, though here too the settlement of Europe had brought significant change. Belgium had been the property of Austria, but dominant as Austria was in the new Europe, she was content to exchange her part of the Netherlands for Galicia in central Europe and Lombardy and Venetia in Italy, joining Belgium to Holland to create a stronger buffer against France. The effects of this were more quickly felt in Italy than in the Netherlands: while the North Italians strained against the Austrian occupation, the Belgians and Dutch were at first quite happily united with Luxembourg in the new kingdom of the Netherlands under William I of Orange, who had spent the war as an exile in England.

There was little in the Netherlands to stir the passions, and the scenery was too placid – river, meadow and sky. For Turner, however, it evoked the spirit of Cuyp, and he returned through Rotterdam and visited the painter's home town of Dordrecht. In 1818 he produced the *Dort,* a celebration not only of the painter and his setting but also of the rediscovered joy of travel. The *Dort* is the very antithesis of the tragic despair of Waterloo – light after dark, a statement on the durable values of a continent and culture once again open.

While Turner was only one of many who made the

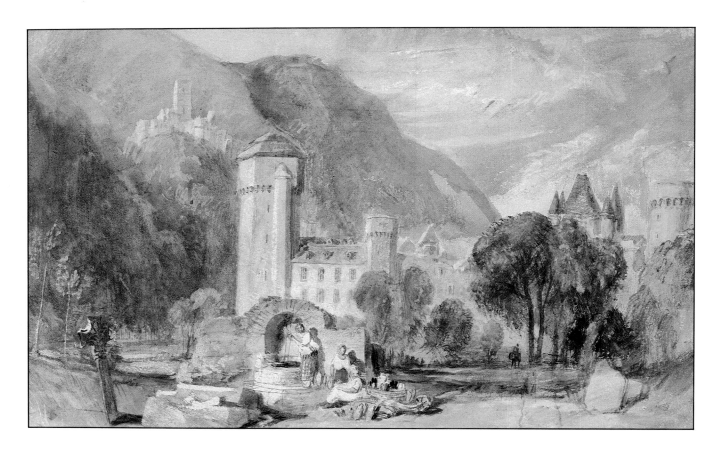

OBERLAHNSTEIN

J. M. W. Turner, bodycolour on prepared
paper, 1817. British Museum, London.
One of the 51 views of the Rhine made
probably very soon after Turner' return,
and acquired by Walter Fawkes.

pilgrimage to Waterloo, it was probably more direct-ly in the footsteps of *Childe Harold* that he continued in 1817 to the Rhine, though once again, Campbell's guide was also at his command. Travelling by road to Aix-La-Chapelle and river to Mayence, he took less time than the author recommended, but still managed to assemble material from which, after his return, he developed a magnificent series of fifty-one water-colours bought by Fawkes. He also contracted, in 1819, to make thirty-six views of the river for engrav-ing by W.B. Cooke and J.C. Allen. Only four were apparently made, perhaps because Rudolph Acker-mann, capitalizing on the growing market for such literature, had published his own *Tour of the Rhine*.

It was hardly surprising that the Rhine should have become an early focus of travel literature – Turner acquired two guides for his library, by Joseph Mawman (1816) and Aloys Wilhelm Schreiber (1818). One of the great rivers of Europe, it was by now becoming prosperous and active. The larger part of the area had been French for twenty years up to 1815, when the left bank was handed to Prussia and other parts to Holland and other German states. It had been well run under the Napoleonic Code, and while much of Germany was then among the most under-developed territory in Europe, the Rhineland was experiencing the beginnings of industrialization. There was much traffic on the river, and along its banks wonderful scenery and the splendid ruined castles, such as Drachenfels and Ehrenbreitstein, which Byron described in *Childe Harold*.

ITALY: 1819

In 1819 Lawrence, who was in Rome painting por-traits of the Pope and Cardinal Consalvi for the Prince Regent, wrote, 'Turner should come to Rome. His

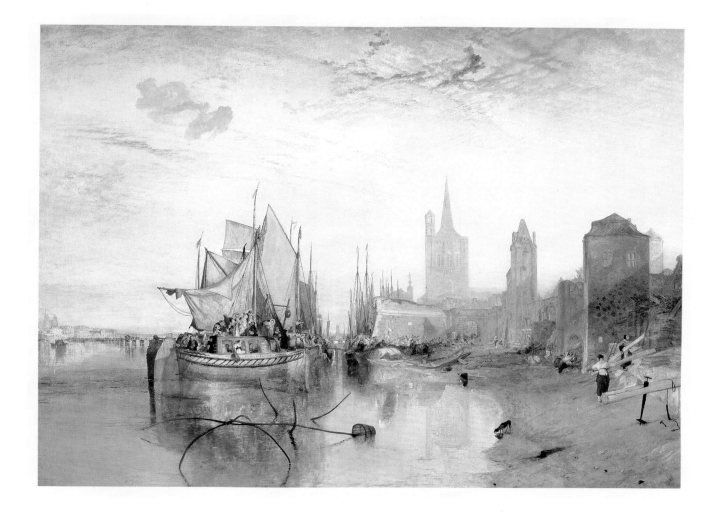

genius would here be supplied with materials, and entirely congenial with it.' His meaning was clear: no modern painter approached closer to Claude than Turner, and Rome must therefore be his spiritual home. Lawrence recognized that Turner's mastery of colour and atmospheric effect was perfectly suited to capture the special qualities of Italy – 'the subtle harmony of this atmosphere, that wraps everything in its own milky sweetness . . . can only be rendered, according to my belief by the beauty of his tones.'

Although the Grand Tour was a thing of the past, destroyed for ever by war, Italy remained a mecca for all lovers of the arts. Turner might well have gone earlier had his commitments allowed, and late in 1817 he had been engaged by the architect James Hakewill to develop a series of illustrations Hakewill had made on the spot for his own *Picturesque Tour of Italy*.

In all, Turner made eighteen designs between 1818 and 1820, and probably had the opportunity to see

COLOGNE, THE ARRIVAL OF A PACKET BOAT. EVENING

J. M. W. Turner, oil, Royal Academy, 1826. Frick Collection, New York. The vivid colour of this picture, far exceeding the hazy golden tones of Cuyp or Callcott, was noticed at once. Turner visited and drew buildings at Cologne in 1825 as well as 1817.

ABOVE:

ROME: THE FORUM WITH A RAINBOW

J. M. W. Turner, pencil,
watercolour and bodycolour on prepared
paper, 1819. Clore Gallery for the Turner
Collection.

CENTRE LEFT:

S. GIORGIO MAGGIORE: FROM THE DOGANA
EARLY MORNING

J. M. W. Turner,
watercolour, 1819. Clore Gallery for the
Turner Collection.

BOTTOM:

THE PANTHEON

J. M. W. Turner, pencil, 1819,
a sheet from the 'St Peter's' sketchbook.
Clore Gallery for the Turner Collection.

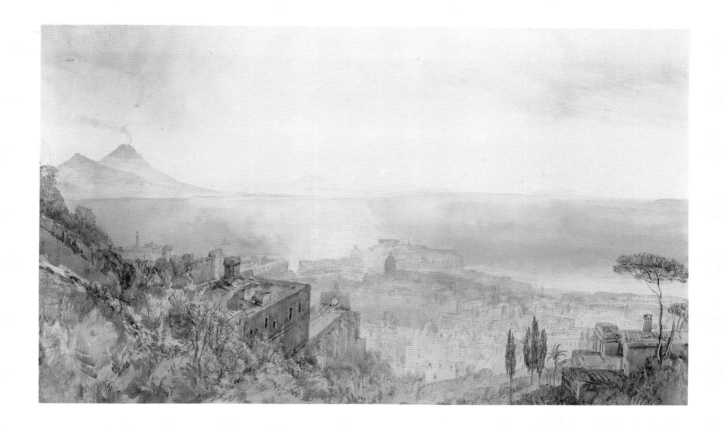

NAPLES FROM CAPODIMONTE

J. M. W. Turner, pencil and watercolour,
1819. Clore Gallery for the Turner
Collection.

ITALY, 1819

*T*he Italy that Turner first saw in 1819 was a land of mingled sadness and beauty. The peace of 1815 had left Italy a mere 'geographical expression'. Where Austria was not the master, as it was in the great new principality of Lombardy-Veneto, and in Tuscany, Modena and Parma, the country was split along old dynastic lines. A Bourbon king, Ferdinand I, now ruled again in Naples and the Two Sicilies, and Victor Emanuel I was restored to Sardinia, Piedmont and Savoy while gaining Genoa. These Italian regimes were often more reactionary than the Austrian, and none more so than that of Pope Pius VII, whose restoration to the Papal States in 1814 had been rapturously welcomed. But while Italy had lost its freedom or independence, it retained its beauty. The great collec-tions of art were restored after the war, and the landscape still spoke, as it had for generations, of Claude and Poussin. It was only afterwards that Turner sought to capture Claudean Italy, and its azure skies, in oil. The largest part of his time in 1819 was spent in making pencil memoranda of the sites of antiquity and the Renaissance, but in some limpid watercolours of Venice, Rome and Naples he found an instant response to the brilliant atmosphere of Italy. In a study of the Forum in Rome he concerned himself as much with vivid natural phenomena as with the fabric of the ruins, and Naples spread itself before him in a shimmering haze. Turner did not refer back to his first Venetian studies for finished watercolours or paintings, but Naples from Capodimonte *was worked up into a watercolour for Walter Fawkes.*

THE FORUM ROMANUM FOR
MR SOANE'S MUSEUM

———

J. M. W. Turner, oil, Royal
Academy 1826. Clore Gallery for the
Turner Collection. A free combination of
the buildings of ancient Rome, this was
painted for his friend the architect Soane.

———

the 300 drawings Hakewill himself had recently made. It was to Hakewill that Turner owed the itinerary that he recorded in his 'Route to Rome' sketchbook, although he modified this with reference to other recently published guidebooks. He left for Italy at the beginning of August, 1819, and followed a variant route, repeating his 1802 journey through France as far as Mont Cenis – this time by diligence – then

*FLORENCE, 'FROM THE PONTE ALLA
CARRAIA'*

*J. M. W. Turner, watercolour,
1816–17. Whitworth Art Gallery,
University of Manchester. One of the
wetercolours for Hakewill's Picturesque
Tour of Italy, based on the authors's own
sketch, made in July 1816. The view is
actually of the Ponte della Trinita, from an
upper window of Schneider's Hotel.*

Although he seems only to have stayed about five days in Venice, probably following Hakewill's advice and putting up at the Leone Bianco on the Grand Canal, the city may well have helped to form his melancholy view of Italy as a beautiful but haunted land. All around were reminders of the Venetians' great mercantile past, yet this once impregnable republic, after a long decline, was now underpopulated and demoralized. With much of northern Italy, Venice was now under Austrian rule, having long ago surrendered to Napoleon; the Austrians had found a city 'partly deserted and ruinous' after the years of French occupation.

An even sadder face was provided by Rome. For all its history and beauty, it was rapidly decaying, crippled by inefficiency, ruthless taxes and repressive laws. This did not prevent an international community of artists from establishing itself there in the early years of the peace, but at least one of them, the

passing through Turin, Como, and Milan and the Simplon Pass. After this, unlike Hakewill who had hurried straight on to Rome, he made a detour through Venice and the Veneto, moving down to Bologna and reaching Rome by way of Rimini, Ancona, Macerata and Foligno. From Rome he made a tour to Naples and the south, and probably spent Christmas in Florence.

165

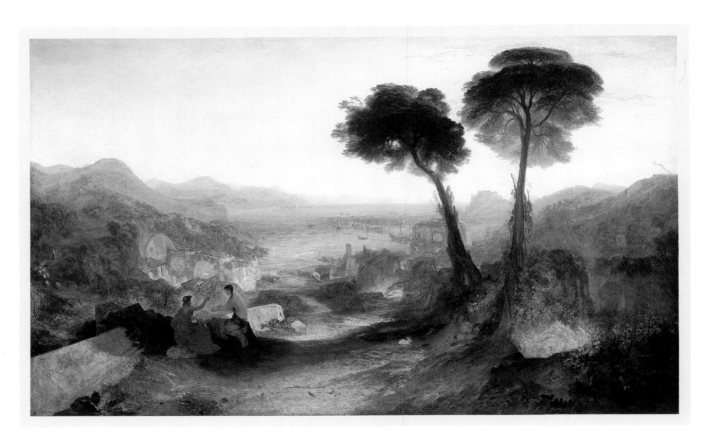

*THE BAY OF BAIAE, WITH APOLLO AND THE
SIBYL*

*J. M. W. Turner, oil, Royal
Academy 1823. Clore Gallery for the
Turner Collection. The second of Turner's
Italian oils painted after his first visit, this
was exhibited with the line 'Waft me to
sunny Baiae's shore'. The story of Apollo
and the Cumaean Sibyl comes from Ovid's
'Metamorphoses'. Turner sets it in a
brilliant Claudean panorama of scenery he
had visited from Naples in 1819, treated so
imaginatively that his friend Jones wrote
'SPLENDIDE MENDAX' (splendid
lie) on the frame.*

LAKE ALBANO

*J. M. W. Turner, watercolour,
c. 1828. Private Collection. An illustration
for the Picturesque Views in Italy planned
but not issued by Charles Heath, this
subsequently appeared in the Keepsake,
1829.*

clear-sighted and unsentimental Wilkie, first in Rome in 1825, did not enjoy the conditions he and two other English painters, Thomas Phillips and William Hilton, were experiencing. 'All agree with me in the opinion that this is a horrible country; and as for cheapness, which they all urge, I say that if, in England, you are satisfied with the same inns, you can live as cheap at home as here. Rooms, with coarse brick floors, shattered windows, such as you would not tolerate even in a wash-house, gain nothing by arabesque and fresco ceilings; and if this were on the confines of Norway or Siberia, allowance might be made for it; but in boasted Italy, the ancient mistress of art – it shows only the degeneracy of her present people.'

Wilkie's comments on the Italian landscape, written home to the painter William Collins, provided no less caustic an antidote to the received view of a land of ideal beauty; 'the country of Claude and the Poussins, what might it not furnish to you? For, in spite of the scanty verdure, the stunted trees, and the muddy streams, still this is Italy.' But Wilkie's jaded opinions – written, it must be admitted, in winter – were soon modified, and having made the necessary allowances he settled down to enjoy himself. He was not the first traveller to find that a true appreciation of Rome, like the city itself, was not built in a day. It was certainly true that an Englishman, bearing his gold currency, could live very well in Italy, as Byron had found in Venice. In Rome there was a lively expatriate circle, dominated by Elizabeth, Duchess of Devonshire, and including Turner's friend Eastlake, whose home was Turner's base on his 1828 visit.

On his first visit, however, Turner remained somewhat aloof from social life, keeping his address a secret and devoting all his time to working undisturbed, exploring the city and its surroundings, its antiquities, palaces, galleries and ruins, and nearby beauty spots like Tivoli. All these he recorded avidly in thumbnail pencil sketches, and in some wonderfully spontaneous watercolours. He was learning, and was not yet ready to produce finished oil paintings.

Probably Turner had little sense of the popular unrest brewing in the Papal States. Yet the Pope's domains were to be the focus of insurrection in 1830 and it would be necessary to enlist the support of the Austrians to settle Pius's successor, Gregory XVI, on the Papal throne. Italy was already networked with secret societies, of which the most vigorous were the Carbonari, or Charcoal-burners, to whose number Byron belonged, and within a year of Turner's first visit to Naples, they were to engineer a revolution in that city against its Bourbon monarch Ferdinand. Inspired by revolt against the Spanish Bourbons, the Neapolitans rose and demanded a constitution. In an appalling piece of perjury, Ferdinand granted it under oath, and then summoned the ubiquitous Austrians to restore absolute monarchy.

Perhaps some presentiment of the outburst in Naples was communicated to Turner when, with a young architect, T. L. Donaldson, he dined with the British Minister in the city. He had reached Naples by the quickest and busiest road, through Velletri, Terracina, Mola and Capua, doubtless to avoid the robbery and banditry that then beset this part of Italy.

In Naples, Turner was again hardworking and secretive – his address is not known, and he maintained his habit of assiduously gathering sketches and information in all the important places of interest in and around the city. Naples had long been a favoured spot with the British. Then larger and more cosmopolitan than Rome, an impressive metropolis with a glamorous if autocratic court, and set on its great bay overlooking one of the most celebrated views in Europe, it had been an essential stop on the Grand Tour. Like Rome, it was steeped in antiquity and tradition – Pompeii had already been extensively excavated by the French although Herculaneum as yet offered little to see – and possessed the added fascination of natural wonders like Vesuvius, which Turner climbed, and the lava fields below. Yet it is tempting to see a symbolic sunset touch in Turner's limpid watercolours of the city and the bay; he was seeing Naples in decline, for besides its political troubles, it was by now losing both its reputation as a resort and its status as an expatriate colony.

Florence, where as in Venice the Austrians now ruled, was to be the reverse of this story, as only later

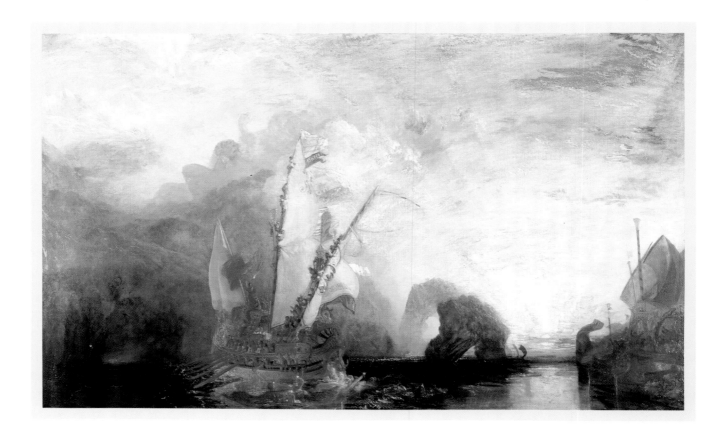

*ULYSSES DERIDING POLYPHEMUS – HOMER'S
ODYSSEY*

*J. M. W. Turner, oil, Royal Academy
1829. National Gallery, London. Based on
an oil sketch almost certainly made in Italy,
1828–9, this gorgeously coloured antique
fantasy is an entirely Turnerian
transcription of Renaissance and baroque
mythologies, in which the artist's
fascination with atmospheric effects in given
literal shape in the form of the nereids
dancing at the prow of Ulysses's ship.*

in the century did it become the haunt of writers and the favoured residence of an English and American community. Although its wealth of art and architecture had assured it a place on the Grand Tour, it had not been popular as a city for living in. All travellers admired its setting among the Tuscan hills, but its narrow and often gloomy streets, and overpowering buildings had made a bad impression. It was partly to catch a more open vista, over the River Arno towards the Ponte Vecchio and the Ponte Santa Trinità, that

English visitors who could afford it stayed at Schneider's Hotel on the Lungarno Guiccardini. Hakewill had included it in his travel advice to Turner, and Turner drew the view from its window several times in 1819. He did not stay long in Florence; he spent Christmas there, left in January, and was back in London on 1 February.

THE FRUITS OF THE ITALIAN TRIP

Turner's response to Italy during and after this first visit was evolved our several years and in several distict series of works. Besides great oils acknowledging

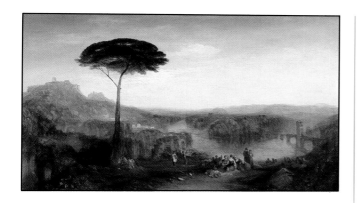

ITALY: CHILDE HAROLD'S PILGRIMAGE –
ITALY

J. M. W. Turner, oil, Royal Academy,
1832. Clore Gallery for the
Turner Collection.

pressed in his subjects for Rogers, which Ruskin recognized as 'the beautiful concentration of all that is most characteristic of Italy'. Rogers's poem was itself typical of a new type of travel literature that avoided the cataloguing of 'must-sees' found in conventional guides but instead collected personal impressions and associations. Without much gift for description, Rogers's approach was more pictorial and episodic, and from the latter's wide-ranging allusions to history and legend and his own sketches, Turner distilled a series of images that perfectly complemented the text. The impression they create is more complete, and wider in emotional range, than the melancholy stress on transience and decay that Turner absorbed from Byron; in the Rogers illustrations we sense the true joy of the informed traveller.

THE SECOND ITALIAN VISIT: 1828–9

Rogers's final poem in *Italy* had been 'A Farewell', and when leaving Italy after his second visit, Turner must have had it in his mind when writing his own poetic 'Farewell to Italy, land of all bliss'. On his arrival he had described Italy to his friend George Jones simply as 'Terra Pictura'.

He behaved differently on his second visit. In his sketchbooks he drew more perfunctorily, with less energy of discovery, and only in pencil. He also made himself more sociable, staying part of the time with Eastlake in the Piazza Mignanelli, and he did plenty of painting. He exhibited several pictures and made some oil sketches, some of which served as the germ of future canvasses, including that brilliant work which Ruskin was to call 'the central picture' in his career, *Ulysses deriding Polyphemus.*

Turner was now playing with antiquity, myth and colouristic effect with a freedom bordering on abandon. One of his Roman exhibits, *Regulus,* a subject taken from Roman history, was (at least after reworking in 1837) hardly less extraordinary than *Ulysses* in its imaginative vision of Classical architecture and the blazing colour that separates it from its ultimate models, the seaports of Claude. But Turner also showed the Romans a more restrained, if still

ancient and Renaissance Rome and the landscape and mythology of the south, he made eight watercolours of Venetian, Roman and Alpine subjects for Fawkes, and between 1826 and 1828, two other series for engraving, one for a set of *Picturesque Views in Italy* proposed by the engraver Charles Heath, and the other to illustrate Samuel Roger's poem *Italy*.

Had it been completed, *Picturesque Views* would doubtless have offered the kind of comprehensive view of a country and its people that one finds in *England and Wales.* The grandiloquent appeal to cultural heritage proclaimed in the oils gave way in the plate-designs to a humbler but very expressive combination of scenic beauty and local life. Here Turner was moving towards the prevailing fashion for the picturesque details of contemporary Italian life found in the work of Eastlake, Wilkie or Thomas Uwins; his oils are among the last great celebrations of Classical Italy and of the ideals of the Grand Tour, but his drawings hint at a change in attitude to Italy and things Italian. Appropriately enough, his illustrations for *Picturesque Views,* aimed at a more popular market, were used instead, on a reduced scale, for plates to the even more popular annual, the *Keepsake.*

The most complete synthesis of Turner's ideas of Italy, at least in the medium of illustration, was ex-

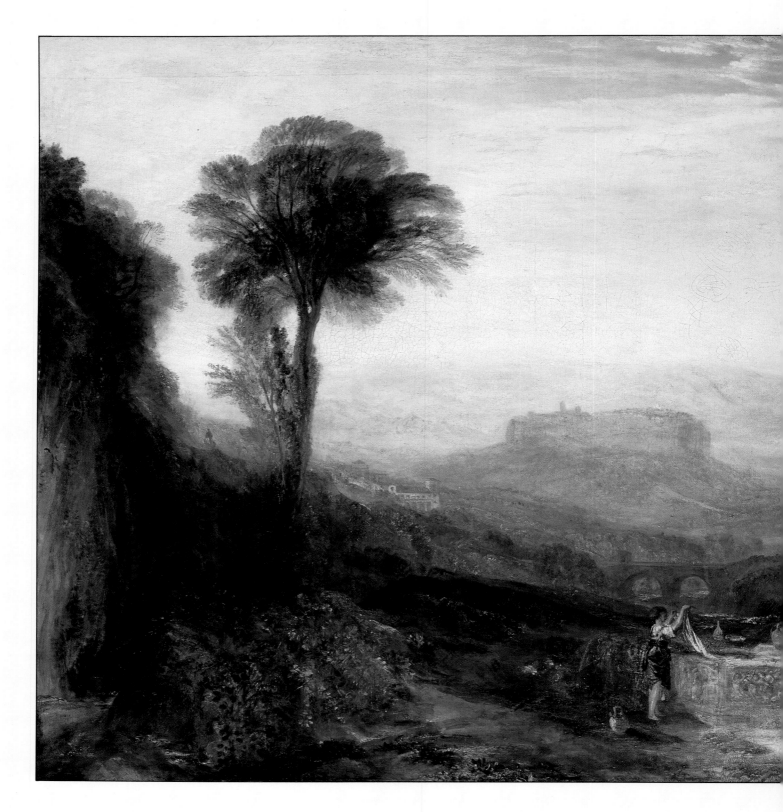

ABOVE:

VIEW OF ORVIETO

*J. M. W. Turner, oil, exh. Rome 1818–9,
Royal Academy 1830. Clore Gallery for
the Turner Collection.*

ABOVE RIGHT:

PALESTRINA – COMPOSITION

*J. M. W. Turner, oil, 1818–9, Royal
Academy 1830. Clore Gallery for the
Turner Collection.*

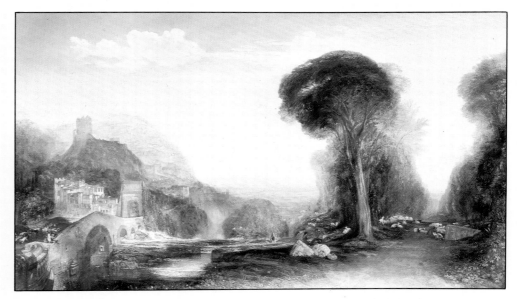

ITALY 1828-29

*A*lthough *Turner had painted some splendid canvases of idealised Mediterreanean landscapes or seaports based on Claude before his first visit in 1819, he did not immediately translate his first-hand experience into oil. His first paintings of Italian subjects appeared between 1820 and 1826. Back in Rome in 1826, however, he established a painting room in the lodgings he had come to share with his friend Charles Eastlake, ordered a roll of canvas, and made both a set of composition sketches in oil, and some more finished pictures. His 'first touch in Rome' was* Palestrina, *painted 'con amore' with the intention of offering it as a companion to Lord Egremont's Claude,* Jacob and Laban – *already acknowledged in* Macon *and* Apullia in Search of Appullus. *He also painted, and included in a one-man show at the Palazzo Trulli, the exquisite pastoral,* Orvieto, *and the dazzling adaptation of a Claudean seaport,* Regulus. *Turner's exhibition, intended to silence the 'gabbling' of the Roman art word, was highly controversial, as Eastlake reported: 'More than a thousand persons went to see his works when exhibited, so you may imagine how astonished, enraged or delighted the different schools of artists were, at seeing things with methods so new, so daring, and excellencies so unequivocal. The angry critics have, I believe, talked most, and it is possible you may hear of general severity of judgment, but many did justice, and many more were fain to admire what they confessed they dared not imitate'.*

171

richly toned, view of their familiar pastoral Italy, the *View of Orvieto,* and had begun the large and beautiful *Palestrina,* exhibited in 1830. This depicted a scene associated with Horace, but it was to Byron that Turner still looked most often to underline his later statements about Italy, giving his all-embracing vision of its fading beauty Byron's own title, *Childe Harold's Pilgrimage.*

In his later years, Venice was Turner's main Italian haunt. Its juxtaposition of sea, sky and splendid architecture, its dancing reflections and maritime climate, offered more than the antique grandeur and brilliant sunshine of Rome. There had been a lonely and faintly sad calm about his Venetian watercolours of 1819, but his later impressions are more robust, capturing a city of fireworks, theatres and entertainments as much as of a silent beauty. Such was the carnival spirit that Byron had celebrated in the lines Turner appended to his Venetian fantasy of 1836, *Juliet and her Nurse:*

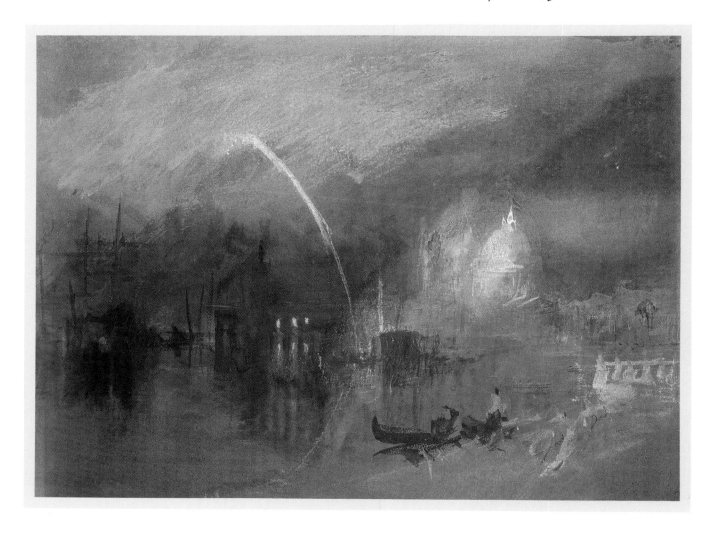

The pleasant place of all festivity
The revels of the earth, the Masque of Italy

In truth, Byron's earlier lament for Venice had been somewhat overstated. In his *Ode on Venice* he had asked rhetorically:

If I a northern wanderer weep for thee
What should thy sons do . . .

But privately, he had enjoyed himself enormously in the city – not least with its daughters.

FRANCE: FROM 1820

The quantity and beauty of Turner's drawings and paintings of Italy notwithstanding Ruskin was convinced that 'of all foreign countries Turner has most entirely entered the spirit of France.' This, he considered, was because 'he had found more fellowship of scene with his own England'.

Undoubtedly, Turner came in the 1820s and again at the end of his travelling career to appreciate the strong affinity between the two coasts of the Channel, but he ranged far beyond the familiar world of the beach, cliff and sky. It was not until after his first trip to Italy that he began to explore France thoroughly, and the inland France of picturesque old towns and noble rivers was now his main concern. In this he was prompted by another of Charles Heath's publishing projects, a series illustrating the great rivers of Europe, the Rhine, Moselle and Meuse, and those of France, the Seine and Loire, had to be investigated.

In the late summer of 1826, Turner accordingly made a tour of Holland and Germany, and then moved down the northern French coast to Abbeville and Dieppe before following the Loire as far as Orléans.

LEFT:

FIREWORKS OF THE MOLO

J. M. W. Turner, watercolour and bodycolour on buff paper, 1833. Clore Gallery for the Turner Collection.

FAREWELL: LAKE OF COMO II FOR ROGERS'
ITALY

J. M. W. Turner, watercolour, c. 1827.
Clore Gallery for the Turner Collection.

After this he returned through Paris. Another tour for the projected 'Rivers of Europe' was made in August 1829, this time to cover the Seine to Honfleur and to study the Normandy coast, Guernsey and Brittany – then uncharted territory for an Englishman. This was in connection with a scheme for a set of views to be called *'the English Channel'* or *'La Manche'*.

Turner might have continued these investigations into 1830, but this was no time to be in France. The reactionary régime of Charles X collapsed in the July Revolution, and was succeeded by the 'citizen monarchy' of Louis-Philippe. The repercussions of the upsets in Paris spread through Europe, but France itself settled quickly into a new constitutional experiment along the lines of English parliamentary monarchy, and Turner returned in September, 1832.

He was still working on the 'Rivers' scheme, but was also gathering material for another engraving project illustrating Walter Scott's *Life of Napoleon*. The first of three volumes of the *Rivers of France, 'Turner's Annual Tour – Wanderings by the Loire'*, appeared the following year; it contained twenty-one plates after Turner with a text by Leitch Ritchie. The first Seine volume, with twenty plates, appeared in

173

ABOVE:

BEAUGENCY

J. M. W. Turner, watercolour, bodycolour and ink on grey paper, c. 1830. Ashmolean Museum, Oxford.

BELOW:

PARIS: THE SEINE FROM THE BARRIERE DE PASSY, THE LOUVRE IN THE DISTANCE

J. M. W. Turner, bodycolour and ink on blue paper, c. 1832. Clore Gallery for the Turner Collection.

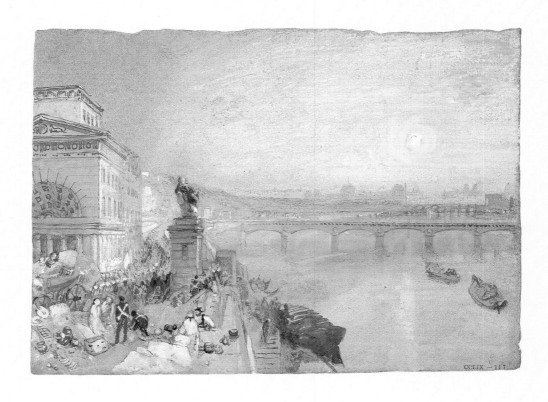

THE CASTLE OF BEILSTEIN ON THE MOSELLE

*J. M. W. Turner, bodycolour on blue
paper, c. 1834. Clore Gallery for the
Turner Collection.*

RIVERS OF EUROPE

*A*mong the most ambitious of the engraving projects for which Turner made drawings in the 1820s and afterwards was a serious covering the great rivers of Europe, launched by Charles Heath in 1826. Only two rivers were actually published, Turner's Annual Tour – Wanderings by the Loire, *1833, and* Wanderings by the Seine, *1834 and 1835. But Turner travelled much more widely for the scheme, investigating the Meuse, Moselle and Rhine. It was on a tour from Trier down the Rhine in the late summer of 1826 that he probably first used the type of soft-covered 'roll' sketchbook, convenient for tucking into his coat pocket, that he habitually took with him on his later travels. The drawings made for the* Rivers *however, were made on small sheets of blue paper. Beaugency, one of those for the Loire series, displays the reductive, suggestive manner that Turner now brought to many of his designs; it was left to the engraver to emphasize the effects of early morning light and reflections hinted at here. The five Parisian views for the Seine series, on the other hand, are more elaborate, touched roughly but effectively with vivid bodycolour and ink to convey a wealth of architectural detail and the crowded humanity of the metropolis. Turner's Meuse and Moselle material was not used by Heath. It included some exceptionally brilliant studies in pure colour.*

175

SCHLOSS ROSENAU

J. M. W. Turner, pencil and watercolour,
1840. Clore gallery for the Turner
Collection. Turner visited Coburg and
Prince Albert's home, in 1840. He
exhibited a painting of it (now at
Liverpool Walker Art Gallery) in 1841.

1834; the Seine was also the subject of the final volume, published in 1835. Together they represent a high point in Turner's work for the engraver, and of his mature approach to topography, while his small drawings, on blue paper and jewel-bright with watercolour or bodycolour, are themselves triumphs of technique.

The other river projects did not materialize, but Turner continued to travel extensively in the 1830s, responding with spontaneous delight to people and places whether or not he had a specific task in mind. In 1833 he made a long and adventurous tour of Europe that took him from Copenhagen to Berlin, to Prague, Vienna and along the Danube, south to Salzburg and Innsbruck, through the Brenner pass to Verona and Venice, and thence back through Munich, Augsburg, Stuttgart and Heidelberg and northwards along the Rhine. Another tour of the Meuse, Moselle

and Rhine took place in 1834, for a proposed sequel to the *Annual Tours* of rivers. Turner was in Belgium again in 1839, and in 1836 he made the first of his final series of visits to Switzerland.

The purpose of the 1833 tour may have been mainly to investigate the picture galleries of Europe. Turner was now involved in the planning of the new buildings for the Royal Academy and the National Gallery in London, and it was perhaps because his mind was on architectural matters – whether the new Neoclassical buildings of Dresden and Berlin or the medieval splendours of Prague – that he made fewer brilliant colour studies of river scenery than on his other trips along the Meuse, Moselle or Rhine. He did, however, make some lovely drawings, whose pale and limpid washes, floated over a swift but highly descriptive framework of pencil outline, anticipate his techniques of the 1840s.

GERMANY: FROM 1833

Turner's 1833 tour had taken him chiefly through Austrian and German territory. In Vienna he witnessed the capital of the Empire whose writ ran through much of Italy and whose influence was still pervasive in central Europe, if only because Metternich had for so long and so effectively warned his satellites of the dangers of revolution if they did not submit to the controls and censorship orchestrated from Vienna. In the German states these took the form of the Karlsbad Decrees, originally presented by Metternich, with the collusion of the King of Prussia, in 1819, following an outbreak of student disturbances in the cause of national unity and liberal ideals, This, the so-called *Burschenschaften,* had been doomed to failure, but in 1833 Turner was travelling through a Germany freshly devoted to unity by the more pragmatic means of trade and commerce. Foolishly, Austria was as yet indifferent to this development, but would soon find herself excluded from a powerful and potentially advantageous Customs Union of German speaking peoples at the heart of Europe. By a further irony, the initiative had come first from Prussia, which had seemed so willing to submit to Austrian manipulation.

When Turner travelled the Rhine, he was observing the main artery of a new and resurgent Germany. The process of customs unification, the *Zollverein,* was well advanced by 1833, and seventeen states were now embraced by it, engaged in free trade with each other and charging a uniform tariff on all frontiers. By 1840, when Turner was again travelling along the Rhine on his way to Venice, the benefits had become clear, and a mutually advantageous treaty was made between Britain and the *Zollverein* the following year.

Prussia was now the dominant German power, but it was in other states that Turner found the strongest evidence of the new German spirit and its relevance to Britain. In the spring of the 1840 Queen Victoria had married the young Prince Albert of Saxe-Coburg, a man of advanced artistic tastes, and returning from his autumn trip to Venice, Turner took care to stop at Albert's family home, Schloss Rosenau. He showed an oil of it at the Academy the following year, still hoping, perhaps, for the royal patronage that had always eluded him.

The same trip took him to Munich, a fine city with splendid new buildings erected under the auspices of another royal arbiter of taste, Ludwig I of Bavaria. At nearby Regensburg on the Danube Turner visited the Walhalla, a great Neoclassical temple then under construction to the designs of Leo von Klenze. This, opened in 1842 with over a hundred marble busts of eminent Germans and appropriate frescoes and sculptures, symbolized the rebirth of national pride. That year, Turner exhibited his own tribute to it, *The Opening of the Walhalla,* a painting which he sent three years later to the 'Temple of Art and Industry' exhibition in Munich, with lines of his own poetry expressing honour to Ludwig and his sense of joy in cultural revival after the ravages of war.

By a cruel irony, the Germans laughed at his picture. They knew Turner's work mainly from the engraved views of Continental scenery like the *Rivers of France,* and could grasp neither the subtleties of his mature style nor the generous message of so didactic a work. Nevertheless, Turner's gesture expressed the deep kinship he now felt with the culture and traditions of Europe as well as its scenery.

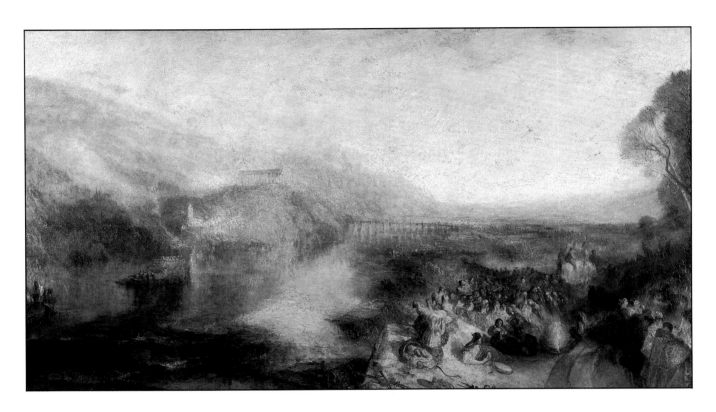

LAST VISITS TO SWITZERLAND AND FRANCE: 1840–1845

The Switzerland to which Turner returned each summer between 1840 and 1844 was in danger of breaking apart on religious grounds. There had been hopes of turning the country into a single democracy, but democratic Protestants were bound uneasily together with traditional Catholics, who found themselves increasingly under threat from mob violence, and in 1834 formed a defensive alliance, the *Sonderbund*. Only their decisive defeat in 1847 cleared the

way for the development of a single Federal State.

In 1844, when civil war was brewing, Turner declared he little knew 'what a cauldron of squabbling, political or religious I was walking over', but it was perhaps significant that in one of his watercolours of Lucerne he included in the foreground a group of men engaged in target practice. On the whole, however, his views of the Swiss cities from his last four visits are redolent of a civilized and urbane calm, heightened by a sense of communion between human activities and magnificent natural settings.

Turner found his mature vision of Switzerland in 1841, and so powerful was the country's impact that he returned to it for the next three years, and would have done so again in 1845 had his health not broken down. It was a vision very different from that of 1802, when he had confronted the insignificance of humanity with the awesome power of nature, and it was concentrated within a particular area, the great triangle of lakes and mountains from Geneva in the east, Zurich and Lucerne in the north, and Bellinzona and Como to the south. His new vision was conditioned also by more comfortable circumstances of travel. Napoleon's roads had opened up the Alps; there were new feats of engineering like the suspension

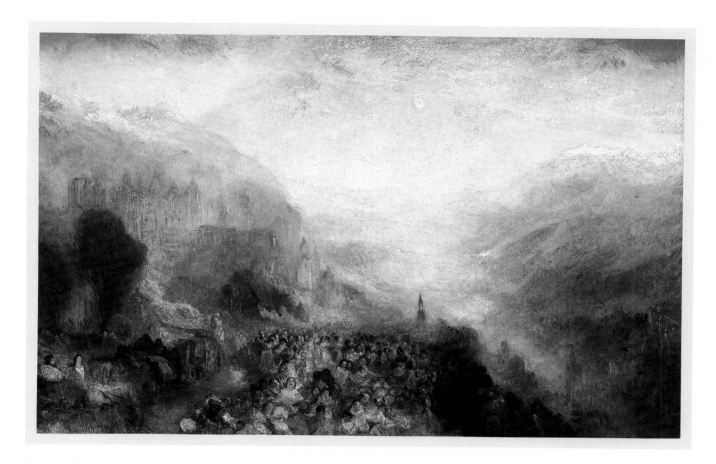

HEIDELBERG

J. M. W. Turner, oil, c. 1840–45. Clore Gallery for the Turner Collection. Turner's Walhalla celebrated resurgent, modern Germany. This exuberant work celebrates historical Germany, probably showing the court of the 'Winter Queen', Elizabeth of Bohemia, sister of Charles I of England.

bridge at Fribourg; steamers plied the lakes; and towns like Lucerne and Lausanne were more and more geared to the tourist industry.

At Lucerne, according to Ruskin, Turner stayed at the Schwan Inn, one of the new comfortable tourist hotels recently recommended by Murray's *Handbook to Switzerland,* published in 1838. It commanded a spectacular view across the northern part of the lake to the Rigi mountain, whose changing appearance under different lights became the object of particular fascination for Turner. Of this famous landmark, and of other Swiss lakes and cities, he made the numerous colour studies and the series of magnificent finished watercolours that represent the consummation of a lifetime of view making and a study of natural phenomena.

Turner early recognized the potential of his Swiss colour studies, selecting a group of those made in 1841 for further development. These he placed with his agent Thomas Griffith as bait for commissions for finished watercolours. Though he did not secure all the commissions he hoped for, he repeated the process

the following year, and a total of twenty-six finished watercolours emerged from his last Swiss tours.

In 1844 Turner went again to Lucerne, but bad weather prevented further progress. 'The rains came on early', he reported, 'so I could not cross the Alps, twice I tried, was set back with a wet jacket and worn-out boots and after getting them heel-tapped I marched up some of the small valleys of the Rhine and found them more interesting than I expected'. Though the traveller's lot was vastly easier than it had been when Turner first visited the Continent, he

STORM CLOUDS: LOOKING OUT TO SEA

*J. M. W. Turner, watercolour, 1845.
Clore Gallery for the Turner Collection. A
leaf from the 'Ambleteuse and Wimereux'
sketchbook.*

was still at the mercy of the elements to a degree inconceivable today. Yet it was typical of him to turn such a hindrance to good account,

Only age and illness would halt it. In 1845 he was set for Switzerland again, but was not too unwell to make the journey. Instead he went twice to France, to the Channel coast of Normandy and Picardy, once in the spring and again in the autumn. The journey was now easily made by steamer, and he travelled light, with nothing 'but a change of linen and his sketch-books'. His artistic purpose was equally single-minded: 'looking out for storms and shipwrecks'. His sketches and colour studies from these last wanderings along the French coast are as exquisitely minimal in their impressions of clouds, wet sands and breaking waves as those of the Kent shore made the same year;

It is fitting that an Englishman with so European an outlook should, near the end of his life, so unite the imagery by which he rendered the two shores of a stretch of water that had for so long protected his country from turbulent events on the other side. Fitting, also, that Turner should be summoned to dine with King Louis-Philippe, whom he had met when the future king was in exile in Twickenham, at his château at Eu on the Channel shore. Turner was staying in a fisherman's house, we are told, and persuaded his landlady to cut up some old linen to make a suitable cravat. That night, as so often in his life and art, Turner crossed the boundaries and broke the barriers of his age.

WHITE CLIFFS AT EU

J. M. W. Turner, watercolour, 1845.
Clore Gallery for the Turner Collection.
King Louis-Philippe's château, where
Turner was invited to dine in 1845, is set
high above the village.

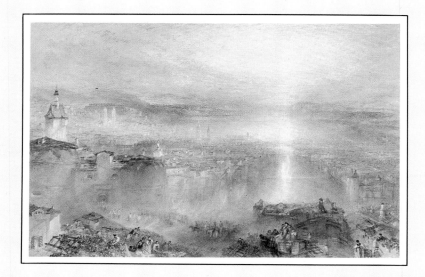

ABOVE:

LUCERNE FROM THE WALLS

J. M. W. Turner, sample study, watercolour, 1842. Clore gallery for the Turner Collection.

LEFT:

ZURICH

J. M. W. Turner, watercolour, 1842. British Museum, London.

THE RED RIGI

*J. M. W. Turner, sample study,
watercolour, 1842. Clore gallery for the
Turner Collection.*

LAST VISIONS OF SWITZERLAND

*T*urner visited Switzerland every summer between 1841 and 1844. In 1802 he had been moved above all by the mountains; now the lakes and cities, especially Lucerne, with their constantly changing lights, proved a source of sustained inspiration, calling forth long series of vivid colour sketches in the soft-bound sketchbooks Turner took with him everywhere. Turner hoped his Swiss studies would prove popular subjects for finished watercolours, and, as what Ruskin called 'signs for his re-opened shop', developed some as samples for offer to prospective purchasers through his agent, Thomas Griffith.

Unfortunately not as many commissions were received as Turner expected, but the 'Red Rigi', one of a large number of studies of this famous mountain under different effects, was among the subjects adopted, for a watercolour for his friend and patron Hugh Andrew Johnstone Munro of Novara, who had accompanied Turner to Western Switzerland and the Val d'Aosta in 1836. Ruskin also proved a generous patron and proud champion of Turner's last Swiss watercolours. Sweeping panoramas of mountains and lakes, shot through with shimmering effects of light, they represent the magnificent climax of Turner's revolutionary progress as a watercolourist, and of his transformation of view-making into an art of visionary revelation.

TURNER'S GALLERY WITH THE ARTIST
LYING IN STATE
———

*George Jones, oil on panel, c. 1851.
Ashmolean Museum, Oxford. Turner's
gallery in his house in Queen Anne Street,
had been a fine and well-lit room when first
constructed. In Turner's later years it was
neglected and dirty and the pictures the artist
stored in it fell into decay.*

———————

CONCLUSION: TURNER'S LEGACY

We hasten, while we have yet room in this, to congratulate the country in having to boast of work which will carry down to posterity the date of the present time and cause it to be named with honour by those who are yet unborn. Contemporary criticism seems puny, and almost irreverent when applied to productions whose flourishing existence, when criticism is hushed and critics are no more, is secured by the eternal laws that regulate the moral nature of man . . . one almost shrinks from discussing in a newspaper paragraph achievements that raise the achievers to that small but noble group whose name is not so much of to-day as of all time.

WILLIAM HAZLITT, IN *THE CHAMPION*, 1815

Turner's art has meant many things to many people: his extraordinary breadth of subject and interest, his development of colour and technique, has given each succeeding generation something new to discover, a different artistic personality to claim as its own. His critical heritage is enormous, and today the study of his work has become an ever-expanding industry.

Turner's work set an unprecedented challenge to the critics of his time, and their attempts to meet it exposed the limitations of traditional criticism, which made no attempt to come to terms with an artist's individual mode of seeing. New standards of analytical writing were established for the future, but it was not only the radical originality of Turner's work that put critics on the spot, but its diversity. Whereas the more single-minded achievement of an artist like Constable could be dealt with on a narrower plane, Turner defeated simple judgement. Patrician connoisseurs like Sir George Beaumont and Lord Francis Egerton admired his early work in the tradition of the old masters but dismissed his later pictures. Others, chiefly his fellow painters, felt their interest engaged only when he began to depart from the art of the past.

The standards and sources of art criticism in the Romantic period were much debated even at the time. Although distinguished writers like William Hazlitt contributed pieces on painting to the better journals, the daily newspapers lacked serious comment on the arts, and the vacuum was filled by self-appointed arbiters of taste like Beaumont, whose influence over the collecting classes was bitterly resented by artists. In the 1820s and '30s matters began to improve, but by this time Turner's work had become highly controversial, far outstripping the tastes of most commentators, although he was acquiring a growing body of imitators and followers.

One of the critics writing in the later 1830s was the young William Makepeace Thackeray, who exemplified the dilemma posed by Turner's art. Like Hazlitt, Thackeray had begun his career as a painter, and to eke out his income he contributed art criticism to *Fraser's Magazine* under the name of Michael Angelo Titmarsh. Unfortunately he could not always resist pandering to readers who had become used to vulgar and overblown comparisons, such as 'asbestos draperies', or 'skies like lobster salads'. He was not ashamed to dismiss Turner as 'incomprehensible' or

'mad', or to liken a chariot in one of Turner's paintings to a coal-scuttle, but he could also be deeply moved, and admitted it. Turner's *Slave Ship,* exhibited at the Academy in 1840, was widely ridiculed, not least by *Punch:*

> *TRUNDLER R A. treats us with some magnificent pieces.*
>
> *34. A Typhoon bursting in a simoon over the Whirlpool of Maelstrom, Norway, with a Ship on fire, an eclipse, and the effect of a lunar rainbow.*

But Thackeray found it 'the most tremendous piece of colour that ever was seen; it sets the corner of the room in which it hangs into a flame.' The previous year he had been moved to a more penetrating analysis of *The Fighting Téméraire,* describing it as 'a great national ode or piece of music'. He recognized all Turner's contrasts of past and present, celebration and elegy, and his comment – 'He makes you see and think a great deal more than the objects before you' – anticipated much of modern Turner criticism as well as that of his great contemporary, John Ruskin.

Ruskin came to Turner while still a youth. In 1836, aged seventeen, he read an attack on *Juliet and her Nurse* in *Blackwood's Magazine* – always the crudest of Turner's critics – and drafted a reply. He sent this to Turner, who advised him not to publish, but his life-long career as critic, analyst, protector, collector and administrator of Turner was launched. In 1843 he published, anonymously, the first volume of his great book *Modern Painters,* which brought art criticism in Britain to new heights. Dedicated to the 'Landscape Artists of England', it was primarily an analytical justification of Turner himself, unashamed in its bias.

Ruskin initially set out to prove that Turner's late style was profoundly true to nature. Later, impressed by the more literal truth to nature practised by the Pre-Raphaelite Brotherhood, formed in London in 1848, he turned to a more subjective investigation of Turner's symbolism and imagery, and somewhat modified his assessment of Turner's very late work. Dividing the artist's development into several distinct phases, he did not hesitate to speak of 'decline'.

Meanwhile, Turner himself was preparing for the judgement of posterity. Although since 1829 he had willed two of his pictures to hang with Claude in the National Gallery, he well knew that his work must be judged as a whole rather than by individual examples. With this in mind, he had begun to amass pictures in his own gallery in Queen Anne Street. Some were finished works he had not sold; a few were those he had bought back, and others were recent sketches and experiments in which he continued to explore problems of light and atmosphere, colour and form. These last were never intended for sale, nor for exhibition in his lifetime, although a rare visitor, Elizabeth Rigby, the wife of his old friend Eastlake, thought them 'matchless creatures, fresh and dewy, like pearls just set', and in our time they have been for some critics his most brilliant and prophetic works, foreshadowing not only Impressionism but Abstract Expressionism.

However, Turner's much disputed will, at least in its final form – codicils were drawn up until 1849 – did not accord these particular works quite the status they have acquired today. Earlier, he had apparently envisaged rotating displays of the unfinished canvases in the gallery he planned for his work. This was either to be attached to a charitable institution for 'Male Decayed Artists', for which funds were provided in his original will, or was to be maintained in Queen Anne Street. But his final will offered only his 'finished pictures' to the National Gallery, provided that additional space was allocated to 'Turner's Gallery'. Only when his relatives overturned the will did the nation receive the entire contents of his gallery and studio – the collection that is now housed, after many vicissitudes, in the Clore Gallery, adjacent to the national collection of British Art at the Tate Gallery in London.

In the intervening years, Turner's critical reputation depended largely on those works from the Bequest that were currently being shown in London or elsewhere or, more occasionally, on works from private collections exhibited on special occasions like the Manchester Art Treasures Exhibition in 1857. That

year, the first selection of works from the Bequest was hung at Marlborough House in London, including some unfinished pictures and sketches. The early selections were made by Ruskin, who tried to achieve a wide range of style and technique as well as subject – as in his own collecting of Turner. Ruskin also arranged pioneering displays of works on paper, though with these he took liberties unthinkable today, even destroying work of which he disapproved.

It was at the South Kensington Museum (now the Victoria and Albert), where the Bequest was transferred in the 1860s, that Monet and Pissarro fell under Turner's spell, to be followed later by Matisse and Signac. For the Impressionists, who naturally focused on those aspects of Turner's art that accorded with their own interests, he was a painter of light and transient effect. This view has endured for many years. Indeed it is easy to see the ancestors of Mark Rothko's resonating fields of pure colour in Turner's expanses of luminous vapour, described by Elizabeth Rigby as 'the mere colours grateful to the eye without reference to the subject'.

But the painter of light was the painter of much more besides, and although this is the most truly liberated aspect of Turner's landscape art, it is only part of his achievement. Today we try to form a complete picture of his wide-ranging art and its place in the historical context of his period. Modern critics and historians rightly apply themselves to Turner's far-flung intellectual interests, aspirations and influences, sometimes rivalling even Ruskin in the ingenuity of their interpretations. In the Clore Gallery, as much weight is given to the early subject pictures as to the later colour studies and sketches, while twenty-five years ago they would probably have been given considerably less emphasis. But the pendulum may swing yet again: in a recent exhibition called *Homage to Turner,* at Agnew's in London, the pictures submitted by living artists, many of them young, focused once again on Turner as the Impressionists saw him.

Most Turnerians, however, have advanced beyond the stage where they feel the need for either generalized or restricting constructions. There are other important claims on their attention: there is much information about Turner's life and work still to be discovered, and a wealth of meaning remains locked within his art. Each year some of the gaps are filled, but there will surely always be unanswered questions and new generations to address them, won over by the rich legacy of England's greatest artist – Ruskin's 'greatest of the age . . . *the* painter and poet of the day'.

INDEX

ACKNOWLEDGEMENTS

Key: a = above b = below c = centre l = left
r = right

Quarto would like to thank the following for their help with this publication and for permission to reproduce copyright material.

"Ashmolean Museum, Oxford": pp22, 96a, 126, 130b, 136b, 174a, 184

By permission of the Birmingham Museum and Art Gallery: p146b

Bridgeman Art Library: p127

By courtesy of the Trustees of the British Museum: pp8, 19br, 31, 101, 131b, 145, 148a, 152, 157b, 160, 182b

The Trustees, The Cecil Higgins Art Gallery, Bedford England: p97

Courtauld Institute Galleries, London (Witt No. 3225): p331

By Permission of the Governors of Dulwich Picture Gallery: p47, 87b

English Life Publications Ltd, Derby: p157a

"Copyright The Frick Collection, New York": p161

© 1990 Indianapolis Museum of Art, Anonymous Gift in memory of Evan F. Lilly: p54/55

© 1990 Indianapolis Museum of Art, Gift in memory of Dr. and Mrs Hugo O. Pantzer by their children: p96b

Louvre: p56b

Manchester City Art Gallery: p115

Paul Mellon Centre for Studies in British Art, London: p40a

Reproduced by courtesy of the Trustees, The National Gallery, London: pp45, 46, 50, 53, 70, 90, 91, 92, 140/141, 144, 168

The National Gallery of Ireland: p44b

National Portrait Gallery, London: p21

The National Trust Photographic Library: pp38, 42

The National Trust Photographic Library/Tim Stephens: p123b

The National Trust Photographic Library/J. Whitaker: p36

Private Collection: pp20, 43a, 49, 67b, 94, 124/125, 136a

Private Collection, England: p49

Private Collection formerly The Leger Galleries, London: p66b

Royal Academy, London: pp15, 16, 24, 33b

Royal Collection, 'Reproduced by Gracious Permission of Her Majesty the Queen: p64

"The Royal Borough of Kensington & Chelsea": p11

"Ruskin Gallery, Collection of the Guild of St. George": p34

"Reproduced by permission of Sheffield City Art Galleries": p43b

"Formerly with Spinks & Sons Ltd": p136a

The Toledo Museum of Art, Toledo, Ohio: p48

The Turner Collection, Tate Gallery London: pp2, 6, 12, 14, 191, 27a, 29, 33a, 38b, 39, 40b, 52, 58, 59a, ar, 60, 61, 62, 66, 68, 69, 74, 75a, b, 77, 78, 79, 81, 82, 83, 84, 85, 86, 87a, 88/89, 95, 98, 99, 100, 102al, ar, 103, 105, 106, 107, 108, 109, 110, 111, 112, 113, 114, 116a, 117, 118, 119, 120, 121, 122, 128, 129, 130a, 132a, 134, 135, 137, 139a, 142, 146, 148b, 149, 150, 151, 154a, 156, 158, 162, 163, 164, 166, 169, 170, 172, 173, 174b, 175, 176, 178, 179, 180, 181, 182a, 183

"Courtesy of the Board of Trustees of the V & A": pp271, 67a, 73, 77b, 102b

Whitworth Art Gallery, University of Manchester: p165

Yale Center for British Art, Paul Mellon Collection: pp26, 44a, 56a, 65, 116b, 131a, 132b, 139b, 154b

Every effort has been made to trace and acknowledge all copyright holders. Quarto would like to apologise if any omissions have been made.